A Hiker's Guide
to the Rocky Mountain Art
of Lawren Harris

For permission to reproduce works of art, reprint text, and
publish photographs, by all artists, authors, and poets in this
volume, grateful acknowledgement is made to holders of
copyright, publishers, or representatives thereof. Every rea-
sonable attempt has been made to identify and clear such
copyright. If notified, the publisher will be pleased to rectify
any omissions at the earliest opportunity.

Front cover image *Mountain Sketch LXVII*, Lawren Harris,
Private Collection
Front cover design by Rachel Hershfield/RH Design
Back cover and interior design by Articulate Eye Design
based on a design by Cathie Ross, Glenbow Museum

The publisher gratefully acknowledges the support of
The Canada Council for the Arts and the Department of
Canadian Heritage.

We acknowledge the financial support of the Government of
Canada through the Book Publishing Industry Development
Program for our publishing activities.

Printed in Canada.

00 01 02 03 04/ 5 4 3 2 1

Canadian Cataloguing in Publication Data

Christensen, Lisa.
 A hiker's guide to the Rocky Mountain art of Lawren Harris
 Includes bibliographical references and index.
 ISBN 1-894004-43-4
 1. Harris, Lawren, 1885–1970. 2. Rocky Mountains,
Canadian (B.C. and Alta.) in art.* 3. Hiking—Rocky
Mountains, Canadian (B.C. and Alta.)—Guidebooks.*
I. Harris, Lawren, 1885–1970. II. Title.
ND249.H36C57 2000 759.11 C00-910236-1

Published in Canada by
Fifth House Ltd.
Calgary, Alberta, Canada

Published in the U.S. by Fitzhenry & Whiteside
121 Harvard Ave.
Suite 2
Allston, Massachusetts
02134

A HIKER'S GUIDE
TO THE ROCKY MOUNTAIN ART
OF LAWREN HARRIS

LISA CHRISTENSEN

FIFTH
HOUSE
PUBLISHERS

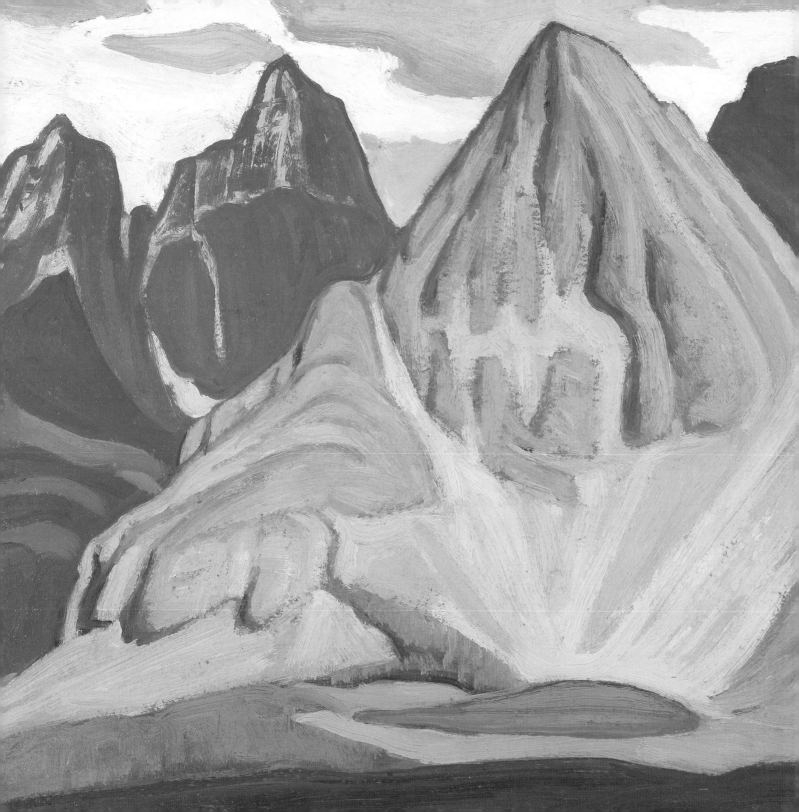

For david, who introduced me to jasper,

and to barb and don, for lake edith.

"I FELT THE STRANGE BROODING LONELY PRESENCE OF NATURE FOSTERING A NEW RACE, A NEW AGE, AND

AS PART OF IT, A NEW EXPRESSION IN ART. IT WAS AN UNFOLDING OF THE HEART ITSELF THROUGH THE

EFFECT OF ENVIRONMENT, OF PEOPLE, OF PLACE, AND TIME."

—Lawren Harris in *The Beginning of Vision*, 1982

Lawren Harris
Mount Sampson, Maligne Lake, Jasper, c. 1924
pen and ink on card
Private Collection

This project would not have been possible without the support of my family and friends, and the encouragement of a remarkable and patient partner.

In particular, I must thank my confidants, Cathie Ross and Anita Dammer, who were never too busy to discuss anything, and my Jasper friends, whose love of the region they call home was a constant inspiration.

Special thanks go to my Christensen family for introducing me to Jasper through beautiful Lake Edith and to my hiking companions, Sherry Anne, Nancy, and Anita.

My greatest debt of thanks must be paid to my babysitters: Mom and Dad, Barbara and Don, Richard, Susanne and Natalie, Susie and Travis, Lori, Jeff and Christy, Angela and Lindsay, Judy and Bill, and Rhonda, who kept my children occupied so I could crunch out the last month.

Assistance with the location of artworks was provided by many individuals: Doug MacLean of Canadian Art Gallery, Canmore; Romana Kaspar and Daniel Lindley of the Collector's Gallery, Calgary; Gian Carlo Biferali of the Dominion Gallery, Montreal; Tom and Joan Chapman of the Four Corners Gallery, Red Deer; Jeffrey Joyner of Joyner Fine Art, Toronto; Brent Luebke of Lando Fine Art, Edmonton; Doug Levis of Levis Fine Art Auctions and Appraisals, Calgary; John Libby of John A. Libby Fine Art Gallery, Toronto; and especially Rod Green of Masters Gallery Ltd., Calgary, who has brought so many works by Harris home to the Rockies.

Registrars, archivists, conservators, and curators at a number of institutions across the country answered many questions and provided details on the works from their collections: Katherine Rhomba at the Agnes Etherington Art Centre, Queen's University; Christine Braun at the Art Gallery of Hamilton; Donald Rance, Liana Radvak, Larry Pfaff, and Erin Webster at the Art Gallery of Ontario; Bruce Dunbar at the Edmonton Art Gallery; Christy Vodden of the Geological Survey of Canada; Barry Agnew, Jennifer Churchill, and Lindsay Moir at Glenbow; Cynthia Ball, Glenda Cornforth, and Phil Pype at the Jasper Yellowhead Museum and Historical Society; Peter Urquhart of McGill News Alumni Quarterly; Sandy Cooke, Linda Morita, and Linda Tanaka at the McMichael Canadian Art Collection; David Horky, Michael MacDonald, and Michael Eamon at the National Archives of Canada; Franc Duhamel at the National Gallery of Canada; Melanie Johnson at the Robert McLaughlin Gallery; George Brandak and Ken Hildebrand at the University of British Columbia, Special Collections Library; Lori Ellis and Lena Goon at the Whyte Museum of the Canadian Rockies; and Anneke Shea Harrison at the Winnipeg Art Gallery.

Without the published research of Canada's established Harris and Jackson scholars, I could not have charted the trails to the works. Thanks to Jeremy Adamson, Anne Davis, Ted G. Davy, Naomi Jackson Groves, Charles C. Hill, Christopher Jackson, Peter Larisey, Joan Murray and Robert Fulford, and Dennis Reid.

Special thanks go to Charles C. Hill, Curator of Historical Art at the National Gallery of Canada, who always answered my questions, opened his research files to me, and was willing to speculate on where and when.

Thanks to the staff at the trail office in Jasper National Park, especially Mike Day, who took an interest and dug out old photographs for me. Thanks also to John Auger, Kim Forster, Paul Krywicki, Caroline Longtin, Mike Mitchell, Shirley Niven, Alexa Pitoulis, Vicki Wallace, and Kim Weir, all of whom accommodated endless changes to my trail reservations and looked at photographs of paintings with all the enthusiasm they could muster, and to Wendy Niven, who answered those last minute questions. To warden Mike Westerbrooke, thanks for the boat ride and for letting Peter drive.

Thanks are also due to: Merilee Atos, who kept me organized and provided invaluable assistance as a researcher; to the many collectors whose works are illustrated herein; to my excellent readers Christopher Jackson at the McMichael Canadian Art Collection, and Brian Patton, of Mountain Research, Canmore, who also supplied trail information; and to Liesbeth Leatherbarrow, editor, for sorting out organizational difficulties, cleaning everything up, and most of all, for sharing the vision.

Finally, thanks to the descendants of Lawren Harris and A. Y. Jackson, particularly Mrs. Margaret Knox, Mr. Stewart Sheppard, and Dr. Naomi Jackson Groves and her assistant, Anna Brennan, for answering my many questions, allowing me to reproduce works from their collections, and for supporting the idea behind this book.

Bess Harris, Lawren Harris, and Ira Dilworth near Lake Louise, 1940s

"JACKSON AND I WENT TO THE ROCKIES; WALKING THE COUNTRY AND CARRYING OUR BACK-PACKS, WE

LIVED LIKE FOREST RANGERS."

—Lawren Harris in *Lawren Harris*, 1969

"ART IS THE DISTILLATE OF LIFE, THE WINNOWED RESULT OF THE EXPERIENCE OF A PEOPLE, THE RECORD OF THE JOYOUS ADVENTURE OF THE CREATIVE SPIRIT IN US TOWARD A HIGHER WORLD: A WORLD IN WHICH ALL IDEAS, THOUGHTS, AND FORMS ARE PURE AND BEAUTIFUL AND COMPLETELY CLEAR, THE WORLD PLATO HELD TO BE PERFECT AND ETERNAL. ALL WORKS THAT HAVE IN THEM AN ELEMENT OF JOY ARE RECORDS OF THIS ADVENTURE."

—Lawren Harris in personal papers, 1920s

The paintings by Lawren Stewart Harris that depict the Rocky Mountains of Canada are among the most visually stunning mountainscapes ever produced in this country. Luminous, arresting, and monumental, they convey the spirit of the places they depict with a unique combination of a particular painterly style, hung on a specific philosophical framework. They mark a time in our mountain history that has since passed, and a time in our art history that will not likely be seen again.

Harris's artistic exploration of the Rocky Mountains of Canada began with fellow Group of Seven painter Alexander Young (A. Y.) Jackson, in 1924. Jackson had painted in the west before, visiting by train and painting in the Yellowhead region of British Columbia in 1914, but Harris had not yet seen the Rockies. Together, the two painters visited Jasper National Park for an extended sketching trip. They explored the Maligne Lake region, including Jacques Lake and the mountains of the Colin, Queen Elizabeth, and Maligne Ranges. Then they ventured west into the Athabasca and Tonquin Valleys. Harris would return to the Jasper region again, painting nearby at Mount Robson Provincial Park as

well, and later developing these sketches into notable studio works, culminating with the large canvas *Mount Robson*, c. 1929. He would also paint in other regions of the Rocky Mountains, venturing south into Yoho and Banff National Parks and later working into the coastal ranges of British Columbia.

The 1924 Rockies trip was a remarkable time for both painters. For Lawren Harris, it was his first experience in the mountains of western Canada, his introduction to the scenery that would preoccupy him for six years. For Jackson, it was the end of mountain painting, a time of disillusionment and self-scrutiny. After 1924, each artist would continue, each in a very different way, to explore the various landscapes of Canada, sketching from east to west and north to south. The 1924 Jasper trip must have been quite the adventure: *"How the paint and the talk must have flown!"*[1]

Lawren Harris's art would undergo considerable stylistic change over the years that he painted out-of-doors in the Rockies. Sketches from that first trip in 1924 record the mountain scenery with adept painterly representation, following the expressive style for which the Group of Seven had become known.

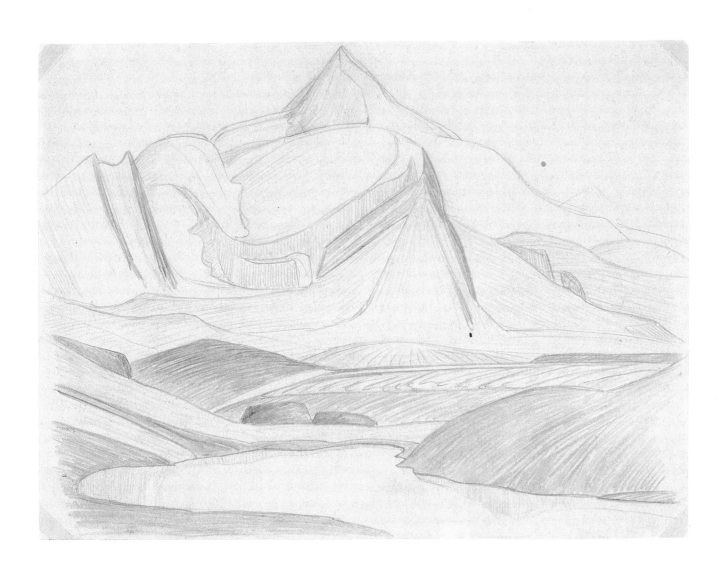

Lawren Harris
Mount Resplendent, 1929
graphite on paper
Private Collection

However, by 1929, the seeds of geometric abstraction that would flower in his later works had been sown. As Harris visited increasingly remote and high-altitude locations in the Rockies, his personal explorations of spirituality would also begin an ascent, and he would embrace the teachings of the Theosophy movement.

Theosophy maintains that all religions are different expressions of one divine whole, and seeks to winnow the dogma and self-aggrandizement away, leaving spirituality and a search for the divine aspects of life to stand alone as its precepts. It is a movement that combines many spiritual ideas with aspects of Buddhism, mysticism, and Hindu teachings. Harris was interested in theosophy as early as 1908, and fully involved in the society by 1922.

The death of fellow painter Tom Thomson, who drowned on Canoe Lake in Algonquin Park in 1917, was followed all too quickly by the death of Harris's older brother Howard, who died in battle during World War I, in 1918. Harris served in this war too, suffering a breakdown as a result. These events left Harris traumatized. Theosophy, with its emphasis on the spirituality of the world and all things in it, was a healing salve for a shaken soul. The movement's interest in art as an expression of spiritual ecstasy held a particular attraction for Harris. He felt that through the pursuit of spiritual growth, one could come to know, or have an experience of, divine wisdom as embodied in the concept of a cosmic spirit. Harris, the artist, was inseparable from Harris, the theosophist:

"You cannot sever the philosophy of the artist from his work. You belittle the man in his work when you accept his skill, his sensitivity in patterning, in building forms, his finesse in accenting, his suavity in technique, but reject his philosophy, his background. People do this through fear or incapacity to accept life. Without the philosophy, or in other words the man, in the work of any great artist, you have nothing."[2]

The mountains were the perfect subject for an expression of the theosophical principles that meant the most to Harris; through them, he began to express himself in his search for reunion with the cosmic spirit. During this artistic and philosophic change, the monumental, triangular peaks of the Rockies were often his choice of subject matter. He would return repeatedly to mountains such as Mount Lefroy, Mount Temple, and Mount Resplendent for imposing compositional fodder.

He gradually pared away any elements he felt to be unnecessary, and refined these mountain shapes into massive geometric, spiritual equivalents. Harris used his art as a tool in his quest for personal philosophical fulfillment, and the resulting works can be followed like rungs in a ladder supporting this climb.

Because of the profound impact that these remote vistas had upon him, Harris would later be drawn to even more austere landscapes, searching the Arctic regions of Canada for imagery that allowed him to express aspects of this ever-deepening philosophy of simplicity and purity in paint.

Despite the fact that Harris began to explore abstractions of natural scenery while working on mountain subjects, his mountain works are not, even at their most abstract and simplified, unrepresentative of the actual topography. An interplay of realism and symbolism, both of which play an important role in these works, can be seen in the paintings. This book intends to demonstrate the balance between the two, to explore the importance of Harris's experiences in the mountains, and to create a guide for readers to further explore by following Harris's trails into the Rockies.

The unique and very specific scenery that Harris selected for his compositions can, almost without exception, be pinpointed on a map of the Rockies. Harris was a capable hiker, covering a distance of almost 50 kilometres in one day with A. Y. Jackson,[3] climbing over several mountain passes and to high elevations to paint his compositions. It is my view that the time Harris spent *on the spot* at these locations was of paramount importance in the resulting canvases. That's not to say that the studies created out-of-doors are better than or convey more of an essence of the mountains than do those that were painted in the studio, but rather that each day's unique experience of weather, light, exertion, and summit was significant for Harris. These realities are not acknowledged in the art historical record; overlooking place and the role it played in resulting works ignores the impact on the artist of the actual physical experience of being in the mountains.

In the early days of the Group of Seven, people observing their artworks for the first time would often make direct comparisons to their own experiences in outdoor environments. A visitor to an exhibition in the early 1920s that included works

depicting northern Ontario commented:

"Must be a queer country. Are the rocks all as flat and flabby as that? Don't the clouds ever float? Doesn't the water flow? Is there no air in the wilds?"[4]

The realities of backcountry travel and the nature of each different region that Harris visited are factors that contribute to the unique qualities in each work. Even the studio paintings, which were not subject to the wind, rain, and snow, still contain the essence of the elements that they depict. In instances when the place visited and depicted was significant to Harris, the result can be quite profound.

An example of the impact of the power of place can be found in an experience that friend and fellow artist Bertram Charles Binning recalled from a time he was hiking with Lawren Harris at high altitude in the Rockies. Harris, upon reaching the summit, was so overwhelmed by the experience that he fell to his knees and began to speak in tongues.[5] Not to be trivialized, this is an example of the profound respect that Harris had for places he felt to be significant. It also conveys a sense of the kind of experience to which Harris was receptive. Obviously, he was moved by mountain scenery, but this feeling developed over time. In 1924, some months after Harris first visited the Rockies, he recalled their visual impact:

"I was discouraged. Nowhere did they measure up to the advertising folders, or the conceptions these had formed in the mind's eye … [but as he] camped and tramped and lived among them, [he] found a power and a majesty and a wealth of experience at nature's summit."[6]

Harris was a ready vessel for the emotional impact of these remote and wild places. He was receptive to the sense of timelessness one can feel in the mountains, to the way in which, as physical structures, they dwarf humankind, and to the respect they demand by virtue of the physical dangers they present. Over the seventy-five odd years since Harris painted in these charged, and to him, newly found places, his works have become separated from the moment of their creation. Revered as Canadian icons, Harris's paintings, which have so much to do with location, are now far removed from the glacial air that would have filled his lungs while sketching, from the chill, and from the sounds of being out-of-doors—so far, in fact, that this aspect of their inception has been all but forgotten.

Harris's own writings attest to the impact that place had upon him. In Canada, the cultural myth of "the north" as a unique place has been well documented. Harris's writings on this topic are expressive of his awareness of spiritual places. In referring to the idea of the north, he states:

"… no man can roam or inhabit the Canadian North without it affecting him, and the artist, because of his constant habit of awareness and his discipline in expression, is perhaps more understanding of its moods and spirit than others are. He is thus better equipped to interpret it to others, and then, when he has become one with the spirit, to create living works in their own right, by using forms, colour, rhythms and moods, to make a harmonious home for the imaginative and spiritual meaning it has evoked in him."[7]

Harris continues, remarking on the physical impact of the north and its climatic effects on one's body and psyche:

"It gives him a difference in emphasis from the bodily effect of the very coolness and clarity of its air, the feel of soil and rocks, the rhythms of its hills and the roll of its valleys, from its clear skies, great waters, endless little lakes, streams and forests, from snows and horizons of swift silver. These move into a man's whole nature and evolve a growing, living response that melts his personal barriers, intensifies his awareness, and projects his vision through appearances to the underlying hidden reality."[8]

In her excellent book *The Power of Place*, Winnifred Gallagher explores the relationship between a person and the place in which he or she exists, and the effect of one upon the other. Subtitled *How Our Surroundings Shape Our Thoughts, Emotions, and Actions*, Gallagher's book chronicles research that looks at human response to the environment. One chapter explores the phenomenon of visions and moments of spiritual ecstasy brought on by being in a place one considers significant. Whether the place is defined as "meaningful and positive" or considered sacred, it is believed that a person's expectations and receptiveness are critical to the experience: *"In short, in an aroused person, the cognitive aspects of a situation determine his emotional response."*[9] Harris was spiritually aroused, ready and receptive to the divinity he felt resided in nature. This divinity, or some sense of it, is what he sought to convey through his art.

"THE POWER OF BEAUTY AT WORK IN MAN, AS THE ARTIST HAS ALWAYS KNOWN, IS SEVERE AND EXACTING, AND ONCE EVOKED, WILL NEVER LEAVE HIM ALONE, UNTIL HE BRINGS HIS WORK AND LIFE INTO SOME SEMBLANCE OF HARMONY WITH ITS SPIRIT."

—Lawren Harris in *Theosophy and Art*, 1933

This is a book about place. Rather than simply discuss the artworks in an art historical context, the intent here is to provide a working trail guide, a map to this unexplored chapter of our art history, a new way to look at landscape art. This is essential to an understanding of Harris's mountainscapes—no mere diversion, but a whole segment of research that has been left untouched.

This book offers readers a chance to follow the trails taken by Lawren Harris during his years of sketching and exploration in the Canadian Rockies. It serves as a trail guide as well as an art historical discussion, and intends to guide you to the places depicted in the artwork illustrated. A. Y. Jackson's works from his 1924 trip with Harris and his first trip to the Rockies in 1914, as well as one work by Harris's second wife, Bess, and another by J. E. H. MacDonald, will also be explored.

In an attempt to roughly follow the chronology of these artists' careers, the trails trace an uneven route from north to south. Within this chronology, some works are out of order in terms of their dates, due to their regional placement in the guide.

The guide begins with Mount Robson and the Yellowhead region, since Jackson first visited this area in 1914, with fellow painter J. W. Beatty. It then follows the route Harris and Jackson took in 1924, charting their trip through the Maligne, Tonquin, and Athabasca Valleys. The guide then documents Harris's subsequent sketching trips in the Rockies to their conclusion in 1929. One section explores the remarkable series of drawings and sketches set in Yoho National Park's Waterfall Valley that culminate in the work known as *Isolation Peak*. The guide also traces a few familiar paths at Lake O'Hara, Emerald Lake, and near Lake Louise and Sentinel Pass.

The artworks in this book fall into several categories. Some were done on the spot, that is, right there in the mountains, with the weather and the ever-changing sky and light playing havoc with composition and palette. These are known as field drawings (usually pencil on paper), or field studies and sketches (usually paintings in oil on small, portable panels or boards). Harris's field drawings are often colour keyed, and include notes on atmospheric conditions. Jackson's field drawings and sketches are often annotated with information about his experiences on the spot—felling trees to cross over streams, sliding down glaciers, etc.

Both artists also executed studio works or finished canvases, which were completed in a studio or other indoor location, far from the mountains that inspired them. There are only two known references to studio works by A. Y. Jackson depicting the Rockies; one work he eventually burned, the other he later painted over, so perhaps the distinction is unimportant for Jackson. Harris, however, often worked and re-worked ideas and concepts from an on-the-spot pencil drawing done years earlier, through several studio versions, to a final, often large-format canvas, such as *Mount Robson*, c. 1929. Harris is also known to have worked up paintings "on demand" for clients, who would contact him, expressing a liking for a certain work.[10] Harris would then simply paint another, perhaps referring to pencil sketches or studies that remained in his possession. Mountain subjects dated after 1929 fall into this category and are referred to in the text as post-mountains.

Many works known to have been created by both artists currently reside in unknown locations. Despite their mysterious whereabouts, these works remain important to the text, and wherever possible, references have been made to other publications that carry illustrations of these works. They are referred to as "lost" (although I trust and hope that their owners know exactly where they are) or as being of "unknown location." Some have even been destroyed. Fire, theft, debt, divorce, and death play a role in the journey that paintings take from owner to owner. The nature of the art world is such that works can change hands frequently, especially when housed in private collections. Many collectors are very private people, and as

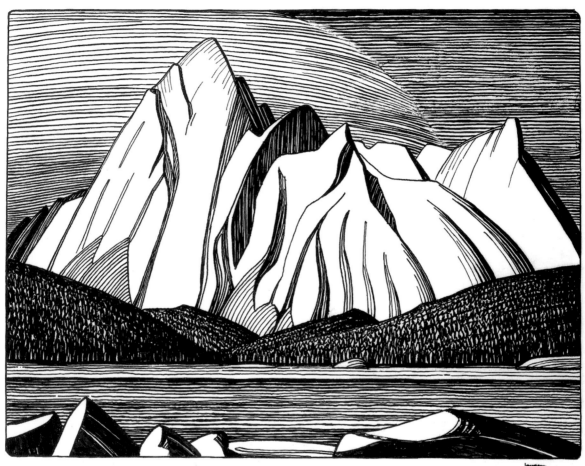

Lawren Harris
Maligne Lake, Jasper Park, Alberta, 1924
pen and black ink on wove paper
National Gallery of Canada

holders of the reproduction rights for any works in their collections, by virtue of ownership, they control their illustration. Public collections, too, have been known to "move" works, and with the present-day financial pressures on public institutions, the inevitable dilemma of museum deaccessioning (the removal of an object from a public collection) will likely become more and more of an issue in years to come.

Placing works in the appropriate collection to best deal with them is another issue related to the movement of artworks. Tracking the movement of these works from owner to owner, often with the added complication of title and date changes that occur along the way, has been an onerous task.

A. Y. Jackson's 1914 trip to the Robson/Yellowhead region took place in late summer, and in his sketches, the use of colour allows us to draw some very specific conclusions. A particular kind of wildflower in bloom, for example, or a certain amount of silt flowing through glacial water, are readable within the colour and shape of his brush strokes. His small sketches of Mount Robson made from the railway line are exacting in their palette, especially in the strata of the mountain's south face, and for works that at a glance appear to be very loose and undetailed, convey a remarkable amount of information.

By contrast, Lawren Harris's works rarely record the minute details that allude to season. Although we know that Harris visited the Rockies most often in July, August, and September, seasonal references, aside from the obvious ones of snow versus greenery, are not readable in his works. Instead, these paintings convey the larger qualities of the scene. Light, air, atmosphere, and temperature are aspects of the mountain experience that would have been more significant to Harris, because of his interest in things of a mystical, indefinable nature. As a result, these works are seasonless, making hiking in the height of summer, or cross-country skiing in winter both excellent ways to visit the corresponding locations. No matter what the season, time spent on the spot contemplating Harris's philosophy is more critical to understanding these works than time of day or year.

In preparing for the research hikes necessary to compile this book, it was obvious that Harris's numeric system of titling his later mountain works, that of the words "mountain sketch" and a roman numeral, would give me no assistance in determining their geographic locations. As well, many untitled works have had descriptive titles attached to them over the course of time. A work depicting a mountain and a body of water may become known as *Lake and Mountains*, when, in fact, it is a still pool along a river that Harris chose to paint. Harris allowed himself great liberties with scenery, adding and eliminating features in many of his works. Mountains were sometimes completely left out of the composition's horizon, especially in the case of secondary or background peaks, that is, features that were not the main focus of the painting. Titles have been changed by owners and dealers, dates amended, and re-amended. All in all, this was a confusing list to collate.

Over the course of my hiking research, I followed a particular plan of attack in trying to determine exactly where Lawren Harris would have been while painting in the Rockies: using maps of the trails that existed in the 1920s, following the routes known from the artist's writings, and second-guessing where an artist might go from an adjacent backcountry lodge, or other likely base. Of all the artists I have researched from this perspective to date, Harris has proven the most challenging. Despite completely blowing out my trusty boots in the summer of 1999, I cannot, for many works, say that Harris stood exactly here, or sat exactly there. But, just as my boots began to give out, I came to understand that his toying with perspectives, moving of mountains, and expanding of distances had much to do with the realities of the outdoor experience. Although the very stillness of many of his works is completely at odds with the wildness of the natural world, Harris truly sensed, often in a profound and metaphysical way, the essence of the spiritually oriented person's sought-after mountain experience. He felt as much, or perhaps even more, than he saw. Some seventy-five years later, his paintings, when layered with an observer's own personal experience of the same place, are likewise felt with more understanding than they are viewed.

Harris compared the experience of looking at art to the sensation of listening to music.[11] It is not the black notes of the musical score that matter, but the sound that you hear. The notes of Harris's paintings are the wind, rain, and snow, the sun, tired feet, and the crest of a summit. These are the sounds of Harris's landscapes, and I hear them best when I am on the spot.

In several cases, I refer to artworks illustrated in my first book, *A Hiker's Guide to Art of the Canadian Rockies*. I also write about many of the same regions described in that book. To avoid overlap here, I have not duplicated any of the artworks illustrated in *A Hiker's Guide to Art of the Canadian Rockies*. This time I have also, as much as possible, described alternate routes to the locations of scenes depicted in both volumes.

The trail information sidebars provided in this guide take you to the best place to view the scene depicted in an artwork from the present roads and trails. When Harris and Jackson were working in the Rockies, many of our current trails and most of our present-day roads did not yet exist. Although Jasper Park was well developed as early as 1924, access to Maligne Lake, Miette, and the Columbia Icefield area was still by trail. Please remain on the current established trails, and observe trail closures and restrictions fully. Trail erosion, evidenced by the parallel ruts of meandering paths through alpine meadows and switchback shortcuts, has left a horrible scar in many places, and every effort should be made to keep the scenery as pristine as it was for Harris and Jackson.

Remember that the best way to break in your boots is to slog through the mud on the trail, rather than tiptoe through the delicate flora alongside.

For full trail information on each hike, it is recommended that readers consult one of the many excellent trail guides available for the national or provincial park they intend to visit. A detailed, up-to-date map is always a must on any trip into the woods. Backcountry permits and wilderness passes are required and strictly enforced in many places, as are trail quotas, open fire restrictions, and registration systems. Visitor and information centres in all Canadian national and provincial parks can provide just about any kind of information you require.

Always remain aware of safety and environmental factors while you are travelling in the Rockies. Make use of all safety and protection devices, such as bear-proof food storage systems, tent pads in the backcountry, and walkways on badly eroded trails. The weather is unpredictable in any region of the Rockies, at any time of year. Foul weather gear and good footwear are an absolute necessity, as are adequate emergency supplies. Your well-stocked knapsack should

never be left behind, even on a short hike in pleasant weather. Pack out everything you take in. One of my worst hiking memories is of following a group of hikers to and from Luellen Lake in Banff National Park and picking up their trail of cellophane caramel wrappers the whole 36-kilometre trip.

Although seeing wild animals is a highlight of many a mountain trip, "animal jams" —masses of cars stopped right in the middle of highways— are dangerous for drivers and downright foolish for visitors leaping out of their vehicles to approach wildlife, camera in hand. Each interaction between a human and a wild animal affects the animal's behaviour. Consider the lesson you teach each time a wild animal sees you. Do not create any stressful or behaviour-modifying situations, which include feeding small animals such as squirrels. On the trails, be aware of your own behaviour at all times. Proper backcountry travel habits can prevent negative interactions and allow for positive ones. And finally, enjoy the art.

Sidebars such as this one are provided to assist you in reaching the locations depicted in the artworks:

Determining exactly where Lawren Harris went on his sketching trips, and when he was there, is difficult. The historical record is incomplete and contains a number of errors. His writings, the dates of his works, the evolution of his style within the mountain works, hotel registration records, and exhibition records all contain bits and pieces of the full chronology. This is a record of his mountain trips as it is currently pieced together. Locations marked with an asterisk (*) are listed assuming that a visit was made to the location in that year because a painting of the same location is dated the same year. These dates are suspect, as the works were not always dated by Harris, and some dates have been applied to works using incorrect literature references.

1924: Visits Jasper with A. Y. Jackson[12]
• Paints at Maligne Lake, Opal Hills, Coronet Creek, and in the Queen Elizabeth Ranges
• Paints at Jacques Lake, the Tonquin Valley, the Athabasca Valley, the Colin Range, Jasper Park Lodge and area, and Lake Edith; also, north of Jasper near Pocahontas, along the Overlander Trail, and at Pyramid Lake and The Palisade

1924: Visits other regions
• Passed through the Yellowhead by train, may have painted at Mount Robson (Berg Lake)*
• May also have painted at Lake O'Hara and in other regions of Yoho National Park (Opabin Plateau, Schäffer Lake, Emerald Lake)*

1926: Paints in Yoho National Park
• Paints at Lake O'Hara, Lake McArthur, Odaray Mountain, Opabin Plateau, Lake Oesa, Lefroy Lake, Mount Schäffer
• May have painted in Jasper (Coronet Glacier, near Maligne Lake, mountains east of Maligne Lake)*
• Paints near Lake Louise, at Mount Lefroy, Mount Temple, Moraine Lake, and Valley of the Ten Peaks
• Paints in Yoho, including Mount Burgess

1927
• May have painted in the mountains, including Jasper, Yoho, Banff, and Mount Robson Parks *

1928
• Paints at Lake O'Hara and Lake McArthur

1929
• Paints near Lake Louise in Banff National Park, at Mont des Poilus in Yoho National Park, and at Mount Robson (Tumbling Glacier, Berg Lake, Mount Resplendent)

In documents prepared by Harris for the Art Gallery of Toronto (now the Art Gallery of Ontario), he states that he painted at Kootenay National Park as well. To date, I have not seen any work depicting a vista that I even suspect is in Kootenay. In his handwritten notes (c. 1940s), which where later used in his book *The Story of the Group of Seven*, Harris notes *"myself to Rockies for 4 summers. Louise, O'Hara, Robson, Jasper."*[13]

Lawren Harris looking back over Lake Louise from Pope's Prospect, Plain of the Six Glaciers, 1940s

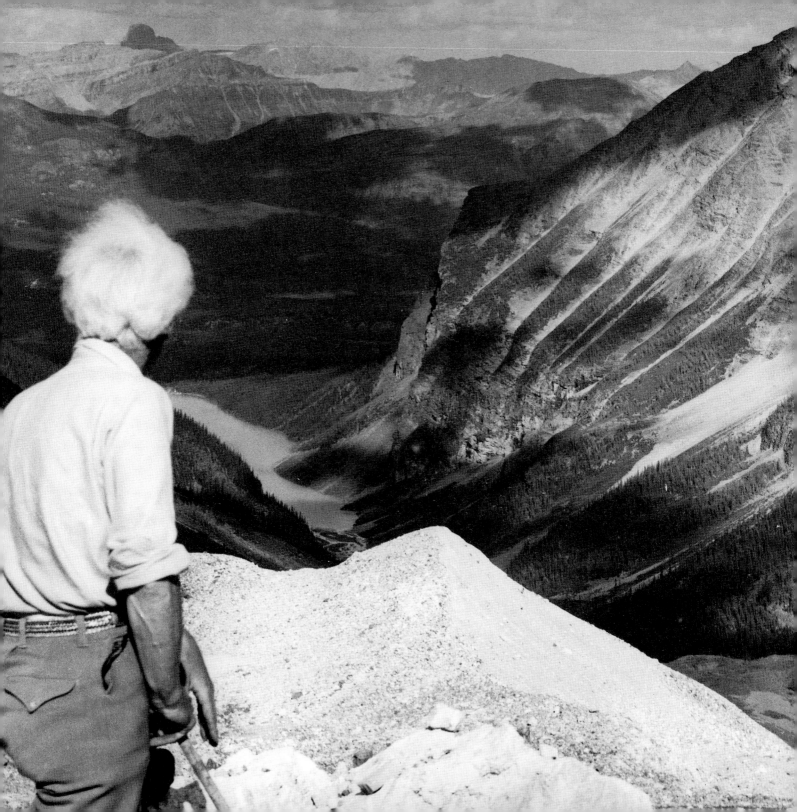

The oil panels executed by A. Y. Jackson during both his 1914 and his 1924 sketching trips to the Rockies have not been well documented in the art historical record. At best, they are given a passing mention in most texts. His pencil drawings have received more attention, notably in Naomi Jackson Groves's *A. Y.'s Canada*. Critical opinions of the mountain oils vary from bad to average, with the occasional positive remark. A. Y. himself was the most critical of all.

Jackson was not at home with the scenery of the Rockies, preferring instead the more rolling, colourful country of eastern Canada in the Laurentians, Algoma, and the small villages of Quebec, and the rolling rhythms of the Alberta foothills, where he frequently painted.[14] It seems that the Rockies gave him a challenge he felt he did not meet; their colour was too green for him, and their massiveness unsuited to his preferred method of composition, which gave a great deal of the space in his paintings over to foreground and middle ground. *"The Rocky Mountains have always been a challenge to our painters,"* he would later say; *"… few of them have enhanced their reputations by depicting them."*[15] He also conceded that the skills of a fellow Group of Seven member were better suited to the mountains than his own. *"Jim [J. E. H.] MacDonald had done it all and he [A. Y.] could not do it as well, he said."*[16]

With his critical eye, Jackson would sort through accumulating piles of panels in his studio and burn those he felt to be lacking. He once told Robert McMichael (founder of the McMichael Canadian Art Collection) *"You know, Bob, I guess I've burned about a thousand of my pictures. They used to be a lot cheaper than firewood."*[17] Jackson's pencil drawings have survived somewhat better, perhaps because they were never intended for sale or public display, but served their purpose instead as tools of his trade, or perhaps they remain intact because they simply provided less heat in the stove.

Jackson's own criticism of his work begs the question of why we examine them herein. Jackson admits regret later in life for the burnings, musing that the canvases he painted of the Colin Range would eventually have been considered "quite good." Art historical hindsight, curiosity about the adventures of Harris and Jackson, and an interest in the place have compelled me to look at these works.

Jackson would teach at the Banff School of Fine Arts in the 1940s. During this time, he would paint in the Rockies again.

However, in his approach some twenty years later, he would use the Rockies only as backdrops for his rural scenes, with only the occasional image of a mountain setting for its own sake.

It is perhaps ironic that we have few images of Jackson's Rockies, when the details surrounding his travels there are so much clearer than those described by Harris. He was quick to recall his trips with Harris when reminiscing, or when asked to talk about his life and work. These trips, which covered many areas of Canada after he left the Rockies behind, were obviously among his fondest memories. Despite the occasional work that is admittedly awkward, viewing these scenes together as a group should shed new light on their merit.

1914: Paints in Yellowhead Pass with J. W. Beatty
- Hikes into the backcountry with various Canadian National Railway staff and paints vistas including Mount Robson, Mount Resplendent, Lynx Mountain, Five Mile Glacier, Yellowhead Mountain, Kushina Ridge, Whitehorn Mountain, and Kinney Lake
- Passes through Jasper, but no works are known to have been painted there

1924: Travels to Jasper National Park with Lawren Harris and the Harris family
- Paints in the vicinity of Jasper Park Lodge, at Maligne Lake including Coronet Creek, and in the Colin and Queen Elizabeth Ranges; also works in the Tonquin Valley, the Athabasca Valley, and near The Palisade
- May have painted at Lac Beauvert, Lake Edith, north of Jasper near Pocahontas, along the Overlander Trail, and at Pyramid Lake
- May have painted at Yellowhead Mountain and in Mount Robson Provincial Park while travelling through by train[†]

[†]It was during this trip by train on the "triangular tour" that Jackson first saw the Skeena River village of Kitwanga. He was fascinated with the scenery there, wondering what it would look like in the winter. He would return in 1926 to sketch with anthropologist Marius Barbeau and artist Edwin Holgate.

A. Y. Jackson sketching in the mountains, undated

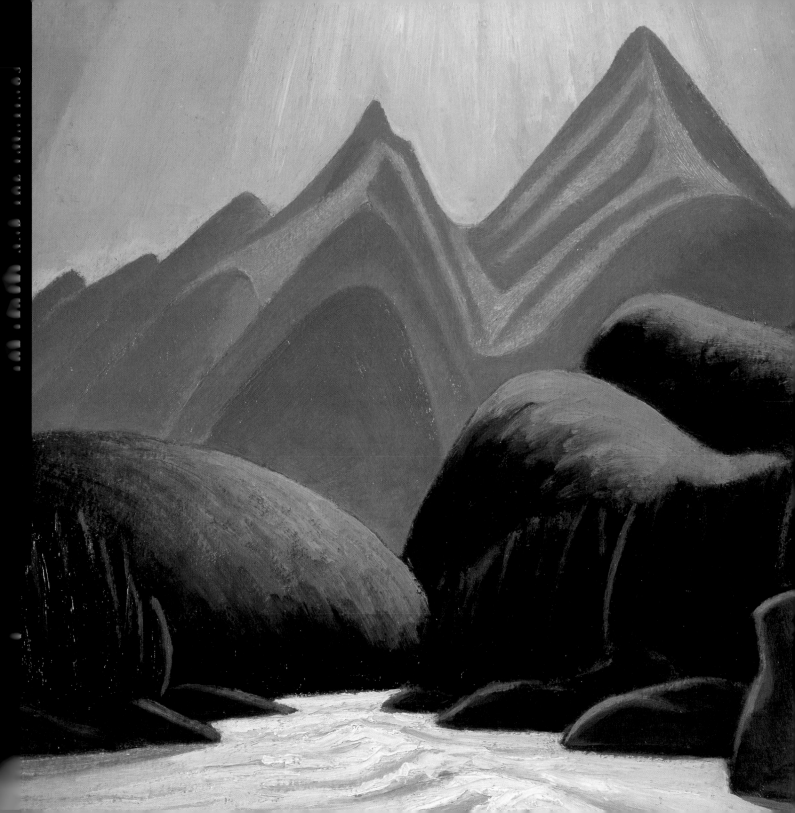

"THEN CAME THE ROCKIES; FIRST WITH SOME SLIGHT CONCERN
AT RECOGNITION, AND LATER AS PURE ABSTRACTIONS; HUGE CANVASES
ON WHICH MOUNTAIN, LAKE AND SKY ARE ONLY SYMBOLS,
BUT WHICH SEEM TO CONTAIN THE SLOW, INEXORABLE POWER OF
THE GLACIERS THAT INSPIRED THEM."

—Merrill Denison on Lawren Harris in the *Calgary Herald*, 1934

Lawren Harris
Rocky Mountain Sketch LX, c. 1928
oil on panel
Private Collection

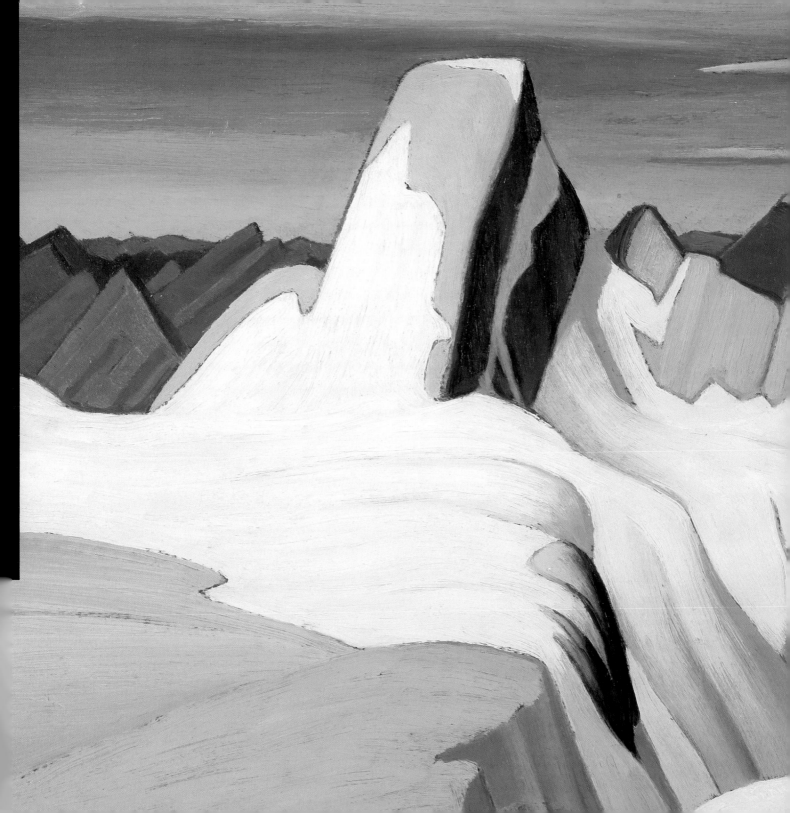

"VISIBLE NATURE IS BUT A DISTORTED REFLECTION OF
A MORE PERFECT WORLD AND THE CREATIVE INDIVIDUAL
VIEWING HER IS INSPIRED TO PERCEIVE WITHIN
AND BEHIND HER MANY GARMENTS, THAT WHICH IS
TIMELESS AND ENTIRELY BEAUTIFUL."

—Lawren Harris in personal papers, 1920

Lawren Harris
North of Mt. Mumm, Robson Park, undated
oil on panel
Private Collection

Mount Robson Provincial Park

Mount Robson Provincial Park was established in 1913 to commemorate the region surrounding the highest mountain in the Canadian Rockies. Originally surveyed at 14,500 feet, Robson's height has been downgraded three times since, as a result of advancing technology; corrected first to 13,700 feet, then to 13,068 feet, its height is now accepted at 12,972 feet or 3,954 metres. Regardless of these downgrades, Robson commands the horizon from every direction in the vicinity, including the nearby railway line that first brought A. Y. Jackson to the foot of this magnificent mountain in 1914. Jackson drew and painted numerous small sketches in the region, including classic views of Mount Robson from the south, Resplendent Mountain from Titkana Peak, Whitehorn Mountain above Kinney Lake, a night view of Mount Robson from Berg Lake, and various views from Snowbird Pass. He later destroyed many of these sketches, feeling that no one liked them. One work, titled *Mount Robson by Moonlight* (not illustrated), was ironically one of only two known to have been painted in the studio, upon returning from the mountains. It was painted over with an Algoma scene in 1919, and now hangs in the Hart House Permanent Collection at the University of Toronto.

Mount Robson Provincial Park is a region worth exploration. Historical sites abound, as do many areas with unique attractions. Beautiful and unusual wildflowers can be found in the wet British Columbia forests that grow in the park. Grass-of-Parnassus, with single flowers of tiny, fringed petals, are worth inspecting at close range. Franklin's Lady's Slipper, once common in Banff National Park, has been picked almost to extinction in some regions of the Rockies. Specimens found in Mount Robson Park should be considered an endangered species. Remember, it is illegal, irresponsible, and selfish to pick wildflowers. Instead, get down in the dirt and enjoy their fleeting beauty there.

Lawren Harris, 1940s

"FULL OF EAGERNESS TO EXPLORE NEW TERRAIN,
AND MAYBE EVEN EARN AN HONEST DOLLAR OR TWO,
A. Y. JACKSON HAD COME WEST IN COMPANY WITH
J. W. BEATTY, LIKEWISE A TENANT OF TORONTO'S
NEW STUDIO BUILDING. BOTH ARTISTS WERE ON A
TENTATIVE COMMISSION ARRANGED BY BEATTY TO
PREPARE SCENIC STUDIES ALONG THE CONSTRUCTION
SITES OF THE CANADIAN NORTHERN RAILWAY, WHICH
WAS BUSILY PUTTING ITS LINE THROUGH THE ROCKIES
IN THOSE RAILWAY-BUILDING-BOOM DAYS."

—Naomi Jackson Groves in *A. Y.'s Canada*, 1968

TRAIL INFO

Site information:
Mount Robson
Type of hike:
Roadside view—easy walk
Trailhead:
Berg Lake parking lot
How to get there:
The Mount Robson
Provincial Park Visitor
Centre is located on British
Columbia's Yellowhead
Highway, 36 km east of
Valemount and 90 km west
of Jasper. Allow for a 1-hour
drive from Jasper. There are
many interesting places to
visit along the way; this
makes an excellent day trip.
Distance: Less than 1 km
Elevation gain: None
Degree of difficulty:
Very easy; wheelchair/
stroller accessible
Viewing time: The Mount
Robson Provincial Park
Visitor Centre is quite inter-
esting, although as is the
case with most such centres,
there is no acknowledge-
ment of the art history of
the mountains. The displays
are easy to follow and fun
for children. There is also a
picnic area, a playground,
and a short interpretive trail
around an adjacent meadow,
making the site a good des-
tination for families with
young children. Although
Jackson's Mount Robson is
set further south across the
Fraser River, you can
approximate the vista very
nicely from here.

MOUNT ROBSON

Mount Robson is a typical example of A. Y. Jackson's approach to the colour, patterning, and composition that he used in his paintings of the Rocky Mountains of Canada. The various hues of his palette include earthy red ochres, rich olive greens, and deep, cold blues. In his use of these pigments, Jackson did not necessarily restrict any colour to mere depiction of one corresponding subject. That is to say, he coloured all over and outside the lines. His green forests are not just green. The sky in *Mount Robson*, for instance, although predominately blue and white, has touches of the same ochres that define the strata of the mountain face below. Conversely, layered in the banding of colours that depict Robson's face are the same blues that Jackson used in the sky.

The painting is almost a key to its own palette, wherein each colour was used pure and straight from the paint tube to rough in a large region of the composition. As the structures of the mountains took shape on the panel, the under-painted colours showed through Jackson's subsequent layers in small staccato windows. Then, as the hair in Jackson's brushes began to fill with paint, residual colours appeared here and there all over the work, resulting in a patchwork of riotous quilted colour. Chaotic at first glance, Jackson's mountain works are, in terms of their colour, a unified sort of chaos—a pandemonium in palette.

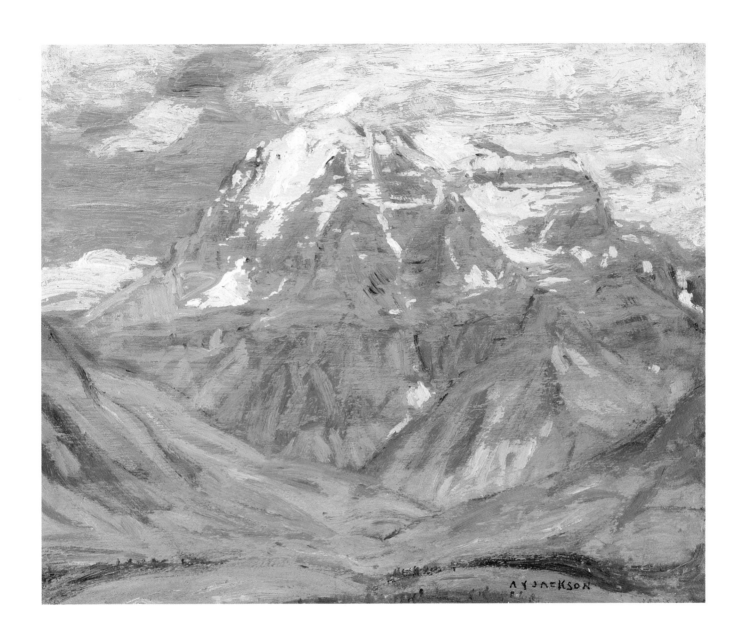

A. Y. Jackson
Mount Robson, 1914
oil on panel
Private Collection of E. F. Anthony Merchant

LYNX MOUNTAIN

A region of unique beauty and unparalleled environment, the Mount Robson region is a wonder. The central feature of this amazing landscape of glaciers, lakes, snowfields, and peaks is massive Mount Robson itself. A mountain that creates its own weather patterns and boasts its own unique eco-system, it is only one of many in the area that Harris would use as a subject. The delightful trail to Berg Lake, an icily tranquil body of silty water at the foot of Robson's north face, takes you through regions with such enticing names as the Valley of a Thousand Falls, and beckons you to explore Snowbird Pass, Robson Pass, the Mumm Basin, and Toboggan Falls. The Berg Lake Trail, in addition to being a lovely hike, is also one of the most heavily travelled trails in the Canadian Rockies. Quotas and a reservation system are in place. Call the Mount Robson Provincial Park Visitor Centre for information and reservations before you go.

As with almost every area in the Rockies, the construction of railways opened this region to artists. The relatively low grade of Yellowhead Pass on British Columbia's eastern boundary with Alberta lured the Canadian Pacific Railway (CPR) to survey there in 1872. They eventually abandoned this route, but in 1905, the Grand Trunk Pacific Railway (GTPR) began to construct a line from Winnipeg to Prince Rupert. This railway reached Jasper (then called Fitzhugh) in 1911, and was completed in 1914. Realizing the potential draw of the fantastic scenery and unexplored alpine regions, the GTPR developed plans for two luxurious hotels, one to be built on the Fiddle River and another in Jasper proper; they even conceived a monorail running up the valley to Miette Hot Springs.[18]

Their rival railway, the Canadian Northern, was also aware of the natural attractions in the area, enlisting artists to depict the scenery for their brochures. They built a competing line crossing Yellowhead Pass, running from Edmonton to Vancouver, that reached Jasper in 1913; the tracks of both railways even ran parallel to each other in places in the Yellowhead. Working in competition in such close quarters led to the likely scenario of problems: sabotage of each other's work, workers repeatedly changing allegiances, and obvious financial inefficiencies. Both companies were deeply in debt by 1916. Steel shortages during the war hastened the demise of both companies, and by 1923, the federal government had taken over and amalgamated the lines into the Canadian National Railways (CNR). It was the CNR that built the grand hotels of which the Grand Trunk Pacific and the Canadian Northern had dreamed, and the CNR that would later solicit members of the Group of Seven to illustrate their 1927 travel brochures.

Despite the fact that A. Y. Jackson's trip to the Yellowhead with William Beatty took place in 1914, during the height of all this competition, the problems between the two railway companies warrant no mention in Jackson's 1958 autobiography, *A Painter's Country*. Instead, Jackson recalls with fondness and humour, and the nostalgia of the retired adventurer, this trip to the Rockies:

"… Bill Beatty got a commission for himself and me to paint in the construction camps of the Canadian Northern Railway which was laying track through the Rocky Mountains. It was an exciting prospect for me particularly, since it would afford my first glimpse of the Canadian West. We travelled first to Saskatoon, then from Saskatoon we went to Calgary by Canadian Northern over a road recently strung across the prairie. It was very rough: every now and then the engine broke loose from the train and had to back up and pick us up."[19]

Jackson then goes on to describe the events of the trip, which included his first meeting with a cowboy, and a stop at a half-finished station for lunch. There are no details of the journey from Calgary to Yellowhead Pass, but the train must have gone west from Calgary to Kamloops in the British Columbia interior, and then northeast through Sicamous to the Yellowhead. Jackson does describe the CNR camps along the Fraser River in detail, and all his descriptions recall a sense of the great adventure he was having. The line was being built on the south side of the river, whereas the camp was on the north bank. Workers used felled trees for bridges to cross the water, and frequently had to replace these logs as the raging river knocked them out. The Fraser is British Columbia's longest river, and here, is relatively close to its

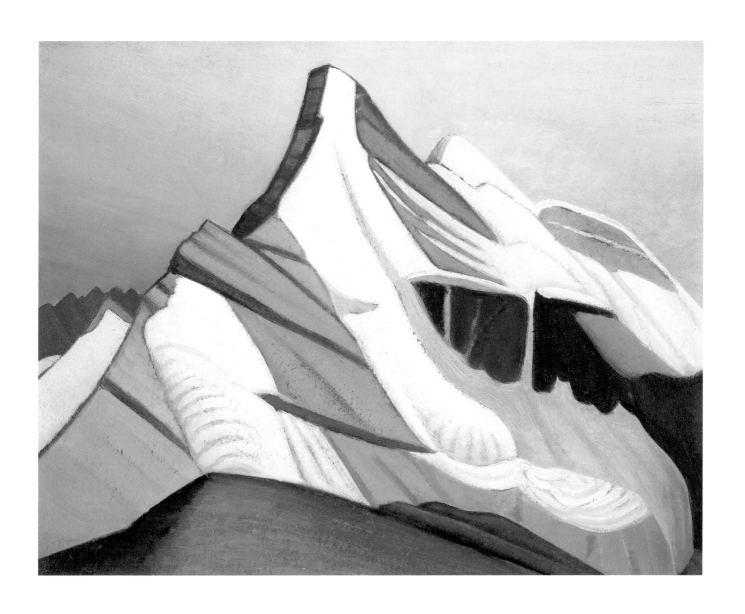

Lawren Harris
Lynx Mountain (Mountain Sketch XLI), undated
oil on panel
Private Collection

source, and charging. One such precarious bridge had to be crossed at night, and Jackson recalls that the only thing that lured him across was the smell of freshly baked pies coming from the lighted cookhouse on the other side,[20] a welcome incentive no doubt.

Despite the fact that Beatty had arranged for the commission, it seems that Jackson worked largely on his own, discovering quickly that he wanted to get well up into the mountains, and realizing that Beatty was unable to keep up. *"We'd start a climb but about halfway up Old Bill would have to lie down, panting, so I'd go on alone."*[21] It may not have been that Beatty was unfit, but that Jackson, who had by necessity walked many a mile in search of scenery, when too poor to afford transport, simply had more stamina than Beatty. *"… as a kid working in a Montreal lithograph shop, I used to hike up to fifty miles a day with cheese and raisins in my pocket to sketch the Quebec countryside."*[22]

He recalls:

"Working from the tracks was not very exciting. So I took to climbing the mountains. The chief engineer did not approve of my going alone, and he arranged that I should always be accompanied by one of the staff. There was no lack of volunteers. The young engineers were tough, husky boys who had much to teach me. I learned from them how to get about in the mountains with neither blankets nor tent, on a diet restricted to oatmeal, bacon and tea … I made many sketches which were never used, as the railway which had commissioned them went bankrupt during the war."[23]

Jackson's letters written from the Yellowhead are few. Those that are known indicate that he was pleased with both the trip and his artistic output, referring to his sketches as being *"up to the standard."*[24] His letters to his close friend Dr. James McCallum, a Toronto doctor who was closely associated with members of the Group of Seven even before its formation, hint at his delight with exploring the region. *"We had good times in the mountains, exciting ones. We took too many chances, sliding down snow slopes with only a stick for a brake, climbing over glaciers without ropes, crossing rivers too swift to wade by felling trees across them."*[25]

A. Y. Jackson sketching near Mount Robson, B.C., 1914

TRAIL INFO

Trail/site information: Mumm Basin/Lynx Mountain
Type of hike: Backcountry overnight hike or climb
Trailhead: Berg Lake parking lot
How to get there: The Mount Robson Provincial Park Visitor Centre is located on British Columbia's Yellowhead Highway, 36 km east of Valemount and 90 km west of Jasper. Allow 1 hour from Jasper. The Berg Lake parking lot is at the end of a 2-km side road that runs north past the Mount Robson Provincial Park Visitor Centre.
Distance: 19.6 km to Berg Lake campground
Elevation gain: 784 m to the Berg Lake shore
Degree of difficulty: Difficult to very difficult
Hiking/viewing time: Allow 3–4 days if you plan to explore the Robson region fully
Route: The first 6.7 km of trail to the Kinney Lake campground allow for mountain bike use. If you are biking, use a bell and remember that hikers have the right of way. There is another campground at Whitehorn Mountain at 10.5 km, Emperor Falls campground is at 15 km, and the Marmot campground, at 17.4 km. The Berg Lake campground is located at 19.6 km, and if you wish to go further into the region, the Robson Pass campground, at 21.6 km, makes an excellent base for a few days' exploration.

The Snowbird Meadows are a good vantage for viewing the peaks depicted in *Lynx Mountain (Mountain Sketch XLI)* and *North of Mt. Mumm, Robson Park.* To reach the meadows, follow the trail that branches from the Robson Pass Trail and heads southeast just past the warden's cabin.

The view depicted in *Lynx Mountain (Mountain Sketch XLI)* is directly to the south. At the toe of the Robson Glacier, a rough trail follows a series of cairns uphill. You can go as far as Snowbird Pass, an additional 10 km, or stop somewhere in the Snowbird Meadows, at about 6 km. If you want to get Harris's exact take on the peak, you will need to gain some elevation, and climb Titkana Peak for a loftier view. Make sure you are both prepared and trained for this undertaking.

The vantage point for the work *North of Mt. Mumm, Robson Park* is a view looking out towards Gendarme Mountain (which is above you and to the west), from the crest of Robson Pass.

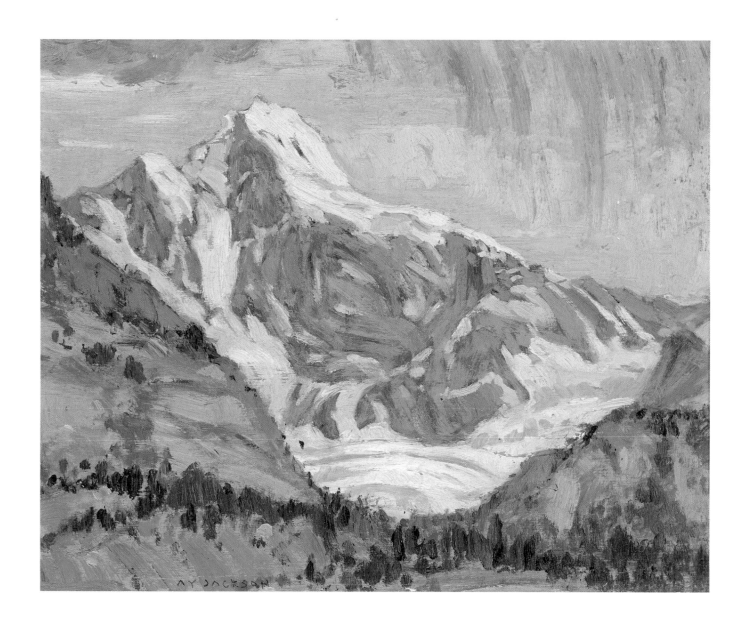

A. Y. Jackson
Mount Resplendent, 1914
oil on panel
Private Collection

"THE ARTIST CANNOT COMPETE WITH THE CAMERA IN RENDERING PANORAMAS, PECULIAR GEOLOGICAL FORMATIONS, OR INFINITE DETAIL OF MOUNTAINS: BUT HE CAN REACT TO THE AUSTERITY OF FORMS, THE IMMENSE RHYTHMIC MOVEMENTS, AND THE STRANGE COLOUR HARMONIES."

— A. Y. Jackson in *A Painter's Country*, 1958

MOUNT RESPLENDENT

A. Y. Jackson's biographers have recalled his self-designed sketching box, a backpacking box filled with sliding panels and a palette full of oils. Such practicalities were necessary in 1914 for the kind of country Jackson encountered in the Yellowhead. While painting at Robson, Jackson appears to have worked exclusively in pencil in both sketchbook and loose paper formats, or in oil on small birch panels. These two methods were undoubtedly the most practical for backcountry sketching. Sketch-books were relatively light, providing maximum drawing surface and adding minimum weight and bulk to one's gear. Jackson is known to have worked up the oil sketch first, and only then would he make a pencil (or sometimes charcoal) drawing. *"I make a sketch first, with brush rather than charcoal, then sometimes I make a separate pencil drawing, which gives me an alternate line."*[27] His niece Naomi Jackson Groves recalls:

"A. Y. often executed small oil sketches on sight and only later did pencil drawings of the scenes, etc. depicted in the sketches. I saw him do this and he probably mentioned it at some point. He considered his graphite drawings to be his 'notes.'"[28]

These small sketches were invariably done on small wooden boards, described in art jargon as panels. Panels are tough and well suited to the horse or backpacker's journey. In the twenties they were cheaper than canvas, which was another common sketching support. Canvas could be packed in precut, lightweight, small unstretched sheets, which were simply tacked to a support while working. Canvas had the advantage that once dry, it could be rolled, whereas panels could not, but the whiteness and soft surface of the canvas did not provide the base that suited Jackson. In many of his little panels, a great deal of the wood itself remains unpainted, the natural tones blending well with his palette. Whether merely unfinished or intended to be that way, the effect is successful.

In some cases, both the oil panel and the corresponding pencil sketch are known. These sets provide an excellent opportunity to compare the two working methods used by Jackson and the results of each. In the pencil sketch for *Mt. Resplendent*, Jackson made colour notes, notes on the location, and anecdotal notes. The shape of the mountain and the middle-ground slopes were quickly defined, but still provide enough detail to convey a great deal of information, separating ice from rock, trees from brush, clear sky from cloud.

In the oil *Mount Resplendent*, Jackson has composed the scene in almost exactly the same manner; the composition and the perspective have changed little. This small panel is an intimate, quick, lively sketch, as much "of the elements" as an out-of-doors painting can be. It is similar in style and approach to the other known works from Jackson's 1914 trip, of which, sadly, there are few to be found. Those that are known, likely the works that had been sold prior to Jackson's periodic burnings, are scattered in private and public collections, and not well documented in the art historical literature. They often have wonderful inscriptions by Jackson on the reverse side, or the "verso" in art jargon. This gives the sketches a revealing, journalistic quality.

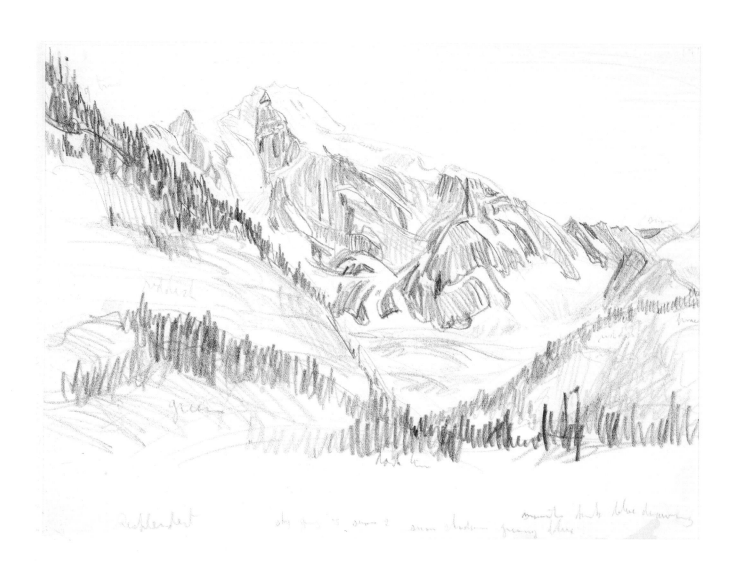

A. Y. Jackson
Mt. Resplendent, 1914
graphite on paper
Whyte Museum of the Canadian Rockies

"IT'S PROBABLY HARD FOR ANYONE LOOKING AT MY LANDSCAPES TODAY TO REALIZE THAT I WAS ONCE REGARDED AS A REBEL, A DANGEROUS INFLUENCE; THAT I'VE BEEN TOLD I WAS ON THE VERGE OF INSANITY, THAT MY PAINTING WAS NOTHING BUT MEANINGLESS DAUBS. LAWREN HARRIS, THE MAN MOST RESPONSIBLE FOR DRAWING THE GROUP OF SEVEN TOGETHER, WAS ACCUSED OF SOMETHING PERILOUSLY CLOSE TO TREASON—HIS PAINTINGS, SAID HIS SEVEREST CRITICS, WERE DISCOURAGING IMMIGRATION."

—Leslie Hannon quoting A. Y. Jackson in *Mayfair*, 1954

On the verso of the oil sketch *Mount Resplendent* Jackson notes: *"Moose River over ledge of valley … thrilling experience going over Razor Mt. which separated the Fraser Valley from moose slide 3,000 feet down …"* In addition to telling us how much fun Jackson was having, the inscription seems to indicate that the scene in the work looks west towards Resplendent Mountain from the east side of Moose River, over a ledge. There is an old moraine near the confluence of Moose River and Resplendent Creek; perhaps this is what Jackson calls the moose slide. When Jackson visited the region, his thrilling experience was likely augmented by the warmth of cabins, now in ruin, along the Moose River, and the fords made a little less wet by the felling of trees. However, it was just as backwoods then as it is now. While he was there, clambering about in the forest, he met outfitter Curly Phillips, who asked him, *"'What do you think about the war?' 'What war?' I asked. I guess it was quite a while since I had seen a paper."*[29]

TRAIL INFO

Trail information:
Moose Pass to Robson Pass to Kinney Lake
Type of hike:
Backcountry trek
Trailhead: Moose Trail
How to get there:
The Moose Trail begins on a side road off British Columbia's Yellowhead Highway, 31 km east of the Mount Robson Provincial Park Visitor Centre or 50 km west of Jasper. From Jasper, allow 30 minutes and watch for the Moose River Bridge. The side road to the trailhead is another 0.6 km beyond the bridge. Alternatively, travelling east from the Mount Robson Provincial Park Visitor Centre, watch for the Moose Lake boat launch; the side road is 3 km farther east. Follow the side road north for 0.3 km. You can park before the railway tracks and there is a posted trail sign.
Distance:
48.9 km to Moose Pass, 63.9 km to Robson Pass, 85 km return via Kinney Lake
Elevation gain: 1,145 m
Degree of difficulty:
Very difficult; this an unmaintained trail

Hiking time:
Allow one week
Route:
Moose Trail takes you along Moose River until it branches off to the east. The trail then follows Resplendent Creek, crosses back over Resplendent Creek to the north, and eventually finds Moose River again. There are no bridges along this trail, and at least fourteen fords are required. The trail is overgrown and wet throughout, and requires bushwhacking in numerous places. Horse traffic sometimes shares the trail. There are rough campgrounds; check with the visitor centre and register before you head out. The 48.9-km trail leads to Moose Pass in due time. From there, you can connect with the Robson Pass Trail at 63.9 km and return via Kinney Lake, a good week's trek. This guide does not provide adequate information with which to undertake this trek; ensure that you have up-to-date maps and a complete hiking guide, and register with the visitor centre staff before you start your trip.

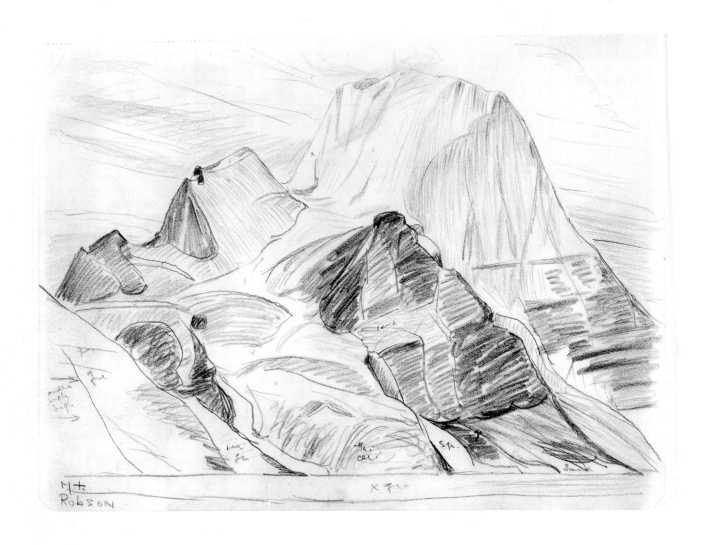

Lawren Harris
Mount Robson, c. 1924–25
graphite on wove paper
National Gallery of Canada

"HIS DRAWINGS TAKE US SOME DISTANCE INTO THE ARTISTIC LIFE OF LAWREN S. HARRIS. IN THAT WAY THEY RESEMBLE THE DIARY ENTRIES OF A WRITER WHICH LATER PROVIDE THE MATERIAL FOR NOVELS OR POEMS."

—Joan Murray and Robert Fulford in *The Beginning of Vision*, 1982

The Fine Art of Drawing

While in the Rockies, Harris worked both in pencil on paper, and in oil on panel. Pencil studies such as *Mount Robson*, c. 1924–25, were customarily used as references and preparatory studies for works, which were later worked up in oil back in his Toronto studio. As some time may have passed between the creation of the field work and the execution of the studio work, sufficient information had to be included in a drawing for Harris to continue with the work. For an artist like Harris, "sufficient" could mean a number of things. Using *Mount Robson*, c. 1924–25 as an example, one can see that Harris has roughed in, with a reasonable amount of detail, all of the elements that he felt necessary to execute a later work. He has added notes on colours to be used, titled the work by noting the location, and set the composition. Areas of light and shadow, cloud formations, and variations in surface detailing are all noted for future reference. It is clearly a preparatory drawing.

The pencil drawing *Mount Robson*, c. 1924–29, is quite different. Set from just a few paces farther up the Berg Lake Trail, this view of Robson is an example of a drawing as fine art. A softly handled, quiet drawing, it contains many nuances and delicate details that set it off from other pencil studies executed by Harris while working out-of-doors. The reflections of Berg Glacier in the mute waters of Berg Lake, the careful shading of the rock formations below the buttress (which is the central and darkest rock feature in the work), and the complete hatching of the sky in pencil, with the subtle variation of light from right to left, attest to his skill as a draftsman. It is a completed drawing, appreciable in and of itself, and uncomplicated with the distraction of notations and colour keys.

Harris's drawings often give helpful clues that assist in determining the geographic locations of the scenery in his more abstract mountain paintings. These clues sometimes provide the key to otherwise unknown locations. Although the initial drawing and the final painting may have little in common, the series of drawings that led to the final painting chart the evolution of the work. Working backwards from the painting through the series of evolving drawings, connecting similar vistas one to another, and finally arriving at the initial field study, has revealed

TRAIL INFO

Trail/site information: Mount Robson

Type of hike: Backcountry overnight hike

Trailhead: Berg Lake parking lot

How to get there: The Mount Robson Provincial Park Visitor Centre is located on British Columbia's Yellowhead Highway, 36 km east of Valemount and 90 km west of Jasper. Allow for a 1-hour drive from Jasper. There are many interesting places to visit along the way; this makes an excellent day trip.

The Berg Lake parking lot is at the end of a 2-km side road that runs north past the Mount Robson Provincial Park Visitor Centre; the trailhead is clearly indicated. You will need a permit to camp in Robson's backcountry.

Distance: 19.6 km to Berg Lake campground

Elevation gain: 784 m to Berg Lake

Degree of difficulty: Difficult to very difficult

Hiking/viewing time: Allow 3–4 days if you plan to explore the Robson region fully

Route: The first 6.7 km of trail to the Kinney Lake campground follow an old fire road and are open and rolling. The forest is true British Columbia, spotted with dogwood and lush with ferny undergrowth. The climbing begins at the end of Kinney Lake with the inevitable series of switchbacks. Trail erosion is becoming a problem here, as it often does on steep slopes. Stay on the trail and be wary of where you place your boots. There are several →

"UNFORTUNATELY, BEAUTY IS SOMETHING THAT MANY OF US SEEM LOATH TO DISCUSS, OR TO PONDER SUFFICIENTLY, PERHAPS BECAUSE IT IS SO INTANGIBLE, SO DIFFICULT TO GET ITS MEANING INTO PRECISE LANGUAGE; OR PERHAPS BECAUSE, LIKE MANY ANOTHER PHASE OF TRUTH IN OUR DAY, IT HAS BEEN FORCED ASIDE BY THE STRIDENCY OF LIFE; OR BECAUSE IT HAS BEEN CARNALIZED AND PERVERTED TO ACQUISITIVE AND SELFISH ENDS, OR MADE TO SERVE THE SENTIMENTALITY, THE LUSH WEAKNESS OF THE PERSONAL MAN."

—Lawren Harris in *Theosophy and Art*, 1922

the secret of more than a few elusive places. However, connecting the related drawings and paintings can also be a challenge because of the changes that Harris made during the evolution of the work. Sometimes, the medium itself is the best clue. For example, a group of drawings executed from the top of Jasper's Tonquin Hill in a 180-degree panorama are spread throughout collections across Canada. No longer together as a series, the key to their relationship, beyond knowing exactly what the panorama itself looks like, is the fact that they are all drawn with what appears to be the same drawing implement and on the same type of paper, which came from a coil-bound sketch pad. At a later and unknown date, the drawings were removed from the sketch pad, the torn perforations along one edge left intact (they were sometimes cut off so that the drawing would appear "neater"), and were eventually dispersed. The works may or may not have been sold together as a lot; the provenance records (the history of the ownership of each work) do not indicate that they were once part of a series. Sometimes you have to think like a detective.

TRAIL INFO

areas that hikers have used to look out over the valley that are now blocked off to allow for rejuvenation of the delicate plants—please respect them and enjoy the many other vistas along the trail. Switchback shortcuts are blasphemous for any hiker worth the laces that tie their boots. I once watched two hikers charge through the forest to avoid the switchbacks on the way down, only to find themselves far off the trail and facing a crossing of the deeply braided channels of the Robson River below. The deceitfully smooth water quickly swept them off their feet and dragged them several metres downstream, where they emerged onto the opposite bank, soaked, frozen, and regretting their detour. This situation could have easily had a bad ending.

On the trail, enjoy the views of Emperor Falls as you climb. A. Y. Jackson painted a small panel, *White Horne Under Cloud* (not illustrated), from near here.[30] As you climb, Mount Robson begins to show above you. There are several campgrounds in the area, all of which require a permit and reservation. The Emperor Falls campground is at 15 km, the Marmot campground is at 17.4 km, the Berg Lake campground is at 19.6 km, and if you wish to go farther into the region, the Robson Pass campground, at 21.6 km, makes an excellent base for a few days' exploration of two of Harris's magnificent paintings: *Mountain Sketch LXVII*, and the famous work *Mount Robson*, c. 1929, illustrated in *A Hiker's Guide to Art of the Canadian Rockies* (pp. 117–118). *Mount Robson*, c. 1929, is a depiction of the backside of Mount Robson, properly known as the Kain Face, which is set from high up on the west side of Resplendent Mountain. Harris's drawings of Mount Robson were made along the Berg Lake lakeshore trail, where today there are several places to stop, and even a few well-placed benches. Better views of this same scene can be found along the Mumm Basin Trail, which takes you above the northern shore of Berg Lake. Take the Hargreaves Glacier Trail where it joins the Berg Lake Trail at 17.8 km, and follow the cairns to the moraine.

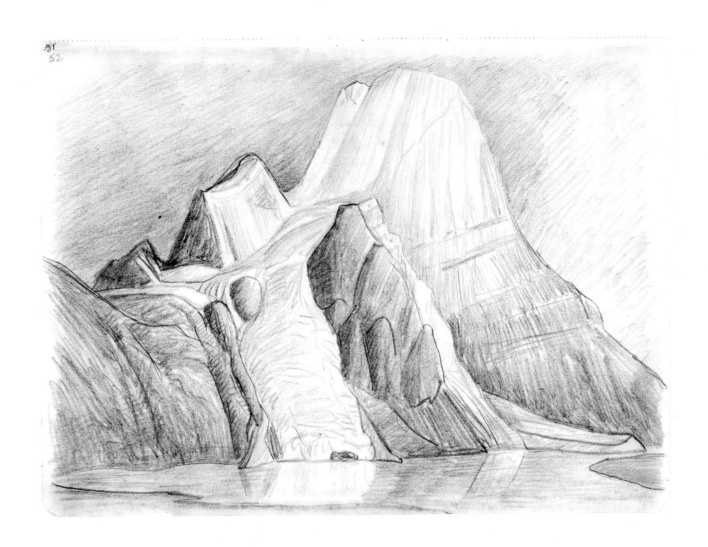

Lawren Harris
Mount Robson, c. 1924–29
graphite on wove paper
National Gallery of Canada

"WHITE … HAS THIS HARMONY OF SILENCE,
WHICH WORKS UPON US … LIKE MANY PAUSES IN
MUSIC THAT TEMPORARILY BREAK THE MELODY. IT IS
NOT A DEAD SILENCE, BUT ONE PREGNANT WITH
POSSIBILITIES. WHITE HAS THE APPEAL OF THE
NOTHINGNESS THAT IS BEFORE BIRTH, OF THE
WORLD IN THE ICE AGE."

—Wassily Kandinsky in *Concerning the Spiritual in Art*, 1914

Fresh Snow and Old Ice—
The Many Shades of Snow

From bright, yellow-white snow in sun, to cold, blue-black ice in shade, Lawren Harris combined his whites with almost every colour in the spectrum in an effort to depict the subtleties of light and shadow on snow, and of age and weather on ice. His colours work their illusion in an extremely understated manner, while using a startling variety of strong hues. Ranging from bright yellow to deep mauves and browns, blues, greys, and even red, these bold colours are not immediately noticed, but play a remarkable role. Together with white, each hue works to differentiate each layer of ice, each ridge of glacier, one from another. Often, an area is under-painted first in a strongly contrasting colour. It is then over-painted in the chosen surface shade, with a slight edge of the under-painted colour left visible along the area's border. This careful blend of near edge-to-edge colour conveys a great deal of information. A section of white for instance, over-painted on a ground of green or red, reads as a particular surface, conveying clues to our eyes as to the direction from which the sun was shining, whether the ice is wet with warmth or dry with cold, blue with the pressure of age, or still young and white.

There are few works in the realm of Harris's mountain subjects that do not include at least some snow, and in many, such as *Rocky Mountain Sketch XXXVII*, an otherworldly painting depicting an unknown location near Jasper, and *Mountain Sketch LXVII*, the depiction of snow and ice takes up most of the space in the composition. In *Mountain Sketch LXVII*, the soft variations of purple and silver-white convey shadows on snow, while bright edges of clear whites and blue-whites delineate the snow-clad ridges of Resplendent Mountain, which this work depicts. The deepest shadows on the glacier that covers Resplendent's flank are an elusive mix of pale pigments, reading as white, purple, silver-grey, and brown. They denote a very slight change in palette from the area immediately above, but a change that conveys, with tangible accuracy, the corresponding change in air temperature that the shadows would have held. *Mountain Sketch LXVII* is a delicious work, audibly quiet and perfectly still. Harris's luminous painting of the peak captures the curve of its graceful white summit exactly. The pencil drawing of the same scene (see p. 3) has been executed on paper so fine that the writing now shows through in reverse. It is equally elegant, with very few actual marks on the paper. It is an essay in simplicity, spare and careful, as finished as the oil. *Mountain Sketch LXVII* is one of three known images depicting Resplendent Mountain.

Colour and its symbolic use have been the focus of some study on Lawren Harris, in particular, his use of the theosophical meanings of colour. Harris was familiar with the works of Annie Besant and C. W. Leadbeater,[31] two British theosophists who published the book *Thought-Forms* in 1905. Leadbeater had also published a book titled *Man Visible and Invisible* in 1902. Among the many discussions therein, these volumes explore the significance of colour as it appears as a result of thought and emotion in the human aura. In theosophical teaching, it is accepted that coloured manifestations of the human aura exist. According to this doctrine, in a highly sensitive person such

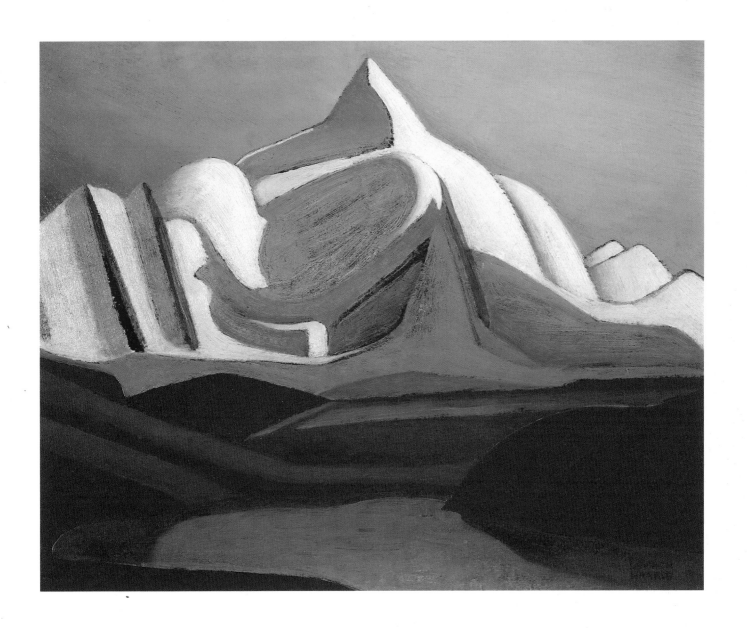

Lawren Harris
Mountain Sketch LXVII, undated
oil on board
Private Collection

as a clairvoyant, these auras are visible to the human eye. They vibrate, and portions of them break off as free-floating thought-forms. They are a physical manifestation of emotion, thought, and intellect. The aura of a spiritually developed person, according to the theosophical definition, would appear in clear, radiant colours, whereas that of an undeveloped person (insensitive, out of tune with the spiritual nature of the universe) would appear in muddy, heavy colours.

In *Man Visible and Invisible*, Leadbeater has provided a key to these colours, a chart with colour samples, and an equivalent emotion listed for each. Assuming fair accuracy in the 1902 printing process, we can look at some of the colours found in Harris's paintings and determine their symbolic equivalents. Pale, pinkish white denoted the highest spirituality; silver blue-white meant devotion to a noble ideal; three shades of yellow, varying in intensity and clarity, equalled three states of intelligence; a pure cerulean blue meant pure religious feeling. These are but a few of many symbolic interpretations of colour. It is an interesting debate to compare symbols and draw parallels between this colour theory and Harris's palette. However, it is also prudent to acknowledge the fact that snow generally appears to our eyes as white, mountains *look* blue, and the sun, most often, shines yellow.

Much has also been made of the symbolism of the triangle in Harris's work. As a geometric shape, it indeed has its religious equivalents. In many religions, mainstream and not, there can be found derivations of the trinity, the apex of a peak, concepts of closeness to God through physical proximity to the heavens (or sky), etc. As well, the symbolism of the number three is without dispute. For Harris, the three states of knowing (atma, knowing the physical world; buddhi, knowledge of the divine world; and manas, experience of the divine world) were means to achieve theosophical enlightenment. These symbolic meanings and their expressions through form and structure in his work are certainly part of Harris's interest in the mountains. Combinations of the symbolic meanings of colour, as well as the symbolism of the triangle, are tied tightly into the knot of experience-on-the-spot that shaped Harris's mountain works. Indeed, the triangle's importance as a symbol is without dispute; yet again, it is a fact of nature that many mountains are simply triangular in shape.

TRAIL INFO

Trail information: Mount Resplendent from Snowbird Pass
Type of hike: Backcountry overnight hike
Trailhead: Berg Lake parking lot
How to get there: The Mount Robson Provincial Park Visitor Centre is located on British Columbia's Yellowhead Highway, 36 km east of Valemount and 90 km west of Jasper. Allow for a 1-hour drive from Jasper. There are many interesting places to visit along the way; this makes an excellent day trip. The Berg Lake parking lot is at the end of a 2-km side road that runs north past the Mount Robson Provincial Park Visitor Centre; the trailhead is clearly indicated. You will need a permit to camp in Robson's backcountry.
Distance: About 32 km to Snowbird Pass
Elevation gain: 768 m
Degree of difficulty: Difficult to very difficult
Hiking time: Allow at least 3–4 days if you plan to explore the Snowbird Meadows and Robson Pass region fully
Route: Follow the trail to Kinney Lake, continue to the Whitehorn Mountain campground and on past Emperor Falls. The Emperor Falls campground is at 15 km. At 17.4 km you will pass the Marmot campground, and the Berg Lake campground is at 19.6 km. The Robson Pass campground, at 21.6 km, makes an excellent base for a few days' exploration of the region surrounding Harris's *Mountain Sketch LXVII*, which depicts Resplendent Mountain from below the Snowbird Meadows. Do not venture onto Resplendent's glacier unless you have the appropriate experience. To reach the meadows, follow the trail that branches from the Robson Pass Trail and heads southeast, just past the warden's cabin. At the toe of the Robson Glacier, a rough trail follows a series of cairns uphill. You can go as far as Snowbird Pass, an additional 10 km, or stop somewhere in the Snowbird Meadows, at about 6 km. Avid hikers may want to plan a loop out via Moose Pass for a view of A. Y. Jackson's Resplendent Mountain (see p. 26).

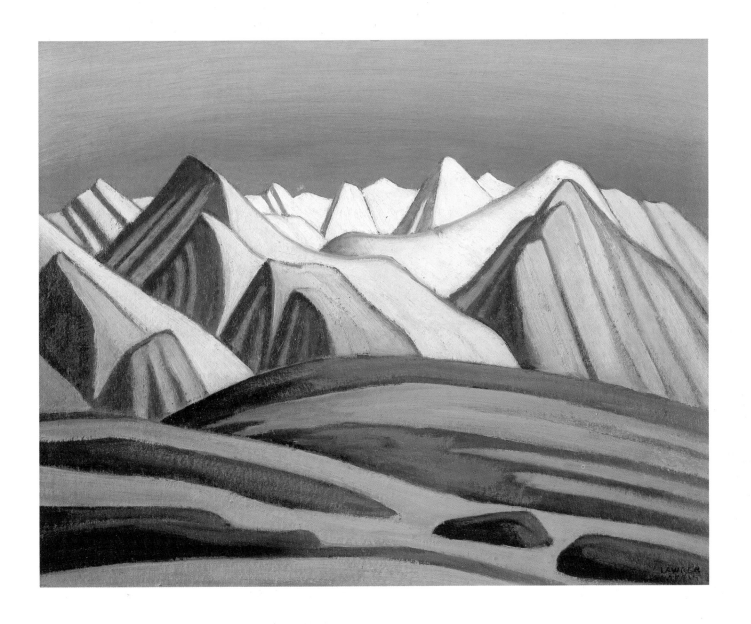

Lawren Harris
Rocky Mountain Sketch XXXVII, c. 1928–29
oil on panel
Private Collection

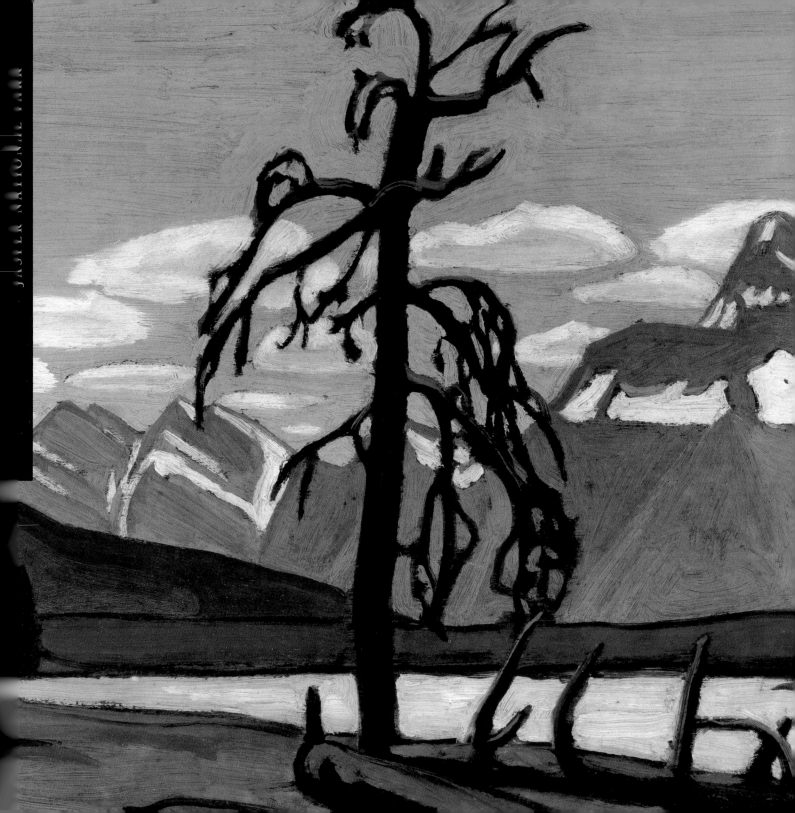

"WE HAD A YOUNG GUIDE WITH US WHEN WE DECIDED TO TRAVEL OVER THE SHOVEL PASS BETWEEN MALIGNE LAKE AND THE VALLEY OF THE ATHABASKA [SIC]. IT WAS NOT AN EASY TRIP; WE HAD TO CLIMB TO EIGHT THOUSAND FEET OVER THE PASS. ON THE WAY UP, WE RAN INTO A SNOWSTORM AND SPENT THE NIGHT NEAR THE TOP."

—A. Y. Jackson in *A Painter's Country*, 1958

Lawren Harris
Athabasca Valley, Jasper Park, 1924
oil on panel
The Edmonton Art Gallery

Jasper National Park

To place Lawren Harris and A. Y. Jackson in the greater timeline of history, the year that they painted together in Jasper was 11,500 years after the first toolmakers are known to have visited the Rockies, and 9,000 years after a visitor left a spear point at the north end of the Overlander Trail. Sarcee, Cree, Iroquois, and Shushwap settled and traded here after 1800. Metis guided here in 1827, and in 1892, Lewis Swift settled just east of the present townsite where he established a base for others. Surveyors, trappers, prospectors, climbers, and explorers came. The North West Company pioneered here in 1810, and David Thompson charted Athabasca Pass that same year. In 1907, the region was set aside as Jasper Forest Park, but for four years, had no road or railway access. Mary Schäffer, botanist, explorer, photographer, and author, visited Fortress Lake in 1907 and Maligne Lake in 1908.

To place our artists in the greater timeline of Canadian art history, the year 1924 was four years after the official formation of the Group of Seven in 1920. Art in Canada was beginning to experience the advent of modernism; painters such as Harris were leaving the pictorial behind. Canada was interested in the arts as a national expression and a subject of contention. Tom Thomson had drowned in 1917, and Emily Carr, after a long period of inactivity, was painting west coast subjects again. J. E. H. MacDonald visited Yoho National Park's Lake O'Hara in 1924, and began an obsessive painterly fascination with the region's scenery. Exhibition programs were starting in many regions of the country, galleries were built, collections begun. It was an exciting time.

In Jasper, Harris and Jackson's destination, tourism had begun. In 1911, Jasper had become a national park, and the Grand Trunk Pacific Railway had reached the town. By 1912, the Canadian Northern (the competition) was building a station. Tourism in the Rockies was dependent on accommodations and support services, and by 1911, several privately owned establishments offered space for sleeping, stabling horses, and restaurant services.[32] In June 1915, the GTPR built Tent City on the shores of Lac Beauvert. It was a well appointed camp of ten large tents with wooden floors and walls, and a dining tent complete with waiting service. Two hundred and sixty-plus visitors paid between $2.50 and $3.00 for a night's stay that first season. The Grand Trunk advertised heavily and invited press excursions to visit in the first few weeks. Success was on their side, but timing was not. World War I led to the camp's closure until 1919. Tent City was then sold to the well-known mountain brothers Jack and Fred Brewster. The struggling railways had begun the long process of amalgamating, eventually becoming the Canadian National Railway Company. They took over ownership of Tent City in 1921 and quickly replaced the tents with log buildings, calling the new facility Jasper Park Lodge and opening it to guests in 1922.

In both 1922 and 1923, new central buildings were constructed at Jasper Park Lodge. Hewn from lumber sledded by the Brewsters from Maligne Canyon during the previous winter, and from logs felled clearing the site, the lodge claimed at the time to be the largest single-storey log building in the world.[33] It was chinked with moss, sawdust, and cement, and by the time of Harris and Jackson's visit in the summer of 1924, had begun to dry to a snug warmth. Many amenities were available, including lounges, a dining and snack room, card rooms, telephones and telegraphs, and hairdressing and manicure services. Ironically, these luxuries were of no interest to A. Y. Jackson, whose letters indicate that he felt conspicuous and pretentious while there, which was not at all to his liking.

Jasper National Park today is an exceptional region. Covering over 10,878 square kilometres of terrain, and boasting over 1,000 kilometres of maintained trails. There are endless possibilities for exploration in the backcountry. The Skyline Trail, one of the most scenic anywhere, takes you through every kind of mountain terrain imaginable. The towering features of the Tonquin Valley's Ramparts, the wonders of the disappearing waters in the karst formations of the Fryatt Valley, and the amazing bird and animal life make the park a delightful place to explore.

Lawren Harris, unidentified man, and Margaret (Peggy) Harris, 1920s

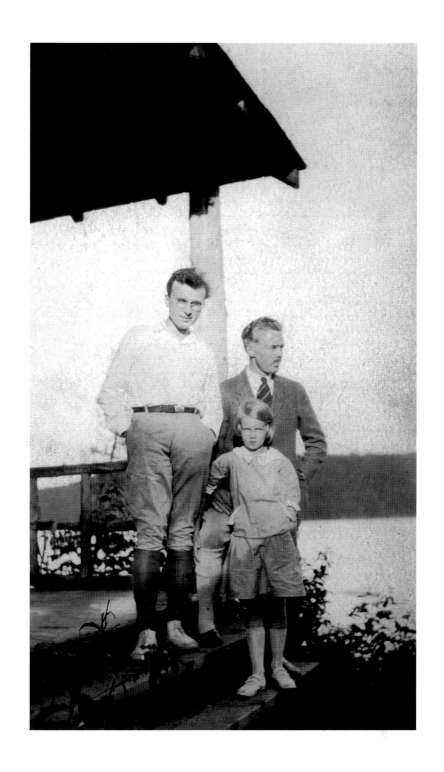

The 1924 A. Y. Jackson/Lawren Harris Jasper Trip

Although enough evidence exists to document the basic route that Jackson and Harris took on their 1924 Jasper sketching trip, this information is not without inconsistencies, and unfortunately, a number of critical facts are missing. The 1952 fire that completely destroyed the central building of the Jasper Park Lodge took with it the registration records and guest books that may have provided additional details to the story. Searching through old outfitters' records, and checking archived hotel and backcountry lodge registries and other historical documents have, together with the writings and personal letters of each artist, provided the basic details. Two important letters, both written by A. Y. Jackson from the lodge to a friend in Toronto, hold a few more clues. Still, getting their trip itinerary right, with all its heres and theres, is a hit-and-miss process. There are discrepancies between each artist's writings and in their documented recollections. Dates and places were incorrectly recalled, or simply forgotten, and some of these errors were admitted to and later corrected, or confused even further by the artists in their lifetimes. There are inconsistencies between the writings by scholars that have been published since, and there is confusion about a number of dates. In an attempt to sort the details out as clearly as possible, I have pieced together the known sources of information and questioned them where things seem wrong, relying on logical assumptions when appropriate.

The first mention of the trip is contained in a letter to Norah Thomson DePencier, a lifelong friend of A. Y. Jackson. It states that he and Harris had made plans for a trip, which for some reason had to be postponed: *"Lawren and I are putting off our mountain trip until September, by that time we will know pretty well just how wild to paint."*[34]

Whatever the reason for the delay, it seems to have sorted itself out. We know from another of Jackson's letters to DePencier that the two painters arrived in Jasper in July. This letter is headed with the notation *"Jasper Park Lodge, Sunday Night"* and postmarked 22 July 1924. It seems to have been written shortly after checking in, and comments:

"Here we are in the lap of luxury—it's changed since I was here last[35]*—the only way I can stay here is to get out. Three meals and a bath and then get out in the mountains and save my money for another day at the lodge in a couple of weeks. However I am trying to look as if I had never known anything else, nonchalant, blasé, but I am glad Lawren has arranged to get out tomorrow morning."*[36]

The two painters arrived together in Jasper and checked into the Jasper Park Lodge in July 1924. They had come from Toronto by train through Saskatoon, Winnipeg, and Edmonton. Apparently they had done a great deal of sketching by this time, indicating perhaps that they had already been at the lodge a few days, as Jackson notes that *"… Lawren has the walls all covered with sketches already so get ready for an awful big exhibition."*[37] Settling in at the Lodge, Harris's wife Beatrice (Trixie) and their children, including *"Peggy … doing somersaults on the bed"*[38] were to remain there while Harris and Jackson went out to sketch for ten days. They would then return to the Lodge, collect Harris's family, and travel by train to Vancouver and Prince Rupert, and then back to Jasper

again, a trip they called "the triangular tour." He writes to DePencier:

"We are known all over reputations preceded us, so we have to live with it. We will stay here for ten days this trip and then go round to Prince Rupert and then a three weeks stay up in the rough stuff."[39]

The trip was divided into two or three segments of sketching. This is where the confusion begins. Harris states in his book *The Story of the Group of Seven* that they visited the Tonquin area first and then went on to the Maligne Lake area. In Jackson's autobiography, it is the reverse. A third letter, also written to a friend by A. Y. Jackson while staying at the lodge, sways the argument to Jackson's side. It is quoted by F. B. Housser in *A Canadian Art Movement* and says: *"We had our first trip … We went to Maligne Lake with Lawren, the guide, four horses and me. I am not used to riding and walked most of the way, about twenty-five miles."*[40] The party would have travelled east from Jasper Park Lodge up the Maligne River Valley past Medicine Lake, and then south into the Maligne Lake area.

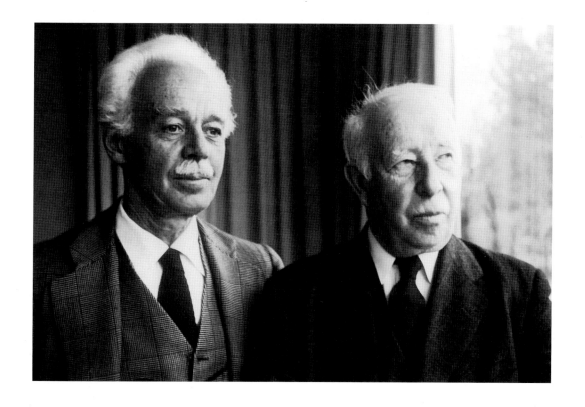

"In the summer of 1924 Lawren Harris took his family to Jasper Park and I went along with him, as we planned to do some work for the Canadian National Railway. We did not find the landscape around Jasper Lodge or along the railroad very interesting, and we wanted to get into the big country, so we arranged with the park superintendent, Colonel Rogers, to have our dunnage taken in by the wardens while we walked in, first to Maligne Lake, then to the Tonquin."

— A. Y. Jackson in *A Painter's Country*, 1958

Lawren Harris and A. Y. Jackson,
1940s

"MALIGNE LAKE [THE CANVAS], SET AMID TOWERING
PEAKS, IS EERIE TO A DEGREE. NATURE, GAUNT AND
GRIM, VIEWING HER REFLECTION IN A FLAWLESS
MIRROR AMID A SILENCE THAT MAY BE FELT."
—Anonymous in *Rochdale Observer*, 1926

MALIGNE LAKE VALLEY

MALIGNE LAKE

The tranquil lake now officially called Maligne (French for
"wicked") seems, on a clear day, too peaceful and inviting for
either name. Maligne Lake is the longest naturally occurring
lake in the Canadian Rockies, and is postcard perfect. One of
the few of nature's compositions that Harris felt little need to
alter, the view is serenely reposed. At the north end of the
lake, where Harris would have been while sketching for
Maligne Lake, Jasper Park, the mountains of the Queen
Elizabeth and Maligne Ranges on either side of the lake run
off in symmetrical, undulating rhythms of smoothed peak and
rounded glacier. Travelling down the lake by boat as Harris
and Jackson did, the mountains increase in both height and
ruggedness. The midpoint of the lake, known as Samson
Narrows, appears to be a converging set of distant banks, hid-
ing the vast second half of the lake beyond. Harris's canvas has
captured this sense of something else, of an expansive mystery
in the work, a sense that alludes to the distant regions just out
of view. Glacial melt waters paint the lake a deep blue-black,
and convey their chill precisely. The tour boats land just past
The Narrows in a small, idyllic bay.

Maligne Lake, Jasper Park[41] is a notable work. Often referred
to as mathematical, it is a scene of perfect compositional bal-
ance, and a study in colour theory. An exploration of the
shades of blue, it is an inviting scene, tranquil and placid.

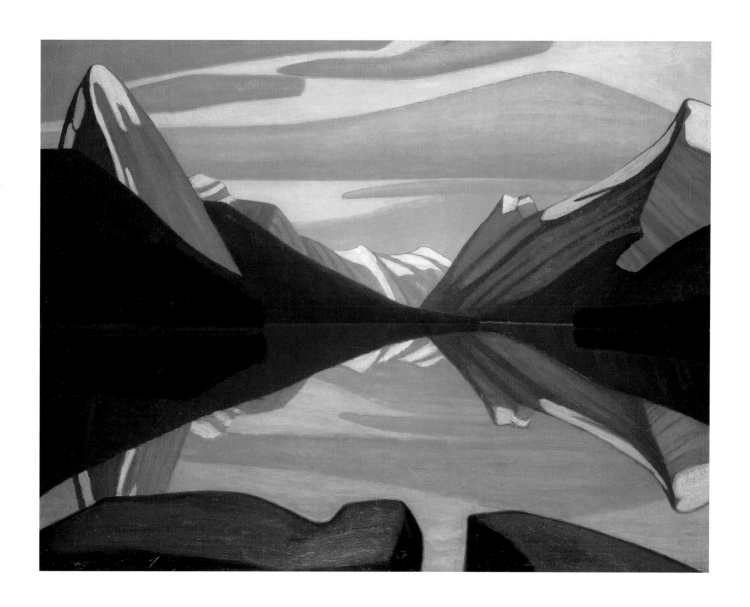

Lawren Harris
Maligne Lake, Jasper Park, 1924
oil on canvas
National Gallery of Canada

"WE LIKED THE CLEAR SUNNY DAYS AND THE GREY
DAYS WHEN THE MOUNTAINS CUT THE SKY LIKE IRON.
THE MOUNTAINS WRAPPED IN MIST AND LOW-HUNG
CLOUDS WE DID NOT ENTHUSE OVER. THERE WAS
ENOUGH MYSTERY IN THE MIGHTY RANGES WITHOUT
HAVING TO RESORT TO MIST AS AN ACCESSORY."

—A. Y. Jackson in *Artists in the Mountains*, 1925

SCHÄFFER POINT

Mountain, Maligne Lake is another depiction of Maligne Lake
near The Narrows. It shows a view closer to The Narrows, from
the Mary Schäffer Loop along the east shoreline of the lake.
The blended shapes of Mounts Charlton and Unwin are the
main focus of the work. Almost indistinguishable from each
other, they are depicted in a palette of purple-brown that is
quite true to their natural colour. The glaciated peak of Mount
Charlton, whose summit is actually 40 metres lower and
behind that of Mount Unwin, shows over Unwin's shoulder.
Maligne Mountain and Mount Paul appear in the distance
along the right edge of the work. An interesting aspect of this
painting is Harris's treatment of the surface of the water. Here
Harris has again captured the reflected face of the mountains
on the surface of Maligne Lake, but instead of the calm, perfect
reflection that we see in *Maligne Lake, Jasper Park,* he has
depicted a wind-stirred lake that reflects a vibrating version of
the mountains. The contrast of these vibrating brush strokes
with the smooth surface of the mountains, clouds, and shore-
line above is interesting. It is softened slightly where the stac-
cato brushwork in the area of the lake's waters are echoed by

TRAIL INFO

Trail information: Schäffer
Point (Mary Schäffer Loop)
Type of hike: Half-day hike
or cross-country ski
Trailhead: East end of the
Maligne Lake parking lot
How to get there: From
Jasper townsite, take the
east exit out of town and
turn left (north) at the
interchange. You are now
on the Yellowhead Highway
(16). Follow the Yellowhead
for 1.7 km until you reach
the Maligne Lake Road
junction. Turn right and
cross the river on a bridge.
The road forks just after the
bridge. Go left at the fork
towards Maligne Lake. The
distance to the main
Maligne Lake parking area
is 44.4 km. For the boat
launch, drive an additional
0.8 km past the teahouse, to
the northwest corner of the
lake. Allow a minimum of
45 minutes one way as the
road, both busy and scenic,
is one lane wide all the way.
Distance: 2.6 km
Elevation gain: Very slight;
this is a rolling, easy trail
Degree of difficulty:
Very easy
Hiking time:
Allow ½ hour to walk the
trail, more to explore along
the lakeshore
Route: You can walk the
trail in two directions,
heading first along the
lakeshore towards the
boathouse, or up through
the trees towards the junc-
tion with the Opal Hills
trailhead, as this text
describes. There is a trail
sign at the parking lot.
Follow the trail past the
junction with the Opal Hills
trail and on through the for-
est. You will pass a kettle,
a large hollow left in the
ground by a chunk of glacial
ice, long since melted. The
trail meanders through the
forest along the flank of the
Opal Hills, and drops back
to the lakeshore at a scenic
little cove. Look out across
the lake from here to see
the vista Harris painted in
Mountain, Maligne Lake.
From there, the trail follows
the lakeshore back past the
historic boathouse, and
returns to the parking lot.

the spikes of the very tops of
the trees in Harris's painted
forest. This work is dated 1951,
indicating that it was done in
the studio. It is definitely post-
mountains in style. Coincident-
ally, a black and white photo-
graph of Maligne Lake taken
from exactly the same perspec-
tive of this work belonged to
Harris and remains in his fam-
ily's possession.

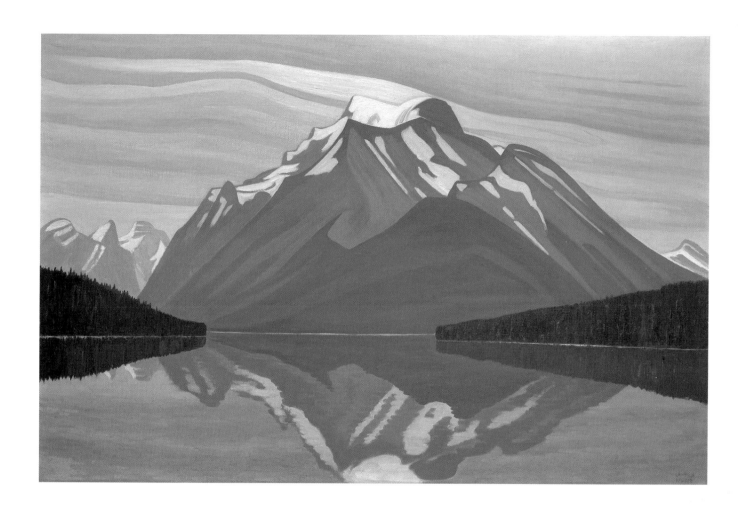

Lawren Harris
Mountain, Maligne Lake, c. 1951
oil on canvas
Vancouver Art Gallery

THE OPAL HILLS

Once at Maligne Lake, Harris and Jackson stayed with the warden for a few days and sketched in the nearby hills. Harris completed several works, which are all set from the region at the north end of the lake. *Mountain Above Maligne Lake, North End* is an oil study of the Opal Hills. Several other oils, difficult to place geographically but very much like the north end of Maligne Lake, exist. There are also a number of pencil drawings looking south down the lake, pencil studies of the mountains bordering the northern end of the lake, and studies looking across the lake from the east and west shores to the opposite sides. One of these drawings was the basis for an oil titled *Mount Sampson, Maligne Lake*, illustrated in *A Hiker's Guide to Art of the Canadian Rockies* (p. 112), and was also worked into a little pen and ink study, *Maligne Lake, Jasper Park, Alberta*, illustrated here (see p. 7). This careful little drawing exactly follows the composition of the oil, which was completed first, and both are quite accurate in their portrayal of topography. The brush strokes used to define the trees on the far shore make them seem more distant than they actually are. The other marks used for the areas of scree and incline in the rock surface of Mount Samson are quite accurate. The undulating forms of Mount Samson seem to have appealed to Harris. He executed another pen and ink drawing of this peak from the north, a "side view" that was illustrated in an October 1924 article in the periodical *The Canadian Forum* and can also be found in this guide (see p. iv).[42]

The trail information provided here takes you up and into the Opal Hills, which are depicted in *Mountain Above Maligne Lake, North End*. You can see the view Harris has captured from the dock near the warden's cabin on the west side of the lake, and approximate it from several places out on the water. The compelling colours of the Opal Hills, named by Mary Schäffer, are equally lovely at close range, and the view from this trail is spectacular.

TRAIL INFO

Trail information:
The Opal Hills
Type of hike: Day hike
Trailhead: East end of the Maligne Lake parking lot
How to get there: From Jasper townsite, take the east exit out of town and turn left (north) at the interchange. You are now on the Yellowhead Highway (16). Follow the Yellowhead for 1.7 km until you reach the Maligne Lake Road junction. Turn right and cross the river on a bridge. The road forks just after the bridge. Go left at the fork towards Maligne Lake. The distance to the main Maligne Lake parking area is 44.4 km. For the boat launch, drive an additional 0.8 km past the teahouse, to the northwest corner of the lake. Allow a minimum of 45 minutes one way as the road, both busy and scenic, is one lane wide all the way.
Distance: 8.7 km return; this trail is a loop
Elevation gain: 700 m
Degree of difficulty: Difficult
Hiking time: Allow two hours or combine this hike with a search for another Harris vista at Maligne Lake and spend the day exploring.
Route: You can climb the Opal Hills in a loop, and by going the steepest and shortest way up, you can return by the easiest and safest way down. Begin at the parking lot, and follow the path through the trees for 65 m until you reach the signed Lakeshore Trail. Go left along this trail (the Mary Schäffer Loop). Continue straight through at the fork (turn left to reach the Schäffer Viewpoint) at 135 m. After hiking another 1.6 km, you will reach the beginning of the loop through the Opal Hills. Take the right trail for the short and steep ascent, and you will begin to climb immediately. You can go left as well for the longer but gentler route, but don't be misled here— they are both steep! The trail divides again at 3 km, where a trail to a viewpoint overlooking the lake goes down and to the right. This view is well worth the side trip if you are energetic; if not, keep to the main path and cross a stream. Shortly after this crossing, the trail begins to loop back, down through the willows and back into the forest. You will reconnect with the Lakeshore Trail at 7.1 km, and return to the parking lot at 8.7 km.

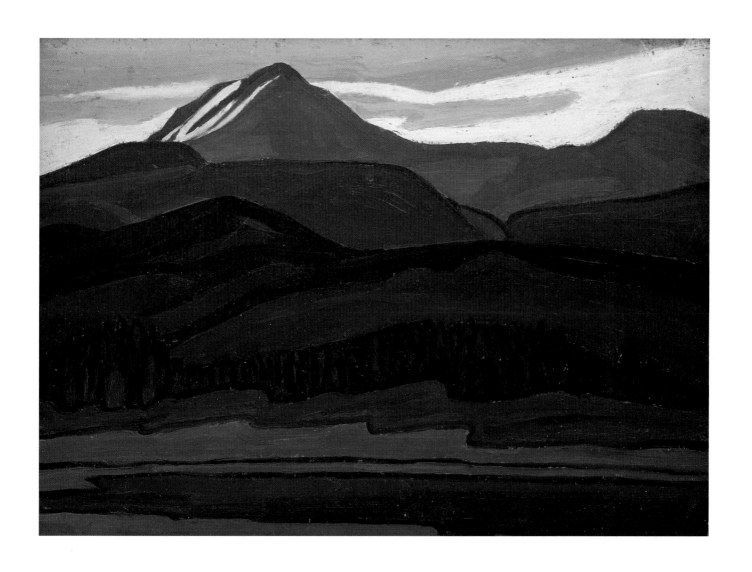

Lawren Harris
Mountain Above Maligne Lake, North End, c. 1924
oil on canvas
Musée d'art contemporain de Montréal

"IT'S A FINE MOUNTAIN, LAWREN, BUT THERE'S NOWHERE TO SIT AT THE TOP."

—A. Y. Jackson to Lawren Harris, date unknown

CORONET CREEK

Maligne Lake fills a river-cut valley with steeply sloped shores. There are many stretches of shore where there is no level place to camp on either side. At the south end of the lake, the alluvial fan formed by the solids in the runoff from Coronet Creek has created one of the few broad, flat stretches of shore. Harris and Jackson camped there, setting up a base of sorts and sketching the surrounding areas. Harris climbed up the Coronet Creek Valley to the northwest corner of the Brazeau Icefields to sketch, and there are four known oil sketches depicting roughly the same region between Coronet Glacier and Mount Henry MacLeod.[43] A fifth work, of unknown location, is mentioned in a catalogue to a 1948 exhibition as having been one of five executed that same day.[44] Jackson's *Coronet Peak, Jasper Park* depicts the same scene.

After spending a few days with the warden, Harris and Jackson borrowed an 18-foot canoe, which they loaded with supplies that Harris had arranged for the wardens to pack in for them. Together they paddled to the far end of the lake, where they *"landed on a gravel beach where we pitched the tent."*[45] It seems that they camped here for several days, using the place as a base from which to work:

"Round about us were vast piles of crumbling mountains that crowded in the cold green, silt-coloured water of the lake. Painting these ancient Chaldean-looking ruins made no appeal to us, but up a valley we could see the great Brazean Icefields, and, after following up the torrent of glacier water that swept down it for several miles, we climbed above the timber to the forget-me-nots and mountain goats and looked across great rolling pastures to the glaciers that almost cover Mount Henry MacLeod and Coronet Peak."[46]

Two works, *South End of Maligne Lake* by Lawren Harris, and *Coronet Peak, Jasper Park*, by A. Y. Jackson, mark one of the few instances when it is likely that the two artists worked side by side. The vista, composition, and lighting in both works are roughly the same. Harris's scene is somewhat more refined that Jackson's, a little cleaner and easier to read. Jackson's is fresh and brisk, painted in the quick manner he referred to as "swatting down" his reactions to things.

The artists began to explore the upper elevations of the shores of Maligne Lake, climbing up above treeline to a place Jackson refers to as *"the Eastern Ridge."*[47] Jackson describes the terrain as *"a weird and ancient country of crumbling mountains and big glaciers."*[48] They concur in their respective writings about liking the looks of a range of mountains they refer to as the Colin Range, which lies between Medicine Lake and the Athabasca River, better than the lakeshore at Maligne. It is uncertain here whether they do indeed mean the Colin Range—or if they really mean the Queen Elizabeth Ranges, which border Maligne Lake's east shore. Harris states that the camp was *"high on the east side of Maligne Lake,"*[49] and Jackson notes that *"we borrowed a horse from the warden, piled our supplies on top of him, and climbed to the top of the timber where we camped."*[50] Harris and Jackson must have returned to the northern end of Maligne Lake at this time, for to have borrowed a horse from the warden meant that they were somewhere near the warden's cabin, which was originally located at today's east shore picnic site, just south of the boathouse. They used this horse to pack their supplies into their timberline camp. It is very likely that this is the same camp Harris and Jackson returned to about a month later, during the second stage of their Jasper trip. From there, they made several painting trips along the ridges, perhaps "the rough stuff" that Jackson referred to earlier.

Up there, on the exposed crests of the Colin (or Queen Elizabeth) Range, Harris and Jackson had to contend with wild weather. With no tree cover at this very exposed elevation, they both became fond of making tea to warm themselves when sitting down to sketch for lengthy periods. This itself proved challenging, and they had to stop at the edge of the treeline to fill their packs with kindling before climbing all the way up. Jackson recalls:

"About five hundred feet from the top, the rain started, and to get the fire going we had to lean over it and keep it from getting drowned. We got soaked and smoked at once. With the last little stick the water in our kettle

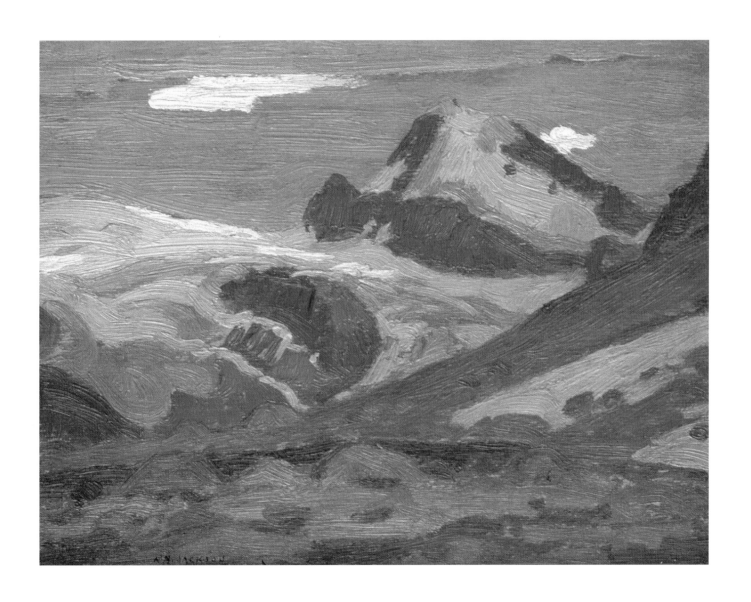

A. Y. Jackson
Coronet Peak, Jasper Park, 1924
oil on canvas
Glenbow Collection

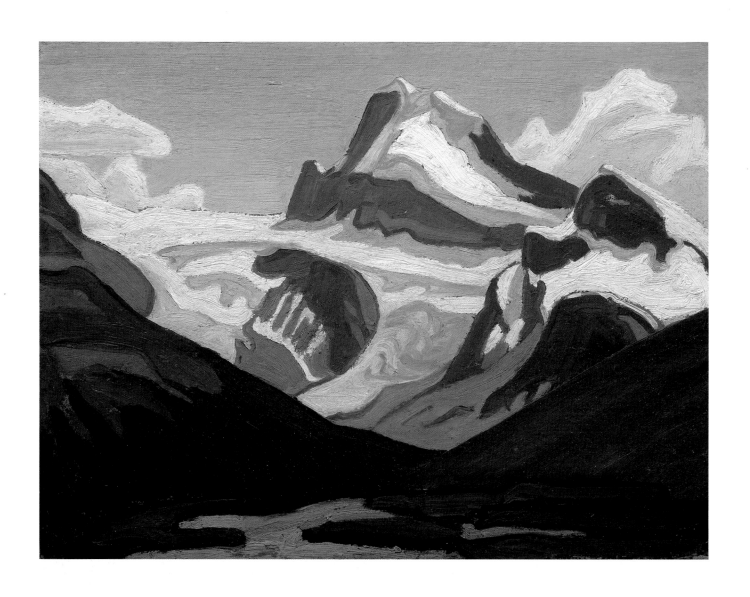

Lawren Harris
South End of Maligne Lake, c. 1925
oil on panel
McMichael Canadian Art Collection

started to bubble and then we resolved at last to see the promised land in the rain and climbed on up."[51]

Upon reaching "the promised land," the sun came out and they were able to see far into the valleys beyond. Although Jackson's descriptions of the region, which they both found *"most satisfying for painting ...,"*[52] as a panorama of red, orange, and grey rock, of sharp cliffs, and glaciated treeless valleys are vivid—*"a land as remote as the far side of the moon,"*[53] he called it—there is little to help determine the exact location mentioned. Using a geological palette of colours, we can compare his descriptions with the actual scenery in the two locations. The homogenous mountains of the Colin Range are mainly made of Devonian carbonates of the Palliser Formation, which weather to pale pewter grey. They are quite distinct, almost silver in sunlight and slate grey in rain. The mountains of the Queen Elizabeth Ranges, where they border the southeastern end of Maligne Lake, and that would have been visible from a high vantage point there, are a complete contrast to the greys of the Colin Range. They are made up of varying strata that include slices of grey Devonian carbonates, brown Triassic siltstones, and iron-bearing Cambrian carbonates and quartzites, which weather to red and orange. Thus the Queen Elizabeth Ranges comprise a vividly different, brighter, more colourful region. These hues of the Queen Elizabeth Ranges match Jackson's descriptions. As well, the glaciated treeless valleys that he mentions are more characteristic of the southeastern end of the Queen Elizabeth Ranges than of anywhere in the Colin Range.

No works by Jackson seem to match this scene, and although there are a number of works by Harris that depict the sawtoothlike formations of mountain tops running off in a repetitive, brown line from above treeline, they are extremely difficult to place with any geographic accuracy. Titles such as *Mountains East of Maligne Lake* do not help—there are many mountains east of the lake. These works are probably of this region, but I have yet to plant my boots with certainty where Harris might have stood.

The weather was its usual unpredictable self at Maligne. Jackson recalls sitting down and beginning a second sketch and turning around to *"find the whole country blotted out with an inky cloud which was hurrying down on us. We had run down six hundred feet when it struck us, an icy blast with a deluge of rain*

and hail."[54] They made a hasty retreat to the camp, and then to the warden's cabin where they hung their gear to dry and reflected on the challenges of this new-found terrain.

Although Jackson felt that the visually satisfying forms of Maligne's mountains were *"an amazing place, a kind of cubist's paradise full of geometric formations, all waiting for the abstract painter,"*[55] there is little evidence of the work that he did while there. Of his known paintings, none appears to

depict this cubist's paradise. Jackson's writings do recall that *"I painted a large canvas of it which no one liked, so I destroyed it. I lived to regret this rash act. It would have been considered a very good canvas twenty-five years later."*[56] This work was titled *Colin Range— East of Maligne Lake.*

Concluding the first leg of the Jasper trip after visiting the Maligne region, Harris and Jackson rejoined Harris's family and took another trip by train, this time to

TRAIL INFO

Trail/site: Coronet Creek
Type of trip: Two- or three-day boat trip
Launch: The public boat launch on Maligne Lake's west shore
How to get there: From Jasper townsite, take the east exit out of town and turn left (north) at the interchange. You are now on the Yellowhead Highway (16). Follow the Yellowhead for 1.7 km until you reach the Maligne Lake Road junction. Turn right and cross the river on a bridge. The road forks just after the bridge. Go left at the fork towards Maligne Lake. The distance to the main Maligne Lake parking area is 44.4 km. For the boat launch, drive an additional

0.8 km past the teahouse, to the northwest corner of the lake. Allow a minimum of 45 minutes one way.
Distance: 15 km by water to Samson Narrows, 25 km by water to Coronet Creek, an additional 8 km on foot to Henry MacLeod campround
Elevation gain: None on the lake, 295 m to Henry MacLeod campground
Degree of difficulty: Very easy in a power boat, moderate to tough if you are in a canoe, depending on headwinds
Best time to go: In clear weather. Maligne Lake is a long, deep, cold lake and can seem even longer in a storm. Make sure you are equally well prepared for rain and hot sun. →

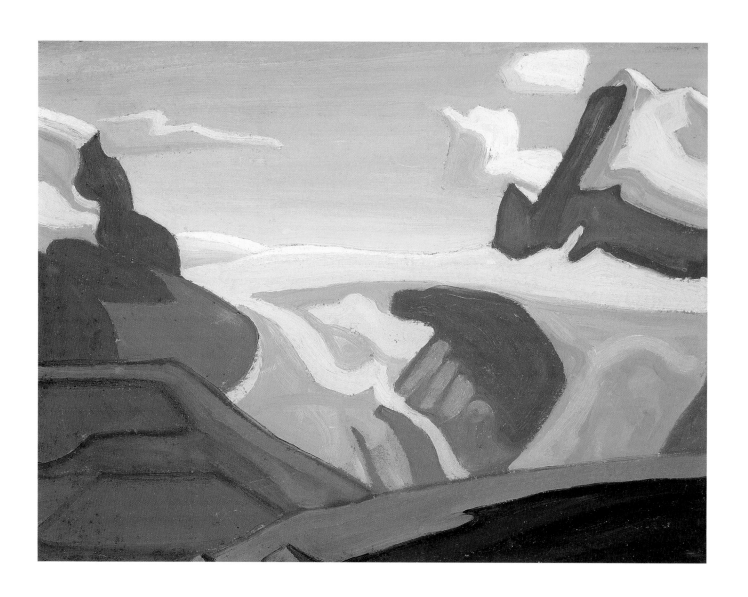

Lawren Harris
Coronet Glacier, Near Maligne Lake, 1926
oil on panel
Private Collection of Dr. and Mrs. W. H. Lakey

Vancouver. Jackson refers to this trip as "the triangular tour," and recalls the Vancouver portion of the trip as being very enjoyable *"lolling around and stuffing ourselves,"*[57] but notes that *"it's another world, the whole city seems to loll round the beach all day and off to movies all night, nothing for the artist—the kids had a wonderful time."*[58] They then travelled back to Jasper by train, arriving on 12 August, where they checked in once more at the Jasper Park Lodge. Jackson's letters again fill in some of the details:

"We returned from Vancouver last night, completed the triangular tour and now we are at the Lodge getting acclimatized and thinking of getting to work again. This isn't the life. Oh shucks, what a complex mess of conventionalities we live in. All I want to do is wander round with a sketch box and swat down my reactions way out in the great Canadian west, and yet it seems about impossible … you have to do the grand seigneur and act like a millionaire. We have to make two more trips to get our material."[59]

They stayed together at the lodge until about 25 August, when Beatrice and the children returned home by train.[60] Then, the two painters mounted another, longer working trip into the mountains, "up into the rough stuff" as Jackson put it. They were eager to return to the Maligne Lake camp they had made above timberline the previous month. Jackson was so eager to leave the lodge that his letters confess he wanted to *"get away from here quick."*[61] They returned to their camp, arriving late in the day, worn out and ready for bed. Harris relates the tale of just how tired Jackson was:

"We started early in the morning to tote our bed rolls, small tent, sketching material, and food for ten days up to this spot. The going was tough, and so it was not until late that same evening that we were settled. We pitched the tent just above the timber line on sloping ground, there being no level location. I built up a pike of crossed sticks under the foot of my bed roll so that it was level. Jackson did not bother to do the same; he simply crawled into his bed roll and went to sleep. Next morning at sunrise I awoke and glanced over to where Jackson was when I last saw him. I looked out of the tent flap and there he was twenty feet below, pulled up against a rock, buried in his bed roll, still fast asleep."[62]

Harris and Jackson painted additional works at Maligne Lake, and then, as there was no convenient paved road to take them down into the Athabasca Valley, went with guide Don Ferris over Shovel Pass (along today's Skyline Trail) and down into the valley. They most probably used Wabasso Lake to exit the hills. Jackson recalls Harris as the eternal optimist, strong on tea and a diet that consisted mostly of a health food cereal, Roman Meal, invented by a Dr. Jackson (no relation to A. Y. Jackson) of Toronto. It was made from wheat, rye, flax, and rice, and Harris would be most disconsolate when out of it. He queried every packer they met about a possible supply. Perhaps it buoyed him enough to manage the heavy packs that they carried, full of tubes of paint and panels.

TRAIL INFO

Boating time: Allow two or three days if you are paddling your own canoe

Route: You can launch your boat from the dock near the warden's cabin on the west shore of the lake. You can also rent boats, canoes, and kayaks from the historic boathouse on the lake's east shore. While boating, keep your eye on the weather and stay close to the shoreline if you are a novice. The commercial boats run continually during operating hours, and although they do slow down for other boaters, they still send wakes across the water, big enough to swamp a canoe. There are picnic sites along the east shore, and a few rocky beaches for rest and relaxation. There are three campgrounds to choose from. Fisherman's Bay is 15 km down the lake at The Narrows. Coronet Creek is at the end of the lake at 25 km, and Henry MacLeod is an 8-km hike from the south shore of Maligne Lake, up the Coronet Creek Valley. You can also access Le Grand Brazeau from here, a serious undertaking, but a spectacular trip. Plan your trip carefully, and remember there is a difference between essential boating gear, which always includes life jackets and a bailing bucket, and hiking gear. You will need to make campsite reservations at the Jasper trail office. These spots fill up fast in the summer months. The vista in both Harris's and Jackson's works depicting Coronet Glacier can be seen from just south of Samson Narrows if you are out on the water, and from the Coronet Creek campground itself.

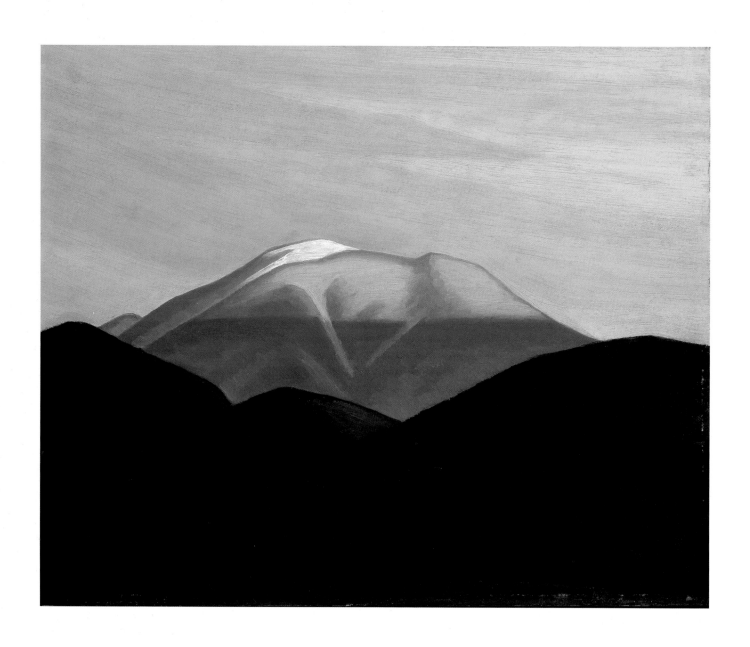

Lawren Harris
Mountain Sketch, c. 1928
oil on panel
Private Collection

"THE UNBOUNDED WARMTH OF RED HAS NOT THE IRRESPONSIBLE APPEAL OF YELLOW, BUT RINGS INWARDLY WITH A DETERMINED AND POWERFUL INTENSITY. IT GLOWS IN ITSELF, MATURELY, AND DOES NOT DISTRIBUTE ITS VIGOUR AIMLESSLY."

—Wassily Kandinsky in *Concerning the Spiritual in Art*, 1914

Not Just Mountains, But Hills

Lawren Harris's interest in using the structural forms of the mountains as a means to convey theosophical ideas has been stated. It is also important to note that this is manifest as well in his less frequent, but equally notable, paintings of hills. *Mountain Sketch*, a distant view of a hill that could be just about anywhere, is an example.

The low, distant blue mound of the hill, touched barely at the top by the white of snow, is cut in half horizontally by a change in colour. This distinct line suggests treeline, or perhaps a cloud shadow, and marks the exact horizontal centre of the panel. Sky, rendered in a pale chalky blue, takes up half of the scene. The entire bottom half of the work, that is, the area of main hill and foreground hills, has been underpainted in vivid, red ochre. This fiery colour shows through in many places along these hills, giving the work a charged quality of something beneath, an almost volcanic visual heat. The slight bottom edge of the work seems to indicate an area of green meadow, or perhaps a shoreline, again underpainted in lava red, and bordered slightly with a deep green forest, barely readable against the purple hills. Rich and intense, it is a very powerful painting.

The distant perspective is intriguing in this work. The hill is viewed from afar, with nothing to restrict our view of it. Perhaps it was painted in the foothills of the Rockies, or across a body of water that is not included in the composition. Nothing about the work provides a clue to the location it depicts, except the v-shaped chutes on the face of the hill. They do not match with my best guess location for this work, one of the unnamed summits of the Bald Hills, between Maligne Pass and Maligne Lake.

THE TONQUIN VALLEY

THE RAMPARTS

The impenetrable Ramparts of the Tonquin Valley, bordered with the serene moat of the waters of Amethyst Lake, are a truly astounding sight. Painted by many artists in the early part of the last century, they are compositionally perfect, a natural scene that seems destined to be used as an artist's subject. Part of the Continental Divide, the stage-set backdrop of The Ramparts frames the expanse of the Tonquin Valley's tranquil Amethyst Lake—a perfect painter's composition. A wide open meadow, bordered with distinctive mountains, and a selection of crystal-watered lakes nearby provided plenty of painting material for Lawren Harris and A. Y. Jackson.

The Tonquin Valley is one of my favourite places in the Canadian Rockies. It is a wonderful wildlife spotting area; one of the few mountain caribou herds in Alberta makes its home in the highlands here. I was lucky enough to observe more than thirty members of this herd high on the slopes of Oldhorn Mountain in 1993. Grizzlies also frequent the valley, and wolverines and wolves are often spotted.

The unpredictable weather of the Canadian Rockies gave Harris and Jackson a greater challenge than did the scenery during the 1924 Jasper trip. In all references made by each painter to this time, the weather and its lack of cooperation are mentioned. They had been rained and hailed on until water ran from their boots at Maligne Lake, caught in a snowstorm at Shovel Pass, and had hiked all the way into the Tonquin in continual rain. These unfavourable circumstances led them to knock on the door of the warden's cabin, and to the friendship they came to share with the warden Percy Goodair, who answered their knock and begrudgingly let them in. Jackson's writings tell the story of the kind of friendship that shared backcountry camaraderie kindles:

"We had intended to camp in the Tonquin country but it was raining when we got there after a long hike, so we spent the night with the warden, a man named Goodair. He was far from friendly, and made it quite clear that he did not like intruders among whom, obviously, he numbered us. After some desultory conversation in the course of which Harris asked Goodair what he did in the wintertime, Goodair replied that he went to Edmonton where he spent most of his time in the library. When Harris asked him what he read, he replied that he was most interested in history, biography, and theosophy. Harris was a theosophist and soon they were in a deep discussion of all the books they had read on the subject. After that evening we would have been welcome to stay a month with Goodair."[63]

While in the region, Harris painted several views of The Ramparts, including a dramatic moonlit scene,[64] as well as scenes along the Astoria River Trail, of Maccarib Pass in snow, and Throne Mountain from the Edith Cavell Lookout. Jackson painted several panels showing the rolling meadows below The Ramparts, which seemed to have appealed to his Algoma sensibilities, having much in common with the palette and brushwork of those eastern scenes. He also painted a lovely panel of Oldhorn Mountain from Maccarib Pass.[65] Most of these are now in unknown locations. The few works illustrated here hint at their fascination with the region, and record the challenges of the Rockies' notorious weather:

"… on a dark night with the rain beating on the roof of the shack, we heard a holler outside. Two bedraggled individuals with a train of pack horses. One was a cook and the other a packer. We gave them shelter and a grand dinner was served. Over a roaring fire they hung their

A. Y. Jackson
The Ramparts, 1924
oil on panel
Private Collection

"A. Y. OBVIOUSLY FELT LESS AT HOME IN THE SHARP-PEAKED YOUNG ROCKIES WITH THEIR UPTHRUST, UPSTART WAYS (AND TOO MANY FUZZY TREES AROUND THE BASE) THAN HE DID IN THE LONG-ROLLING RHYTHMS OF HIS BELOVED OLD LAURENTIANS."

—Naomi Jackson Groves in *A. Y.'s Canada*, 1968

clothes to dry. The cook we found was an Oxford man, our warden a graduate of London University. We talked art and music and philosophy far into the night, and were just starting on the cosmic consciousness when Harry the packer and I fell asleep."[66]

Goodair patrolled Tonquin's backcountry and was stationed at the warden's cabin there for five years, until he was killed by a grizzly in 1929. His gravesite is quite near the Maccarib campground and looks out across the Tonquin Valley onto a view he loved.

Jackson's depiction of The Ramparts uses a west-looking, head-on composition. Rising like a stage set propped behind the waters of Amethyst Lake, The Ramparts form a purple-red backdrop to Jackson's tranquil scene. The rolling greens and soft yellows of the foreground meadow contrast nicely with the purple-red of The Ramparts. These green and yellow shades in the meadow are applied in a manner that seems to convey the boggy nature of this sedgy wetland.

Jackson has painted the southern Ramparts (Dungeon, Redoubt, and Drawbridge, from left to right on the left side of his panel) in a different hue from the northern Ramparts (Bastion, Turret, and Barbican, from left to right on the right side of his panel). An interesting effect of light and distance upon perceived colour, Jackson has captured the changing hues of a rock face that in reality is made of consistently coloured Gog quartzite.

Amethyst Lake is a work in gouache that shows this same scene from a vantage point a few hundred paces south along the trail, past the lakeshore.

TRAIL INFO

Trail information: Tonquin Valley and The Ramparts

Type of hike: Overnight backcountry hike

Trailhead: This route describes a hike following the Astoria River in and Portal Creek out. You will need to arrange transportation to reconnect with a vehicle if you leave one in the parking lot at either end of the route.

How to get there: Follow the Icefields Parkway south from Jasper for 7.5 km, to the sign indicating a right turn to Mount Edith Cavell and Marmot Basin along Highway 93A. Follow Highway 93A for 5.2 km. At the fork in the road, continue straight through to Edith Cavell. You can leave trailers at the drop-off lot; they are not allowed on this road. This is a winding, 14.5-km road that takes you to the base of Mount Edith Cavell. Park at the designated lot by the Astoria trailhead, near the youth hostel.

Distance: 43.7 km

Elevation gain: 518 m

Degree of difficulty: Moderate

Hiking time: Allow 3 days

Route: Begin at the trail sign near the youth hostel. You will descend into the valley, crossing the outlet of Cavell Lake shortly; keep right after the bridge. This is bear country, as is all of the Tonquin.

You will cross the Astoria River and continue to the Astoria campground at 6.8 km. Keep straight at the Chrome Lake junction, at 8.2 km. The Switchback campground is at 13.8 km. Shortly after reaching this campground, you will begin to see glimpses of The Ramparts. The Tonquin Valley proper has several campgrounds, all of which are almost always fully booked. From the Clitheroe junction at 16.9 km, the Amethyst Lakes campground is 3.3 km to the north, Surprise Point is 2.2 km to the southwest, and Clitheroe is just left of the junction. All make good base camps for viewing Jackson's depiction of The Ramparts and Amethyst Lake and for making side trips. From one of these campgrounds, follow the route out from Amethyst Lake towards Maccarib Creek. Maccarib campground is at 23.6 km. Maccarib Pass, a wonderfully open high mountain pass, crests at 31.1 km. From here, you switchback steadily down to Portal Creek and the Portal Creek campground, at 35 km. The final portion of the trail follows Portal Creek to the Marmot Basin Road and the other end of the trailhead at 43.7 km.

A. Y. Jackson
Amethyst Lake, c. 1927
reproduction of a gouache on paper
Glenbow Collection

Lawren Harris
Snow, Rocky Mountains, c. 1925
oil on panel
McMichael Canadian Art Collection

MACCARIB PASS

The weather conditions in the Tonquin provided the material for one of the few scenes by Lawren Harris depicting a fresh snowfall in the Rockies. Harris painted many eastern snow scenes; especially notable are the springtime wet, snow clad clap-board houses of Halifax, stunning depictions of beauty found in the midst of poverty and desolation. Harris's mountain works contain many depictions of old snow, usually in a glaciated state. Here, we see a fresh, wet snow shining in the glory of a bright, sunny day. *Snow, Rocky Mountains* is an intimate and delightful work, a close-up view of a hill covered in waves of multi-coloured white summer snow. A tree, drowned from tip to trunk in thick, sticky white, frames the right edge of the scene.

Harris would later work this same scene into two additional versions. One is a close-up depiction of the tree; the other is a larger format canvas.[67] Although the composition and style of this larger work are roughly the same as those of the little panel, the picture seems to lose some of its intimacy with the increased size. The first small panel always makes me feel as if I am looking out of a backcountry cabin window onto the brilliant, sunlit scene, and captures the character of unexpected summer snowfalls exactly.

Harris set the scene in this work from the crest of Maccarib Pass. Lit by reflections from the summer snow, the distinctive concave triangle of the uppermost point of Chak Peak shows over Maccarib Pass. A. Y. Jackson is known to have painted a work titled *Trees Laden with Snow* (not illustrated) while in the Tonquin; certainly it must be from this same day.

While in the Tonquin, Harris and Jackson were hoping to get enough material to use as reference if they obtained a commission from the Canadian National Railway Company for a large work or series of works for a grand hotel or station. They planned a panoramic scene, based on drawings of the Tonquin Valley completed from Tonquin Hill, *"from which the whole way around the horizon could be seen, a grand panorama of mountains and lakes with stretches of forest and Alpine pastures."*[68] Jackson and Harris each took half of the vista and together they completed drawings of the whole panorama, section by section. Upon their return to Toronto, Harris proposed the idea to Sir Henry Thornton of the railway. Thornton was an avid supporter of the arts, himself an accomplished painter, and although supportive of the idea, lost his own position with the railway shortly after it was proposed. Harris's plans for their joint commission were never realized, and no further works, beyond illustrations by Jackson in a CNR travel brochure in 1927, are known to have been developed from the drawings that they made. These drawings are now spread in collections across Canada.[69]

TRAIL INFO

Trail information: Maccarib Pass via Portal Creek
Type of hike: Overnight backcountry hike
Trailhead: Portal Creek parking lot
How to get there: Follow the Icefields Parkway south from Jasper for 7.5 km, to the sign indicating a right turn to Mount Edith Cavell and Marmot Basin along Highway 93A. Follow Highway 93A for 5.2 km. At the fork in the road, turn right onto the Marmot Basin Road. The Portal Creek parking lot is at 6.6 km.
Distance: 12.6 km
Elevation gain: 320 m
Degree of difficulty: Moderate
Hiking time: Allow 2–3 days
Route: Start at the Portal Creek trailhead on the Marmot Basin Road; you will begin climbing immediately. Cross Portal Creek on a footbridge after 0.5 km and climb steadily for the next 3.7 km, crossing Circus Creek at about 4 km. If you only have two days, the Portal Creek campground at 8.7 km, set among the willows on the rocky banks of Portal Creek, is a great place to camp and leave most of your gear. You can then tackle the switchbacks and visit the Tonquin Valley with less weight to carry. From Portal Creek, you will climb steadily through open sub-alpine meadows, filled with wildflowers in the summer and tinged red-gold in the fall. Maccarib Pass is at 12.6 km. As you begin to crest Maccarib Pass, watch for the point at which you can just see over the top of the pass. If you are lucky enough to be there in conditions that match Harris's snow laden scene, keep moving to stay warm. If not, compare the size of the current trees with those depicted in Harris's canvas. You can also camp just over the pass at the Maccarib campground at 20.1 km, and continue on into the Tonquin Valley, returning the way you came or completing a loop out by way of the Astoria River.

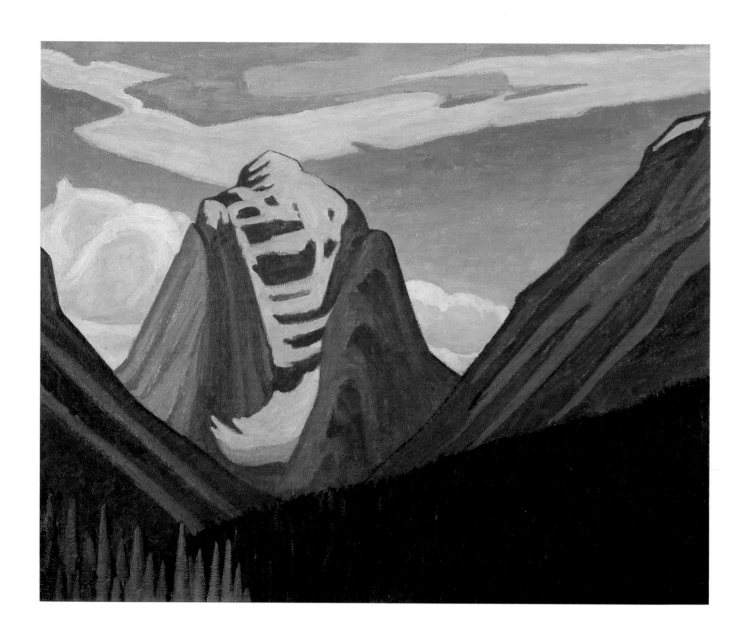

Lawren Harris
Throne Mountain, Rocky Mountains, c. 1924–25
oil on canvas mounted on masonite
Private Collection

"IF WE VIEW A GREAT MOUNTAIN SOARING INTO THE SKY, IT MAY EXCITE US, EVOKE AN UPLIFTED FEELING WITHIN US. THERE IS AN INTERPLAY OF SOMETHING WE SEE OUTSIDE OF US WITH OUR INNER RESPONSE. THE ARTIST TAKES THAT RESPONSE AND ITS FEELINGS AND SHAPES IT ON CANVAS WITH PAINT SO THAT WHEN FINISHED IT CONTAINS THE EXPERIENCE."

—Lawren Harris in *Lawren Harris*, 1969

THRONE MOUNTAIN

Following the 1924 route that Harris and Jackson took into the Tonquin is difficult today. The old trail, in use after 1915, went over Marmot Pass and followed Portal Creek up into the valley. It was described by surveyor A. O. Wheeler as *"the very worst trail I know of."*[70] Trails have since been re-routed up Maccarib Pass and along the Astoria River. This has greatly improved access to the region. It is likely that Harris and Jackson went in along the Astoria River route, as the new Portal Creek route was not completed until 1926. They went out along Meadow Creek towards the Yellowhead Highway, where they may have arranged to be picked up by the train. The Meadow Creek trail has been unmaintained since the late 1970s.

The work *Throne Mountain, Rocky Mountains* looks west towards Throne Mountain through the narrow valley between Mount Edith Cavell and Astoria Pass. The southern flank of Franchere Peak shows on the right edge of the canvas. The work captures the foreboding darkness of this steep-sided valley. Throne Mountain, named for its obvious armchair shape, is the central feature in the work, which very likely dates from 1924 and was probably painted early in the first leg of their trip.

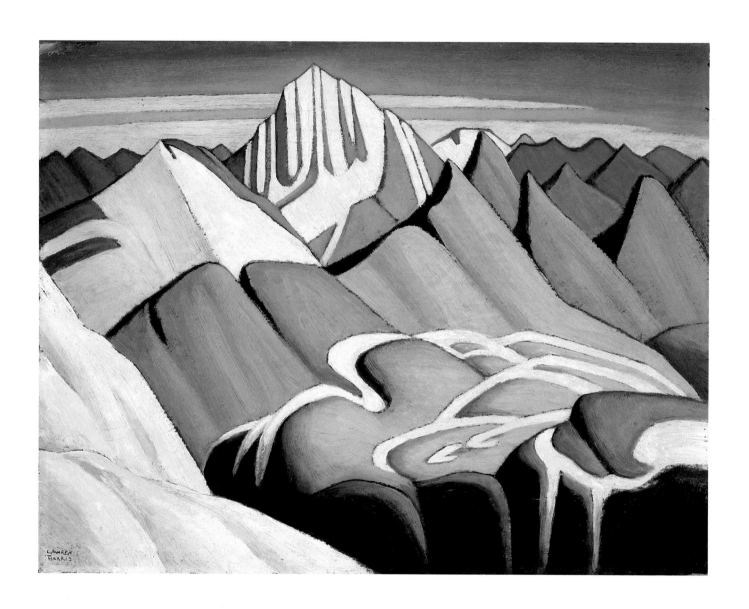

Lawren Harris
Mountain Sketch, c. 1924–28
oil on plywood mounted on masonite
Winnipeg Art Gallery

THE ATHABASCA VALLEY

MOUNT KERKESLIN AND BRUSSELS PEAK

Upon completion of their adventures at Maligne Lake, Harris and Jackson likely came out of the Shovel Pass region and down into the Athabasca Valley, near Wabasso Lake. Today's route is a buggy, heavily treed trail that is busy with horses. From there they went farther south, and painted in the vicinity of Mount Kerkeslin, executing at least three versions looking towards the scene depicted in *Athabasca Valley, Jasper Park*. The two versions by Harris look south towards the Fryatt Valley across the Athabasca River, one being a slightly more distant view than the other. A depiction of the same scene, but rendered this time in gouache by Jackson, was later used to illustrate a Canadian National Railway, Jasper National Park tourist brochure. This work also looks south past Mount Kerkeslin, at the mouth of the Fryatt Valley, and is set from along the Athabasca River.

A classic example of an early mountain work by Harris, *Athabasca Valley, Jasper Park* is a small oil, painted on a wooden panel, showing the Athabasca Valley looking south towards Mount Christie. To orient yourself in the canvas, look to the right of Harris's skeletal pine tree. Mount Christie (3,103 m) shows as the highest triangular peak in the canvas. Brussels Peak, a distinctive mass on the horizon, looking like the top of a submarine boat, has been cut off by Harris. The slightest edge of the southeastern flank of Mount Fryatt (3,361 m) shows on the right edge of the work. Catacombs Mountain, Dais Mountain, and the Winston Churchill Range run off successively to the left edge of the painting. The Athabasca River, characteristically chalky with runoff and silt, is in the foreground.

With a typical "blasted pine" motif dead centre, this work is transitional, marking the passage in Harris's works from an eastern approach to a western response. The pine tree, likely a lodgepole pine with its root hold eroded away by the swift and transient waters of the Athabasca River, may be true to its place, or it may be an eastern hangover. In Harris's early depictions of the mountains, one often finds this central tree. Three depictions of the Athabasca Valley, all drawn from roughly the same location as this image, are known, and all use this same pine motif in the central space. A painting of Mount Robson and a depiction of Emerald Lake also contain one such tree—this time, horizontal as a length of driftwood and worked more successfully into the overall composition, illustrated in *A Hiker's Guide to Art of the Canadian Rockies* (p. 92).

This work also shows the beginnings of change in Harris's brushwork. The thickly laden canvases of the east, swirling and choppy, became more refined, and gradually gave way to works with smooth, slick brush strokes, notable in his Arctic works, and culminating in the abstractions of his late career. His palette, too, begins to change, as much to depict the scenery in its actual colours as to convey philosophical explorations of colour and light and their symbolic meanings within the doctrines of theosophy.

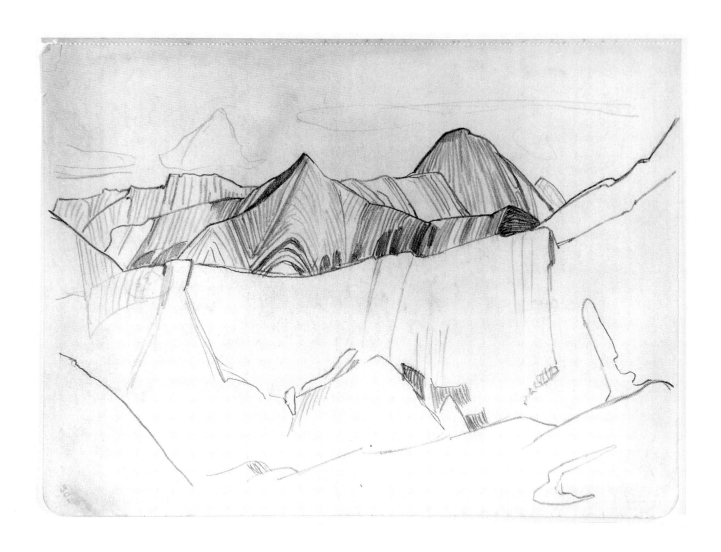

Lawren Harris
Rocky Mountains #733, c. 1923–30
pencil on paper
London Regional Art and Historical Museums

"JACKSON AND I TRAVELLED, CAMPED, AND PAINTED
TOGETHER MORE THAN ANY OF THE OTHER
PAINTERS [MEMBERS OF THE GROUP OF SEVEN]—
AND WE STILL GET ALONG REASONABLY WELL
TOGETHER. IF YOU KNEW US BETTER YOU WOULD
CONSIDER IT IS A CREDIT TO EACH ONE OF US."

—Lawren Harris in a talk given at the Vancouver Art
Gallery, 1954

THE COLIN RANGE

Heading north on Highway 16 from Jasper townsite, you will travel below the western slopes of the Colin Range. *Colin Range, Maligne, Rocky Mountains #733*, and *Mountain Sketch*, c. 1924–1928, by Harris are depictions of these ranges from the west. A repetitive series of grey thrust faults, the undulations and symmetry of the Colin Range captured the eye of both Harris and Jackson. Several of Harris's late abstractions found their beginnings here, and two of his later mountain works, although much too abstract to place with certainty, seem to depict the sawtoothed features of this range.

The two pencil drawings, *Colin Range, Maligne*, by Jackson, and *Rocky Mountains #733*, by Harris, depict the best-known feature of the Colin Range from an unlikely location. Roche Bonhomme, or Oldman Mountain, is a landmark feature that, when viewed from the south, looks exactly like a figure lying on his back, gazing skyward. A remarkable feature, this southern view is well known. Harris and Jackson have drawn a view from the west, depicting instead the unassuming yet geometrically appealing peaks between Mount Colin and Roche Bonhomme. The best place to view the scenery depicted in these works is from the centre of the footbridge that connects the island in Pyramid Lake with the shoreline. These pencil drawings show a remarkable stylistic and compositional similarity to one another, and are unusual in that Harris's and Jackson's works in oil are so very different in style and technique. Without the camouflage of brush stroke and colour, the spare pencil lines, laid bare, show that both artists were interested in the same characteristics of these peaks. The sharpness of the ridges, the angular slopes, and pointed central peak predominate in both of the drawings. Jackson has given the foreground ridge slightly more attention than Harris, and Harris's perspective is from slightly higher than Jackson's, but at a glance they have more in common than not. Jackson later published yet another version of these mountains in pen and ink, which appeared in *The Canadian Forum* in September 1926 (not illustrated).

The Palisade Lookout trailhead is located close to the Pyramid Lake parking area. An excellent afternoon's outing can be had by combining

69

"DEAR ALEX. WHEN THE POSTMAN POKED HIS OFFERING THROUGH THE HOLE IN THE DOOR THIS MORNING … AND WHEN I SAW THOSE UPPERMOST PICTURES OF JASPER LODGE, WITH A SWOOP LIKE A TERN AFTER A SHIVER AND A 'OH LORD FOR WHAT WE ARE ABOUT TO RECEIVE'—I GATHERED YOUR EPISTLES UP … FOR WE CERTAINLY ARE INTERESTED IN OUR 'ART AND ARTISTS'—ESPECIALLY THOSE THAT ARE OUT IN THE BIG NORTH, WHISTLING AT BEARS, —AND TUMBLING ROCKS OFF LEDGES TO HEAR A GREAT BIG NOISE."

—Bess Housser in a letter to A. Y. Jackson, 8 September 1924

a picnic at Pyramid Lake with a hike or bike along the fire road to the lookout, to the location of the scene depicted in the slick Harris oil *Mountain Sketch,* c. 1924–1928. An example of Harris in the Rockies at his absolute best, this work also depicts the peaks between Mount Colin and Roche Bonhomme. The view looks west from a location along the fire road, which is now obscured by trees. Much of the look-out fire road runs along a steep cliff and scrambling through the trees to determine the vantage point is not recommended. The best approximation is from the lookout itself, also on a high cliff, but at least with a clear view. Otherwise, it wouldn't be much of a lookout.

TRAIL INFO

Trail information: Palisade Lookout/Pyramid Lake parking area
Type of hike: A steep half-day hike or bike and hike
Trailhead: At the far end of the Pyramid Lake parking area
How to get there: From Jasper townsite, take Connaught Drive to Bonhomme Street and follow it to the intersection with the Pyramid Lake Road. The road starts climbing immediately, passing Cottonwood Slough at 1.2 km, and Patricia Lake at 4.1 km. You will reach Pyramid Lake at 6.5 km; follow the shoreline until you reach the end of the road at 8 km. Allow 15 minutes for the drive.
Distance: 10.8 km one way
Elevation gain: 865 m (a grunt)
Degree of difficulty: Difficult
Hiking time: Allow 5 or 6 hours
Route: Begin at the access road beyond the gate that restricts traffic from the Pyramid Lake Road from venturing along the old fire road. Vehicles servicing the Pyramid Mountain relay station still use this road, so watch for the occasional truck, especially if you are biking. Follow the road past the outlet of Pyramid Lake at 1.1 km. A section of Jasper's trail systems, Trail Number 2, forks off here; keep to the road. You will begin to climb almost immediately. At 7.6 km, take the right fork; this is the branch to the old look-out site. The left fork goes to the relay station; bike access ends here. The terrain becomes rougher and over-grown in places, and is heavily treed all the way. There is little water on this popular trail, so come prepared. Once you reach the lookout, your view approximates the view in Harris's *Mountain Sketch.* On the day Harris sketched here, there may have been a fresh snowfall on the opposite ridge, as indicated by the swirling white ribbons on the lower slopes of the mountain, as well as the white-blue bluff of The Palisade itself, which Harris has used to border the left corner of the work. An interesting and subtle palette can be seen in this work; Harris has replaced the green forest of the Colin Range with buff tones of tan and yellow, and the receding mountains in the right distance are painted an almost iridescent purple-blue. This colour, quite intense and lucid, is used in many of his later mountain works to shade far-off mountains and distant, "added" peaks.

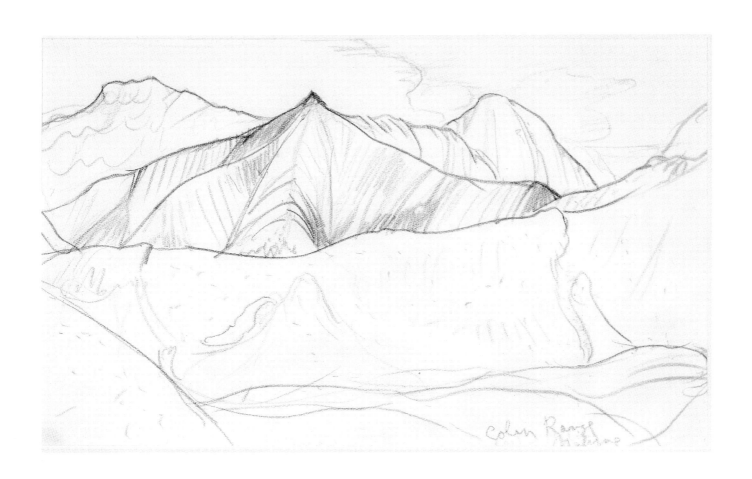

A. Y. Jackson
Colin Range, Maligne, 1924
graphite on paper
Whyte Museum of the Canadian Rockies

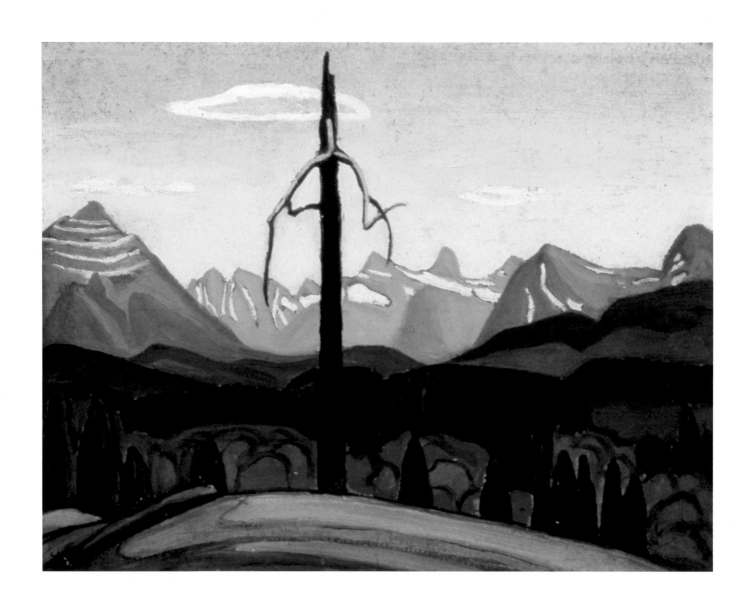

Lawren Harris
Athabasca Valley, Jasper Park, undated
oil on wood
Agnes Etherington Art Centre

> "ART IS NOT AN AMUSEMENT, NOR A DISTRACTION, NOR IS IT, AS MANY MEN MAINTAIN, AN ESCAPE FROM LIFE. ON THE CONTRARY, IT IS A HIGH TRAINING OF THE SOUL, ESSENTIAL TO THE SOUL'S GROWTH, TO ITS UNFOLDMENT."
> —Lawren Harris in *Theosophy and Art*, 1933

I Can't See the Mountains for the Trees …

Among the many challenges that presented themselves in the summer of 1999, when I hiked the trails that Harris and Jackson had walked before me, was the realization that I couldn't see the mountains for the trees. In 1924, natural forest fires, which went largely unchecked, were a recent occurrence in Jasper. The construction of the railways through the Athabasca Valley sent many an unattended spark flying, and the resulting burns cleared valleys and mountain slopes at random. Seventy-five years later, and over one hundred years since the last major forest fire, the trees of Jasper National Park have continued to grow without this natural and essential part of forest ecology. On many a hike, I found myself in a location where I had expected to find a vista, but instead found myself staring at a wall of lodgepole pine trunks. Frequently reaching a height of 20 metres, lodgepole pines present a formidable barrier to a clear view. One of these locations was my sought-after view from along the Athabasca River Valley towards the peaks of the Fryatt Valley. Another vista across a lakeshore was so overgrown that I almost took an unplanned swim trying to find a likely spot where Harris might have sat to sketch.

In recent years, the necessity of natural fires has been recognized in our national parks, and controlled burns of varying intensities are being set. It is a controversial issue that requires us to acknowledge the importance of the greater lifespan of a forest over our own wish to keep things pretty. We must learn to see the beauty in our forests in all their natural states, including burns. It is easy to see it in a recovering burn; nothing is more startlingly lovely than the vivid magenta of fireweed against the black and silver of charred wood. Harris's painting *Athabasca Valley, Jasper Park*, with its burnt pine dead centre, testifies to the wonder of the natural world renewing itself.

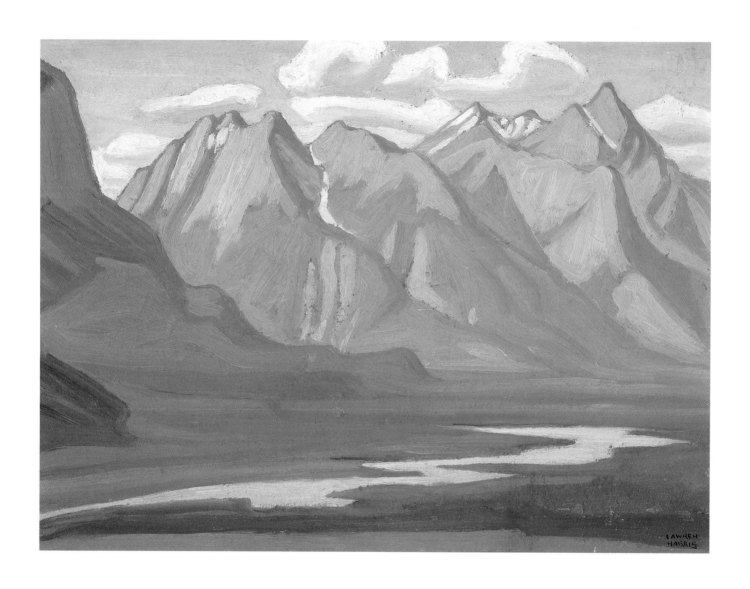

Lawren Harris
Athabaska at Jasper, 1924
oil on panel
Private Collection

CHETAMON MOUNTAIN

Travelling north up the valley of the Athabasca River on Highway 16, below The Palisade, you can visit the site of another early mountain scene by Harris. *Athabaska at Jasper* depicts Chetamon and Esplanade Mountains from the east bank of the Athabasca River. The Overlander Trail is a likely spot for Harris to have sketched, having been in use since 1862 when the Overlanders travelled north in search of gold. It is also the site of the ruins of John Moberly's cabin, which were intact until an illegal campfire damaged them in 1989. Moberly was the son of a Jasper House fur trader. The seeded legacy of his 1908 garden, which included a field of wheat, can still be seen here in the summer.

Harris's scene looks northwest towards Chetamon and Esplanade Mountains across the Athabasca River Valley. The view is set from roughly a kilometre south of Mrs. Swift's Sulphur Spring. The distinctive edge of the Pyramid Bench shows on the left side of the canvas. Chetamon Mountain is in the centre, and Esplanade Mountain runs off to the right. The scene resounds with the restraint that characterizes a number of Harris's earliest Jasper scenes, but the expansive view here seems to have helped sort out this compositional problem. As well, the brushwork in this panel begins to hint at the smooth, liquid strokes that he would later make. You can also approximate this vista from The Palisade picnic site, although the region is heavily treed. The first few metres of the Snaring River Road, just after you pass under the railway bridge, also afford approximate views, but both of these latter approximations lack the meandering silver snake of the Athabasca River in the foreground.

"FOR THE FIRST FEW DAYS THE VISITOR WILL PROBABLY CONTENT HIMSELF WITH THE POINTS WHICH CAN BE REACHED BY MOTOR. HE WILL EXPLORE THE MYSTERIOUS GORGE OF MALIGNE CANYON, VISIT PYRAMID LAKE LYING LIKE A SPREAD PEACOCK FAN AT THE BASE OF PYRAMID MOUNTAIN, AND THE LOVELY CHAIN OF LAKES ON BOTH SIDES OF THE RIVER. HE WILL TAKE THE SPLENDID HIGHWAY THAT SWEEPS UP TO THE BASE OF MOUNT EDITH CAVELL, GAINING, AS IT RISES IN WIDE SPIRALS, HIS FIRST GLIMPSE OF THE TRUE GRANDEUR AND MAGNIFICENCE OF THE GLORIOUS ATHABASCA VALLEY."

—Anonymous in *Canadian National Railways Brochure*, 1927

The 1927 Canadian National Railways Tourist Brochure

Despite the efforts of Lawren Harris, no commission for a large work or, as he had hoped, a series of murals in a station or grand hotel, was forthcoming from the Canadian National Railways following the 1924 sketching trip. In 1927, however, a tourist brochure illustrated with works by a number of artists was printed by the CNR. *"A minor outcome"*[71] of Jackson and Harris's plans, the brochure did not include anything at all by Harris. J. E. H. MacDonald, Frank Carmichael, A. Y. Jackson, and A. J. Casson all contributed. MacDonald's works are engravings after photographs; he did not visit Jasper in his lifetime. Carmichael and A. J. Casson (a later addition to the Group of Seven) are not known to have visited the mountains either. Their illustrations are also black-and-white reproductions of engravings, likely taken from photographs. Of the original members of the Group of Seven, J. E. H. MacDonald, Lawren Harris, Fred Varley, Arthur Lismer, and A. Y. Jackson painted in the Rockies at one time or another.

In the brochure, the only works illustrated in colour are those of A. Y. Jackson. Six works depict the following locations and are titled as such: *The Athabaska Valley, Mount Edith Cavell, Amethyst Lake, Maligne Lake, Pyramid Mountain,* and *Mount Robson.* The original gouache paintings by Jackson were likely created after the 1924 trip, and may be based either on his oil sketches or drawings from 1914 or 1924, or worked up from photographs provided by the railway. One could also speculate that Jackson used a Harris sketch as material, as a known work by Harris, titled *Pyramid Mountain Sketch,* c. 1924 (not illustrated), of unknown location, shows the same composition as Jackson's gouache. To date, I have not been able to match any 1914 or 1924 works in oil or pencil by Jackson with his gouaches. The latter seem to have been unearthed in recent years and appear with fair frequency at auction.

Jackson's view out across Lac Beauvert towards Mount Edith Cavell is, apart from views of Spirit Island at The Narrows on Maligne Lake, probably one of the views most associated with Jasper. The distinctive outline of Edith Cavell's silhouette, although not exactly captured here, and the patterning of the snow and glacial ice, more successfully captured here, are as familiar to people who know Jasper as Mount Temple is to people who know Lake Louise.

The young forest depicted in Jackson's work, very sparse by comparison to the forest now covering the distant shore, is softly reflected in the pale waters of the lake. Gouache, Jackson's medium for this work, uses opaque watercolours mixed with a binder of gum and a filler of clay or barite. It has a characteristic chalky quality, even when used with dark pigments, and here, the overall effect is soft and pale.

The brochure itself is a romantic document. Embossed and tied with a silky, gold cord, it is printed on heavy rag paper and conjures up all the notions associated with the Rockies at their most flowery and poetic. The Canadian

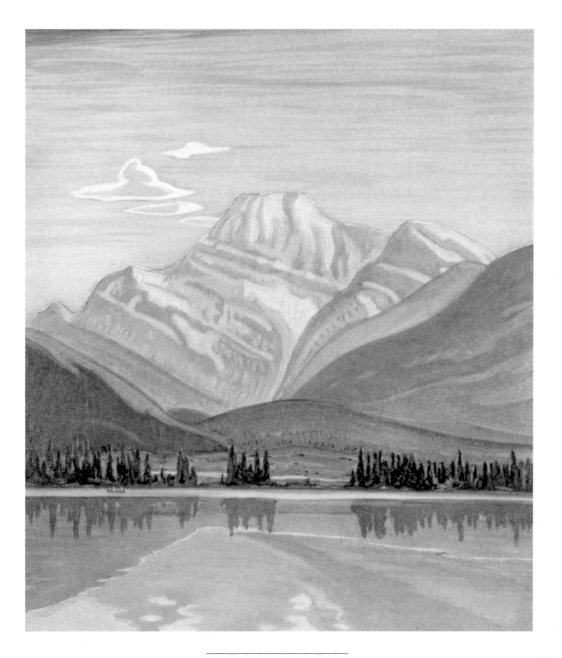

A. Y. Jackson
Mount Edith Cavell, c. 1927
reproduction of a gouache on paper
Glenbow Collection

"A. Y. JACKSON FELL IN LOVE WITH LANDSCAPES AND NEVER FELL OUT OF LOVE WITH THEM."

—Naomi Jackson Groves as quoted in *The Lethbridge Herald*, 23 April 1970

National Railway set out to entice adventurers to Jasper with descriptions of the park's lakes being *"the most magnificent thing a human being can hope to look on this side of Paradise,"*[72] and Jasper being *"a place apart and enchanted, surcharged with mystery,"*[73] and bordered with *"mountains on whose barren breast the floating clouds do often rest."*[74]

Edith Cavell is a stunning mountain, very much one that would have appealed to Harris's eye. I trust that someday a work depicting it will surface in the art world for interested hikers and art followers to enjoy.

In addition to the colour reproductions in the 1927 CNR brochure, there are a total of seventeen reproductions of engravings of scenes in and around Jasper by artists J. E. H. MacDonald, Frank Carmichael, and A. J. Casson. They are typical "tourist" images, probably worked up from photographs, and designed to attract visitors to the Jasper region for fishing, motoring, relaxing in spas, trail rides, wildlife spotting, and other such pastimes. The quote that accompanies the image of Jacques Lake, illustrated here, appeared with this same image in the original brochure.

The trail to Jacques Lake is easy, rolling, and pleasant. Many people bike into the lake, as the first part of the trail is a fire road, and the grade is gentle throughout. In 1999, I hiked there one afternoon with a friend and set up camp late in the day. We had the lake to ourselves, intending to stay for two nights and explore. We shared the evening with a moose cow and her twin calves, watching them forage calmly in the inlet as we enjoyed the long summer evening and the light as it changed over the lake. I had successfully placed MacDonald's drawing of the lake when we decided to head to our tent.

The campground at Jacques Lake suffers from real estate discrimination. While the warden's cabin is built on a glorious open meadow, the campground is set in a salad bar for bears. The tent pads are scattered like serving platters in a large patch of musty cow-parsnip, favourite bear food, and at the time of our visit, they were perfectly ripe. But as only a tame mule deer foraged there, we climbed into our tent, closed our eyes, and then spent about an hour listening, as we found out later, to what we thought was each other's unusual snore. I had just wondered at how much my friend's snore sounded like a snuffling

TRAIL INFO

Trail information: Lac Beauvert Walking Trail
Type of hike: Half-day hike, easy walk
Trailhead: Public parking lot at Jasper Park Lodge
How to get there: Follow the Icefields Parkway north from Jasper for 2 km, to the signed right turn to Maligne Lake and Canyon, and Lac Beauvert. You will immediately cross a bridge on the Athabasca River. The road forks just after you cross the bridge; go right at the fork. You will pass under the wooden sign for Jasper Park Lodge. There is a turnoff to the left for Lake Annette; continue straight through the intersection. The road winds left around the ridge above the Athabasca River and re-enters the forest briefly. As Lake Mildred appears on your right, the road divides for two-way traffic. Continue straight through and respect the lodge's parking restrictions. There is a lot indicated for public parking on the left, near the stables and just before the golf course. Park here and walk towards the main lodge on one of the many pathways.
Distance: Less than 1 km
Elevation gain: None
Degree of difficulty: Very easy
Hiking time: Allow 1 hour
Route: The walking path meanders along the north shore of Lac Beauvert in front of the guest cabins. There are four sun platforms—large, raised balconies, painted different colours and set with inviting wooden chairs—along the shore between the boathouse and the promontory on the lake. Jackson's gouache looks south across Lac Beauvert from the third sun platform, directly in front of cabins 140–143. This is a wonderful spot to stop for a break.

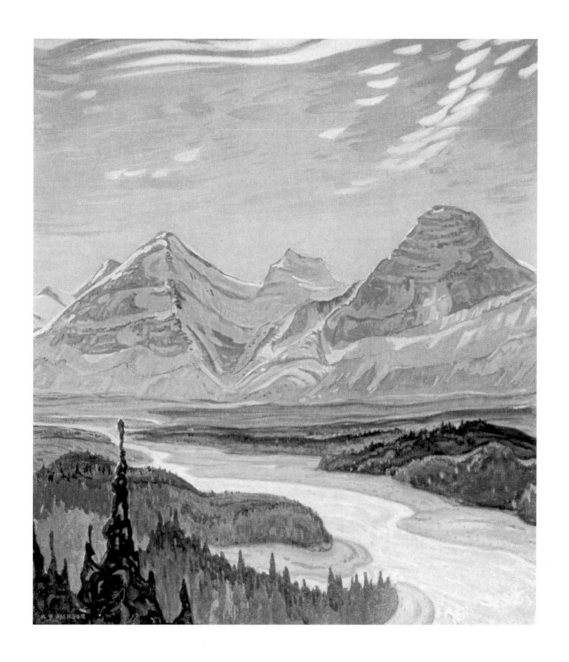

A. Y. Jackson
The Athabaska Valley, c. 1927
reproduction of a gouache on paper
Glenbow Collection

> "IT IS NOT ALL OF FISHIN' MERELY TO FISH."
>
> —Anonymous in *Canadian National Railways Brochure*, 1927

animal, when a commotion broke out at the inlet of the lake. A horrible sound, somewhere between a human scream and the wail of an animal in terrible distress, all mixed up with the sounds of splashing and thrashing at the inlet, caused us to bolt upright. The sound went on for what seemed like minutes, and then all was calm.

We climbed out of our tent into the parsnip buffet, and explored as much as caution permitted, but we could see nothing to have caused such a sound. Knowing the frequency of bear sightings in our vicinity had been high that summer, and being the only tenters in the camp, we discussed our situation. If indeed, as we suspected, a bear had been bold enough to charge the moose and calves, or bold enough to get so close to them to be charged by the mother, it was too bold a bear for us. Summer had arrived very late that year; in fact, we had abandoned plans to hike a higher trail in favour of Jacques Lake due to the late snow pack. Bear food, we expected, was at a premium. As the peeled shrimp of the salad bar, we decided a hasty, yet dignified retreat was in order.

I imagine our camp breakup could go on record as one of the fastest, with the sound of whatever it was still in our ears. We hit the trail at 10:45 P.M., unevenly loaded but completely packed. We exhausted our repertoire of everything from Jimi Hendrix to show tunes on the way out, worried now about surprising a porcupine. We arrived back at Beaver Creek at 1:23 A.M., intact but for our toes, which complained about the sleeping socks and longed for the hiking socks. We later discovered that a black bear had been pepper sprayed at close range in the camp just ten days earlier, and the region was closed for a while later that summer due to a few close encounters. Toes aside, we felt we had made a good decision.

I was pleased to have determined with unusual ease exactly where MacDonald's photographer had been while capturing his view of Jacques Lake. He was in the meadow in front of the warden's cabin, not in the bears' salad bar.

TRAIL INFO

Trail information: Jacques Lake

Type of trip: Overnight backpack or long day hike/mountain bike

Trailhead: At Beaver Creek picnic area

How to get there: From Jasper townsite, take the east exit out of town and go left (north) at the interchange. You are now on the Yellowhead Highway (16). Follow the Yellowhead for 1.7 km until you reach the Maligne Lake Road junction. Turn right and cross the river on a bridge. The road forks just after the bridge. Go left at the fork towards Maligne Lake. The Beaver Creek picnic area parking lot is just past Medicine Lake at 28.0 km. Allow 25 minutes for the drive.

Distance: 12.2 km

Elevation gain: None

Degree of difficulty: Easy

Hiking time: Allow a full day to go in and out, or you can camp overnight and explore the Merlin Pass and the South Boundary Trails

Route: Begin at the Beaver Creek picnic area, at the south end of Medicine Lake. The first 4.6 km of the trail follow an old fire road, and are easy walking. You will pass Beaver Lake at 1.6 km, and reach the first of the two Summit Lakes at 4.8 km. In 1999, the trail along the lakeshore here was completely flooded with crystal clear water, through which we could see not only the trail, but the submerged flower heads of wild onions, which must have bloomed before the late runoff caught them by surprise. This species, which grows about 25 cm high, would have been tough for the bees to reach that year. The second Summit Lake is at 6 km, and there are two more small, unnamed lakes before you reach Jacques Lake itself, at 12.2 km. The path is often muddy throughout its length, and with increased mountain bike use, many tree roots have been exposed. Still, these roots should only give you trouble if you are hiking fast, in the dark, with a poorly stuffed pack and your wrong socks on.

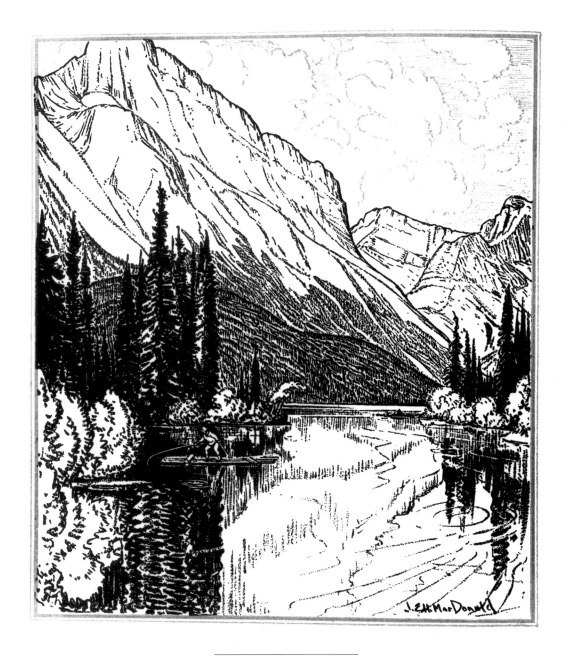

J. E. H. MacDonald
Jacques Lake, 1927
reproduction of an engraving on paper
Glenbow Collection

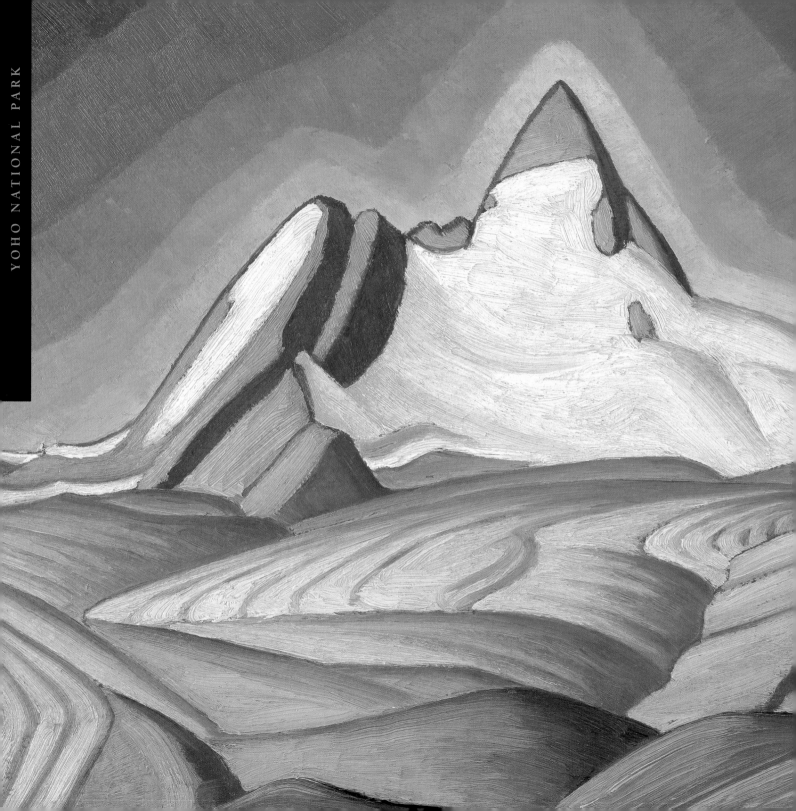

"THE TRUTH IS THAT WORKS OF ART TEST THE SPECTATOR

MUCH MORE THAN THE SPECTATOR TESTS THEM."

—Lawren Harris in *Modern Art and its Aesthetic Reactions*, 1927

Lawren Harris
Isolation Peak, c. 1929
oil on panel
Private Collection

Yoho National Park

Yoho National Park is the setting for many of the most precious gems of the Canadian Rockies. From the Burgess Shale Fossil Beds, a truly remarkable World Heritage Site, to the visual delights of Lake O'Hara, Yoho's wonders are many.

Yoho National Park has a long history of attracting artists. Frederick M. Bell-Smith painted in Yoho as early as 1887. Lucius O'Brien, Thomas Mower Martin, and Marmaduke Matthews all painted along the railway lines and travelled through what is now Yoho National Park during their association with the Canadian Pacific Railway near the turn of the 20th century. In the 1920s and '30s, Walter Phillips, who painted so many regions of the Rocky Mountains, worked at Lake O'Hara, Twin Falls, Emerald Lake, and in the Yoho Valley. A. C. Leighton, J. E. H. MacDonald, Peter and Catharine Whyte, and numerous artists since have also been attracted to the beauty of Yoho.

Perhaps the most famous work, certainly one that has had immeasurable impact as a "calling card" for Yoho, is American painter John Singer Sargent's depiction of Lake O'Hara (see *A Hiker's Guide to Art of the Canadian Rockies*, pp. 64–65). This iridescent canvas first exposed affluent eastern Americans to the wild beauty of Canada's parks when it was hung in the gallery of Cambridge's Fogg Art Museum in 1916. A steady line of Massachusetts and New England-based visitors have been returning to Lake O'Hara for generations, enjoying the comfort of the luxurious hotels, lodges, and teahouses that the Canadian Pacific Railway built to accommodate them.

Yoho National Park covers a region of 1,313 square kilometres of British Columbia Rockies. There are over 350 kilometres of trails, ranging in setting from the desolate beauty of The Iceline to the cedar forests of Mount Burgess.

Lawren Harris, Bess Harris, and A.Y. Jackson in the Rockies, 1940s

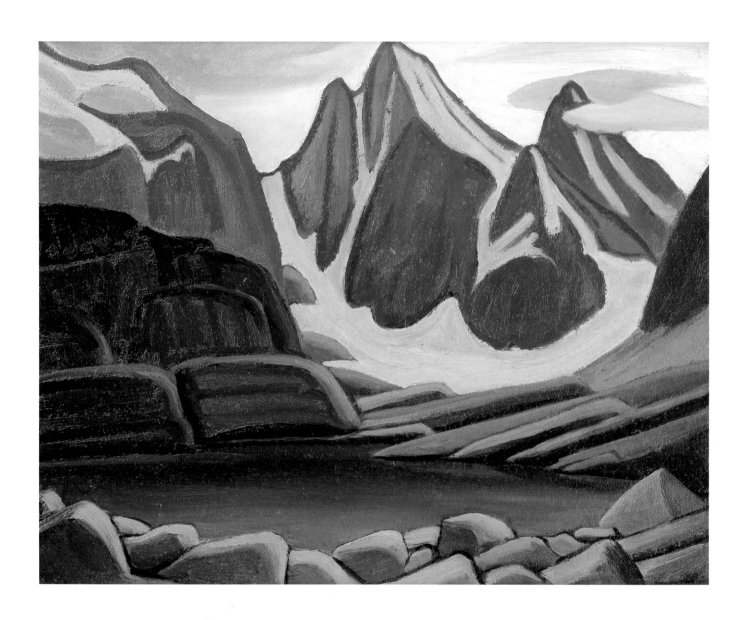

Lawren Harris
Mountain Sketch XXXII, undated
oil on panel
Private Collection

> "... I WENT FOUR YEARS VIA OTTAWA TO LAKE
> LOUISE, MORAINE LAKE, AND YOHO ..."
>
> —Lawren Harris in *Lawren Harris*, 1969

LAKE O'HARA

LEFROY LAKE

In the years following the Jasper trip, Lawren Harris visited other regions of the Canadian Rockies to sketch. He travelled to these destinations both on his own and as a part of family vacations. News of Lake O'Hara's reputation of unparalleled scenery reached him early on, and he registered at the newly opened Lake O'Hara Lodge on 17 July 1926.[75] He would visit again two years later on 16 July 1928.[76] A popular destination for artists since the turn of the century, Lake O'Hara's many beautiful views have been captured in print and paint by artists F. M. Bell-Smith, Walter J. Phillips, John Singer Sargent, Arthur Lismer, and Jock Macdonald. The easily accessed and picturesque lakes, numerous trails, and panoramic vistas are addictive. Lake O'Hara has a reputation for being impossible to visit just once. J. E. H. MacDonald, Harris's fellow Group of Seven colleague, would develop a singular fascination with the region, returning for annual autumn visits over a seven-year span. Although they twice visited Lake O'Hara in the same year, Harris and MacDonald's visits did not overlap; Harris came in July, MacDonald in September, and they did not paint together at O'Hara.

In *Mountain Sketch XXXII*, the areas of blue and white read cleanly against one another in the snow chutes that circle the bottom edge of Ringrose Peak. The scene looks southwest across Lefroy Lake and up towards Ringrose Peak. The north edge of Hungabee Mountain's sharp peak shows over the edge of Yukness Mountain. Lake Oesa nests just over and above the ridge of mossy dark rocks that form the far shore of the lake. Harris has eliminated the forest that stands here, but captured exactly the colour of the sun hitting the buff-toned scree slope on the slight edge of Yukness Mountain. This view of Ringrose had a particular appeal to painters; J. E. H. MacDonald, Walter Phillips, and Peter and Catharine Whyte all painted here.

TRAIL INFO

Trail information: Opabin Plateau to Lefroy Lake
Type of hike: Half-day hike
Trailhead: Opabin Plateau to Lefroy Lake
How to get there: From Lake Louise village, follow the Trans-Canada Highway heading west towards Field. The Great Divide Road junction is at 9.7 km. Turn left onto this road. You will cross railway tracks 0.2 km past the junction; turn right after the tracks into the parking lot for Lake O'Hara. From here, you must either walk in on the 11-km road or take the shuttle bus. Make arrangements to take the shuttle bus through the Yoho Visitor Centre.
Distance: About 13 km (with many options)
Elevation gain: About 340 m
Degree of difficulty: Easy to moderate, with side options of greater difficulty
Hiking time: 3 hours
Route: Follow the Adeline Link Memorial Trail around Lake O'Hara in a counterclockwise direction, heading right as you leave the lodge. There are two routes (west and east) up to Opabin Plateau. You will reach the west junction first; from there it is 3.1 km to the plateau. The east junction is at 0.6 km; from there it is also about 3.1 km to the plateau.

From Schäffer Lake, take the All Soul's Trail at the junction at 1.8 km, and climb to All Soul's Prospect at 2.9 km. From here, you can hike across to the Opabin Terrace pools and Opabin Plateau, a total of about 4 km. You can also add a trip from Schäffer Lake to the Opabin trails via the Big Larches Trail to either the West or East Opabin Trail and up to the Plateau.

Once you reach Opabin Plateau, look north and west across the Lake O'Hara valley to see Harris's vistas. This is a delightful place; tread softly and keep to the trails. After exploring the plateau, walk to the north shore of Hungabee Lake, and connect with the Yukness Ledge trail to reach Lake Oesa in 3.3 km. Watch carefully for the blue markers painted on the rocks. It is easy to lose your way up here. The views are magnificent and the trail is amazing, but should not be attempted in poor weather. Lefroy Lake is just below Lake Oesa, and you can take the Oesa Trail back to Lake O'Hara, a distance of about 5 km, and then go either way around the lakeshore trail to return to Le Relais. Harris's scene looks southwest across Lefroy Lake and up towards Ringrose Peak.

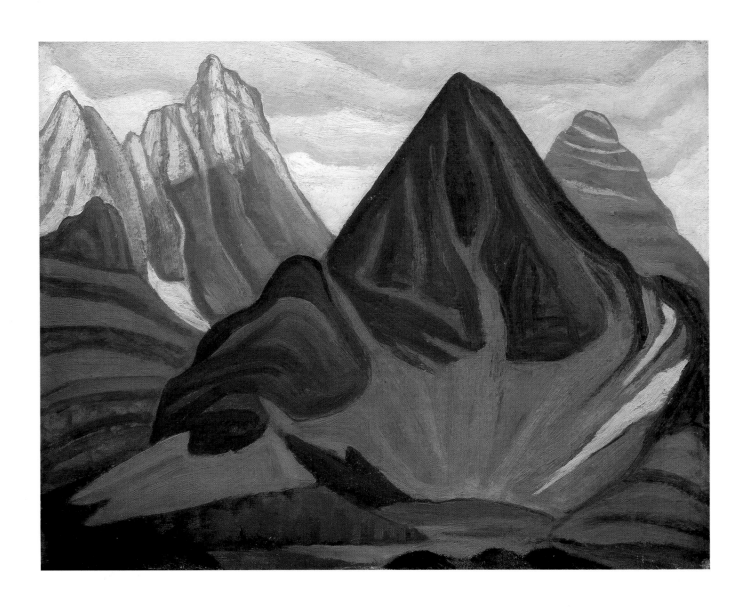

Lawren Harris
Mountain Sketch XLVI, undated
oil on board
Courtesy A. K. Prakash

SCHÄFFER LAKE

Harris's works from this picturesque region at Lake O'Hara begin his stylistic move away from concern with topographical representation and towards abstraction. Although *Mountain Sketch XLVI* is very much an on-the-spot type of work and looks very much like the place it depicts, it also begins to chart Harris's stylization of his mountain subjects. This little composition differs from the tight vistas of 1924. Rough brushwork and "blasted pine" give way to smooth upthrust and a sense of distance.

The scene is set from the Odaray Grandview Trail in the Lake O'Hara region of Yoho National Park. On the left-most edge of the work, the distant slopes of Mounts Ringrose and Hungabee are dusted with fresh snow. Mount Schäffer occupies most of the space in the middle ground of the composition, and Schäffer Lake can be seen below. The peak of Mount Biddle shows over Mount Schäffer's shoulder on the right side of the work, and Biddle Pass runs off the edge of the scene. There are two versions of this scene (see p. iv) that differ only very slightly. These may demonstrate Harris's interest in reworking the same subject, or be indicative of his ability to work up additional paintings "on demand."

The billowing cloud formations hint at the direction Harris's skies would later take, and are more suggestive of a divine presence than any impending weather. They, too, contribute to the feelings of distance and weightlessness that start to show in comparable works.

Around this time, Harris's mountain scenes begin to have an elevated feel to them. By this I mean elevated in a literal sense, as if the perspective Harris used is from above the ground—not an eagle's eye view, but more of a giraffe's eye view, as if set from a levitating viewpoint. As well, the works begin to show incongruities in distance relationships within the setting. Mountains painted from close range appear to be far away. Distant mountains seem even farther away.

TRAIL INFO

Trail information: Schäffer Lake and Odaray Prospect
Type of hike: Half-day hike. You can easily combine this hike with others at Lake O'Hara to explore the region more fully.
Trailhead: The Schäffer Lake Trail, just behind the Le Relais day shelter at Lake O'Hara
How to get there: From Lake Louise village, follow the Trans-Canada Highway heading west towards Field. The Great Divide Road junction is at 9.7 km. Turn left onto this road. You will cross railway tracks 0.2 km past the junction; turn right after the tracks into the parking lot for Lake O'Hara. From here, either walk in on the 11-km road or take the shuttle bus (make arrangements through the Yoho Visitor Centre).
Distance: 4.1 km
Elevation gain: 500 m
Degree of difficulty: Easy
Hiking time: 2 hours
Route: Begin at the Le Relais day shelter. Follow the trail to the Alpine Meadow and the Elizabeth Parker Hut, the site of the old Lake O'Hara Camp at 0.7 km. Continue past the camp, and follow the trail to Schäffer Lake at 1.7 km.

This is the little lake you will see from up above in Harris's *Mountain Sketch XLVI.* Take the McArthur Pass Trail through the forest, which is strewn with larches and delightful in the fall. Just before McArthur Pass at 2.5 km, take a right turn onto the Odaray Highline Trail. After you begin to climb, look back over your right shoulder to the Goodsirs. The view to the southeast matches the vista depicted in *Mountain Sketch XLVI.* You can stop at the Odaray Highline junction with the Grandview Trail (4.0 km) or continue along to the Grandview, which is another kilometre or so straight up. The view is well worth the effort.

Note: Many of the trails in the Linda and Morning Glory Lakes region, the Odaray Plateau, and the vicinity of McArthur Pass have been closed in recent years to leave grizzly bear habitats undisturbed. A Parks Canada warden will meet hikers taking the bus in, and explain current conditions. You can also check the posted maps at the Le Relais day shelter, just down the road from the lodge, before you head out. Please observe trail closures fully.

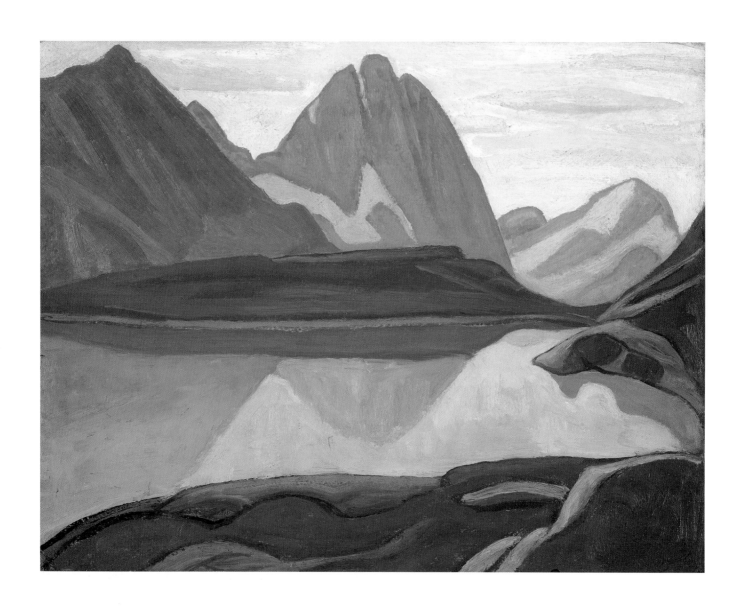

Lawren Harris
From Opabin Pass, Rocky Mountains, c. 1924
oil on beaverboard
National Gallery of Canada

"THE PRIMARY FUNCTION OF ART IS NOT TO IMITATE OR REPRESENT OR INTERPRET, BUT TO CREATE A LIVING THING; IT IS THE REDUCTION OF ALL LIFE TO A PERFECTLY COMPOSED AND DYNAMIC MINIATURE— A MICROCOSM WHERE THERE IS PERFECT BALANCE OF EMOTION AND INTELLECT, STRESS AND STRAIN RESOLVING ITSELF, FORM RHYTHMICALLY POISED IN THREE DIMENSIONS. SO LONG AS PAINTING DEALS WITH OBJECTIVE NATURE, IT IS AN IMPURE ART, FOR RECOGNIZABILITY PRECLUDES THE HIGHEST AESTHETIC EMOTION. ALL PAINTING, ANCIENT OR MODERN, MOVES US AESTHETICALLY ONLY IN SO FAR AS IT POSSESSES A FORCE OVER AND BEYOND ITS ASPECT."

—Lawren Harris in *Lawren Harris*, 1969

OPABIN PLATEAU

As Harris's works became more and more unfettered by the realities of topographical accuracy, the atmospheric conditions depicted in his works also took on unreal qualities. In *From Opabin Pass, Rocky Mountains*, a sense of ethereal weightlessness is keenly demonstrated. The view in this hazy, soft work looks out across Opabin Plateau from the southwest shore of the lower Opabin Moor Lake, midway along the shoreline. In the distance, the hump of Odaray Mountain takes centre stage, while the northern scree slope of Mount Schäffer, darker and reflected in the waters of the small lake, repeats the triangular rhythms of the horizon. Mount Stephen rolls off to the right. Viewing the scene in this work, I feel as if I am sitting on the edge of a precarious cliff, feet dangling into the air below, somewhat tempted by the urge to leap. Harris has captured the elation of elevation in this work, and one experiences a sense of being free from the physical laws of gravity and earthly constraints.

TRAIL INFO

Trail information: Opabin Plateau via the West Opabin Trail
Type of hike: Half-day hike
Trailhead: On the Lake O'Hara shoreline, about 0.3 km beyond the lodge
How to get there: From Lake Louise village, follow the Trans-Canada Highway heading west towards Field. The Great Divide Road junction is at 9.7 km. Turn left onto this road. You will cross railway tracks 0.2 km past the junction; turn right after the tracks into the parking lot for Lake O'Hara. From here, you must either walk in on the 11-km road or take the shuttle bus. Make arrangements to take the shuttle bus through the Yoho Visitor Centre.
Distance: 3.4 km
Elevation gain: 280 m
Degree of difficulty: Moderate
Hiking time: 3 hours
Route: Follow the Adeline Link Memorial Trail around Lake O'Hara in a counterclockwise direction, heading right as you leave the lodge. There are two routes (west and east) up to Opabin Plateau. You will reach the fork to the western route first; from there it is 3.1 km to the plateau. The fork to the eastern route is at 0.6 km, and from there it is also about 3.1 km to the plateau. The western trail is more spectacular but slightly tougher, as it climbs the side of a sheer cliff. Lovely views back towards Cathedral Mountain over Mary Lake encourage frequent rest stops.

You will pass the All Soul's junction at 1.7 km; continue straight through. At 2 km the climbing ends and you will reach Opabin Prospect. There are a number of unnamed ponds up on this magical little plateau, artistically set among the larches and wildflowers. Once you reach Opabin Plateau, look north and west across the Lake O'Hara valley; you will easily see Harris's vistas. This is a delightful place. Tread softly and keep to the trails; there are many to choose from. Once you reach Opabin Lake at 3.4 km, you are well placed to connect with other hiking trails, or you can return via the East Opabin Trail to Lake O'Hara proper.

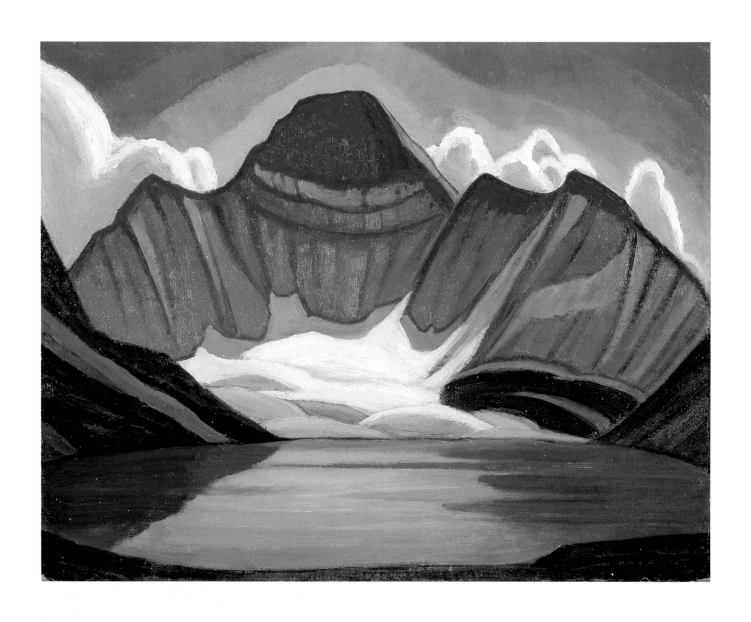

Lawren Harris
Lake McArthur, Rocky Mountains, c. 1920s
oil on plywood
Winnipeg Art Gallery

"IT IS THE PECULIAR QUALITY OF LAWREN HARRIS'S PAINTING THAT IT IS PARTLY AN ACT OF WILL. HE DOES NOT SURRENDER TO NATURE AND LET IT GROW ORGANICALLY THROUGH HIS MIND INTO ART; HE HAS A STRONGLY INTELLECTUAL MIND WHICH IMPOSES PICTORIAL FORM ON NATURE."

—Northrop Frye in *The Pursuit of Form*, 1948

LAKE MCARTHUR

Virtually every artist visiting Lake O'Hara has painted a classic view of Lake McArthur, and Lawren Harris is no exception. Set from the northern shore of the lake, his version of the scene looks out across Lake McArthur's brilliant blue waters and opens up into an expansive view of Mount Biddle. Lake McArthur's incredible blue colour is breathtaking. A true cerulean, robin's egg blue, its colour is unique among mountain lakes at this altitude. J. E. H. MacDonald, in one of his many published poems, called it *"rainbow green or mermaid's eyes."* Set against the snow of Biddle Glacier, Harris's Lake McArthur sparkles. The halo effects in the sky, auralike formations that run in parallel ribbons along the contours of Biddle's uppermost ridge, resonate with the upward motion of the brushwork on the mountain's face. It is a vibrant work depicting an enchanting lake.

Despite heavy traffic on the trails, magical Lake McArthur is a good wildlife-spotting place. Its rocky shores are home to a large colony of hoary marmots that can often be seen lazing about and sunning themselves around the lake. I have seen golden eagles soaring here on several occasions, once met a mother and baby mountain goat on the trail out, and watched a wolverine crossing the lower slopes of Park Mountain in 1998.

TRAIL INFO

Trail information: Lake McArthur
Type of hike: Half-day hike
Trailhead: Lake McArthur via the High Level Cutoff
How to get there: From Lake Louise village, follow the Trans-Canada Highway heading west towards Field. The Great Divide Road junction is at 9.7 km. Turn left onto this road. You will cross railway tracks 0.2 km past the junction; turn right after the tracks into the parking lot for Lake O'Hara. From here, you must either walk in on the 11-km road or take the shuttle bus. Make arrangements to take the shuttle bus through the Yoho Visitor Centre.
Distance: 3.6 km
Elevation gain: 340 m
Degree of difficulty: Moderate
Hiking time: Allow 3 hours
Route: Begin at the Le Relais day shelter. Follow the trail to the Alpine Meadow and the Elizabeth Parker Hut, the site of the old Lake O'Hara Camp at 0.7 km. Continue past the camp, and follow the trail to Schäffer Lake at 1.7 km. This is the little lake in Harris's *Mountain Sketch XLVI* seen up close. Harris's view is painted from a short distance up the Odaray Highline Trail. To reach this location, continue along the trail after crossing the Schäffer Creek bridge, head left at the junction, and follow the lakeshore for about 50 m. You will begin to climb as soon as you leave the lakeshore, ascending through a beautiful forest of larches. The junction with the Odaray Highline Trail is found at 2.5 km. Continue straight through and begin climbing along the north flank of Mount Schäffer. You will reach Lake McArthur in 1 km. Return the same way.

Note: Some of the trails in the vicinity of McArthur Pass have been closed in recent years to leave grizzly bear habitats undisturbed. Please observe trail closures fully.

"In all our camping and sketching trips we explored each region for those particular areas where the form and the character and spirit reached its summation. In those areas the character is most pronounced—the form most opulent or austere—the spirit most pervasive. We became increasingly aware that—while the artist must select his subject, determine how it is to go within the four sides of his canvas or sketch, decide what he must eliminate and what he should emphasize and how he should reorganize the various factors in order to make it a unity of expression—yet he must not impose some preconceived or borrowed idea upon it because that acts as a barrier between him and nature.

—Lawren Harris in a talk given at the Vancouver
 Art Gallery, 1954

GOODSIR PEAKS

Harris must have explored the McArthur Creek Trail to the Ottertail Valley to paint his view of the Goodsirs. Today, we have to content ourselves with approximating his scene of the Goodsir towers from the Odaray Highline, as access via McArthur Creek to the Ottertail is closed. Harris's view in this work looks south over McArthur Pass to the 3,562-metre northeast face of this striking peak, composed of McKay shale. This is the best view of the Goodsirs from Lake O'Hara.

Harris has included a small portion of the west flank of Park Mountain on the left side of the painting, a compositional device that figures in many of his "middle" mountain works. The structural elements of the mountain's features in *Goodsir Peaks, Rocky Mountains*, have been painted with a cartographer's eye. Each division of surface—snow to ice, scree to rock, water to shoreline—is sharply defined, often with the thin edge of contrasting under-painted colour showing, as if to mark a boundary between the two areas.

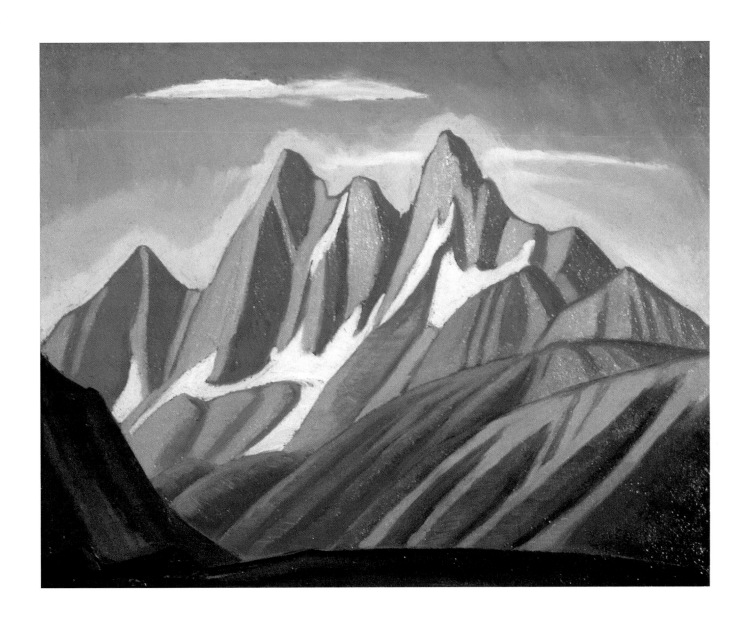

Lawren Harris
Goodsir Peaks, Rocky Mountains, undated
oil on board
Art Gallery of Hamilton

Trail information: The Lake O'Hara Harris Circuit

Type of hike: Full-day or two-day hike using the Lake O'Hara facilities as a base

Trailhead: Two loops have been outlined to take you to all five of the works by Harris illustrated here. Loop 1 covers Odaray Prospect to Lake McArthur. Loop 2 covers Opabin Plateau to Lefroy Lake. There are so many interconnecting trails at Lake O'Hara, the best way to see the region is to get a current map and just explore. If you include Opabin Plateau, Lake McArthur, and the Odaray Highline in your itinerary, you will see all of Harris's vistas in the area.

How to get there: From Lake Louise village, follow the Trans-Canada Highway heading west towards Field. The Great Divide Road junction is at 9.7 km. Turn left onto this road. You will cross railway tracks 0.2 km past the junction; turn right after the tracks into the parking lot for Lake O'Hara. From here, you must either walk in on the 11-km road or take the shuttle bus. Make arrangements to take the shuttle bus through the Yoho Visitor Centre.

Distance: Loop 1, about 5 km (with many options); Loop 2, about 13 km (with many options)

Elevation gain: Loop 1, about 395 m; Loop 2, about 340 m

Degree of difficulty: Easy to moderate, with side options of greater difficulty

Hiking time: You can complete both loops in one long day if you are energetic, or add a few side trips and take two days

Route: For Loop 1, begin at the Le Relais day shelter. Follow the trail to the Alpine Meadow and the Elizabeth Parker Hut, the site of the old Lake O'Hara Camp at 0.7 km. This region sees heavy foot traffic, and in past years many of the fragile meadows in the area have suffered. Thanks to the work of the Lake O'Hara Trails Club, most of this region has begun to rejuvenate. Continue past the camp, and follow the trail to Schäffer Lake at 1.7 km. This is the little lake you will see from above in Harris's *Mountain Sketch XLVI*. There are a number of side trip options from here, including the Big Larches Trail. Take the McArthur Pass Trail through the forest, which is also strewn with larches and delightful in the fall. Just before McArthur Pass at 2.5 km, go right along the Odaray Highline Trail. After you begin to climb, look behind you to the distant Goodsirs. The view to the southeast approximates the vista depicted in *Mountain Sketch XLVI*. You can stop at Odaray Highline junction with the Grandview Trail (4.0 km) or continue on to the Grandview, which is another kilometre or so straight up. The view is well worth the effort. Return along this same trail to the McArthur Pass junction. This time, turn left at the MacArthur Pass

junction (the lower McArthur Trail is presently closed) and begin to climb along the north flank of Mount Schäffer. You will reach Lake McArthur in 1 km. Return the same way. To link up with Loop 2, watch for the Big Larches junction near Schäffer Lake.

For Loop 2, follow the Adeline Link Memorial Trail around Lake O'Hara in a counterclockwise direction, heading right as you leave the lodge. There are two routes (west and east) up to Opabin Plateau. You will reach the west junction first; from there it is 3.1 km to the plateau. The east junction is at 0.6 km; from there it is also about 3.1 km to the plateau.

If you have already completed Loop 1, take the Big Larches Trail junction at Schäffer Lake to Mary Lake and connect with the West Opabin Trail. Or better yet, from Schäffer Lake, turn onto the All Soul's Trail at the junction at 1.8 km, take a deep breath and climb to the magnificent All Soul's Prospect at 2.9 km. From here, you can hike across to the Opabin Terrace pools and Opabin Plateau, a total of about 4 km. A more gentle ascent from Schäffer Lake can be had via the Big Larches Trail to either the west or east Opabin Trail up to the plateau. If the trail and you are in good shape, take the All Soul's Route; it is a grunt but magnificent.

Once you reach Opabin Plateau, look north and west across the Lake O'Hara valley; you will easily see Harris's vistas. This is a delightful place. Tread softly and keep to the trails; there are many to choose from. After you have explored the plateau, make your way to the north shore of Hungabee Lake. From here, connect with the Yukness Ledge Trail to reach Lake Oesa in 3.3 km. Watch carefully for the blue markers painted on the rocks. It is easy to lose your way up here. The views are magnificent and the trail is amazing, but should not be attempted in poor weather and without proper footwear. Lefroy Lake is just below Lake Oesa, and you can take the Oesa trail back to Lake O'Hara, a distance of about 5 km; then go either way around the lakeshore trail to return to Le Relais.

Note: Many of the trails in the Linda and Morning Glory Lakes region, the Odaray Plateau, and the vicinity of McArthur Pass have been closed in recent years to leave grizzly bear habitats undisturbed. A Parks Canada warden will usually meet hikers taking the bus in and explain current conditions. You can also check the posted maps at the Le Relais day shelter, just down the road from the lodge, before you head out. Please observe trail closures fully.

Lawren Harris cooking lunch with unidentified companion at Odaray Prospect, Lake O'Hara, 1940s

"HE SEEMS TO HAVE BELIEVED, LIKE MANY A MYSTIC BEFORE HIM, THAT THE MOUNTAINS BY THEIR PHYSICAL HEIGHT TOOK HIM CLOSER TO A SENSE OF ETERNITY. AS A GOOD THEOSOPHIST HE PRACTISED A PHILOSOPHY OF PERSISTENT UPWARD STRIVING, AND THE MOUNTAINS BECAME A KIND OF METAPHOR OF HIS QUEST. AS HE MOVED UP IN THE ROCKIES, UP FAR BEYOND THE TIMBERLINE, HARRIS WAS MOVING DEEPER INTO HIS OWN SENSE OF THE INFINITE."

—Joan Murray and Robert Fulford in *The Beginning of Vision*, 1982

MONT DES POILUS

The drawings, sketches, studies, and canvases that depict the mountain known in the art historical world as Isolation Peak provide a fascinating tool to study the development of Lawren Harris's style. Well known and well publicized in the art historical literature, they depict in a neat, orderly line, the transition from topographically accurate sketch to geometric stylization. The drawings illustrated here mark the beginning, and the oil *Isolation Peak*, along with the work titled *Isolation Peak, Rocky Mountains*, illustrated in *A Hiker's Guide to Art of the Canadian Rockies* (p. 91) mark the end of the line. A luminous and almost surreal work, *Isolation Peak*, c. 1929, is often discussed as being more cerebral than topographical. In reality, topography and iconography play an equal role, each being unattainable without truth to the other. The mountain in question is Mont des Poilus, at the head of Yoho National Park's Yoho Valley. A little-visited valley of ethereal, ancient, glacial air and almost otherworldly landscape, it is a short distance up the valley from the oft-visited region of Twin Falls.

In August of 1997, I hiked in along the Iceline Trail, during three days of torrential rain and heavy cloud. The Iceline is a magnificent trail hewn through glacial rubble and scree, which connects the Yoho Valley with the Little Yoho Valley. For some

TRAIL INFO

Trail information:
The Iceline Trail
Type of hike: Backcountry overnight hike
Trailhead: Takakkaw Falls parking lot
How to get there: From Lake Louise village, follow the Trans-Canada Highway heading west towards Field. After you descend the Big Hill, turn right onto the signed Yoho Valley Road at 22.3 km. Follow this switchbacking road up the scenic Yoho Valley. Watch out for long vehicles negotiating the turns; they sometimes have to back up once or twice to make it around the corners. The trailhead is at the Whiskey Jack Hostel at 12 km, but you have to park at Twin Falls at 13 km and walk back to the trailhead.
Distance:
22 km with various side options
Elevation gain: 625 m
Degree of difficulty:
Moderate to difficult
Hiking time: Allow 2–3 days
Route: There are several options in and out of the Yoho Valley and Little Yoho Valley; you should include an up-to-date map in your gear for this trip, as the trails have changed in recent years, and some are now closed. Begin your hike at the Whiskey Jack Hostel, which is a converted 1922 CPR bungalow, relocated out from under the nearby avalanche slopes. The trail heads up, almost straight up in places, directly behind the hostel. You will switchback up the avalanche slopes heading south through a birder's forest of Engelmann spruce. The Lower Iceline Trail, at 1.9 km, takes you up and above two older, now-closed trails. These are the Highline Trail, at 3 km, and the old Skyline Trail, at 8.5 km. Please allow the delicate meadows in those regions to rejuvenate. The newer (1987) Iceline Trail has been built in the spirit of Lawrence Grassi, the man responsible for the extraordinary trails at Lake O'Hara. There is excellent footing all the way. The Iceline Trail is an amazing route through a fantastic region. The nearby Emerald Glacier began receding at the end of the little ice age—only some one hundred years ago. This area is a glaciologist's dream, with etchings of glacial ice on bedrock running everywhere underfoot. Continue on the Iceline Trail until you reach the Upper Iceline junction at 3.4 km. From here you can carry on along the Upper Iceline Trail →

Lawren Harris
Isolated Peak, c. 1929
graphite on wove paper
National Gallery of Canada

five kilometres, the trail parallels the toe of the Emerald Glacier. For most of my trip, the sights were obscured by heavy cloud, and everything, including our little group, was dripping with rain. Although perhaps not to everyone's liking (including mine at the time) this wet, grey trip brought me closer to what I consider Lawren Harris's mind-set to have been when he was there, than months in the sunshine ever could. In the rain, the thundering of Takakkaw Falls across the valley recalled to mind Belmore Browne, Walter Phillips, Peter Whyte, and other artists who had painted there in the 1920s, '30s, and '40s. The Emerald Glacier, hidden in misty cloud, was not visible, but very present—a huge body of 100-year-old ice, so close at hand, it had a physical effect on me. It was like a person standing behind me, not seen but very much felt, breathing cold, wet breath all around.

The second day, which took our group from Twin Falls Chalet to the Whaleback, began again in rain. The short hike through the ancient forest of Engelmann spruce took us up and beyond the 180-metre limestone cliff over which the spectacular Twin Falls cascade, and on into the Waterfall Valley. Whaleback Mountain is to the southwest, and Isolated Peak, which is not the peak Harris used as his subject, is to the west. As we continued up the valley, the rain grew lighter and finally stopped. Sunshine began to break through the clouds, and as we neared the toe of Glacier des Poilus, the sky began to clear.

It was a profound experience for me, to see this massive peak, which I had looked at as a painting for years, under such conditions. The physical strain of the hike, with my mind focused on Harris, recalling his writings as I walked, combined with the expectation of seeing only clouds, and then the sudden elation of the sky clearing, was all quite moving. I felt that Harris's responses to the mountains were also affected by such experiences. Admittedly emotional and perhaps even bordering on spiritual, these are the intangible treasures of our Rockies, personal responses that vary with the personalities of each visitor.

For Harris, a receptive and seeking soul, such conditions and vistas would have left lasting impressions on his mind's eye. They would have satisfied his philosophical explorations and furthered his quest to convey theosophical principles through his art. I would argue again that the experiences Harris had are as important to the success of the resulting artworks as are the formal elements of composition, colour, and form. Each relies

TRAIL INFO

into the Little Yoho Valley. You will cross a bridge at 11 km, and the Little Yoho campground is at 11.2 km. To reconnect with the Iceline Trail, follow the same route out from the Little Yoho campground, or head back down the Little Yoho Valley Trail to the Yoho Valley, a total added distance of about 9 km, but a nice diversion and a good campground to use for a night. You can also omit the Little Yoho Valley from your trip, and instead head straight to Twin Falls and the Waterfall Valley. On the Iceline Trail, watch for the Celeste Lake trail sign at 6.1 km. Head northeast here on the Celeste Lake Trail. You will pass Celeste Lake and connect with the Little Yoho Valley Trail at 10.6 km. The Whaleback junction is a few hundred metres up the trail. Once on the Whaleback Trail, you will reach Twin Falls at 14.2 km. The rustic Twin Falls Chalet was used as a base by many painters, including Peter and Catharine

Whyte, Carl Rungius, and Walter Phillips. The scenic view of Twin Falls from the front steps is without equal for waterfall vistas. There are two campgrounds nearby; Twin Falls campground is 1.5 km down the Yoho Valley Trail, and Whaleback campground is 3 km up the Whaleback Trail. Use either of these as a base.

To reach the Waterfall Valley and your end destination—Harris's view of Mont des Poilus—continue on the Twin Falls Trail up past the falls, and turn at the junction just before the suspension bridge. There is a great lookout over the falls, but watch your footing. The trail can be precarious in places. You will reach the Waterfall Valley in less than 3 km. This trail reaches an elevation of 2,073 metres and is often still snowbound in July. Mont des Poilus is dead ahead, a distant triangle jutting up above the river of ice that Harris has depicted in *Isolation Peak*, c. 1929.

upon the other to achieve a common goal. The most successful works depict the most unique places. The painting *Isolation Peak* represents both the physicality of the place and the presence of the place, with all of its intangible, emotive, indefinable qualities.

Lawren Harris
Isolation Peak, 1928
pencil on paper
Dalhousie Art Gallery

"... Here you get the ten dollar view: the scene of Mount Burgess and Emerald Lake was engraved on the back of the old ten dollar bill. The currency has changed and it won't buy what it used to, but the view is unspoiled—and beyond price."

—Don Beers in *The Wonder of Yoho*, 1989

Emerald Lake

A tranquil, but often busy spot in the Canadian Rockies, Emerald Lake, by virtue of its very name, calls to mind everything that is beautiful in the Rockies. It is a vividly coloured lake, often in shades of a true emerald green. It has been attracting artists since outfitter Tom Wilson's thirsty horses (who had been there before—likely with the Stoney) discovered it in 1882.

The panel of *Emerald Lake* is another example of Harris's ability to view his scene from a viewpoint that seems to originate above the ground. A softly handled work, it has much in common with *From Opabin Pass, Rocky Mountains*. Hazy and tranquil, the work may indicate atmospheric conditions remarked upon by another painter—J. E. H. MacDonald—who painted at Lake O'Hara in the 1920s. MacDonald complained in his letters from Lake O'Hara that the view was obscured by the smoke from forest fires and dust in the air. The dirty thirties were just around the corner, and dry con-

ditions added to the haze. MacDonald's Lake O'Hara scenes are records of these atmospheric conditions; in very general terms, their palette has an overall greyish tone, and the line of definition between different features in the scene, rock and sky, lake and shoreline, is indistinct and blurred.

Harris's hazy treatment of the air at Emerald Lake is quite effective, regardless of the reason behind it. It has the quality of a humid, steamy forest scene, where the edges of the lake, forest, and peaks are blurred by a classic movie camera lens.

TRAIL INFO

Trail information: Emerald Lake
Type of hike: Half-day hike
Trailhead: The Emerald Lake parking lot
How to get there: From Field, follow the Trans-Canada Highway northwest for 1.6 km. Turn right onto the Emerald Lake Road. Follow the road until you reach the parking lot and Emerald Lake at 9.2 km. Allow 10 minutes for the drive.
Distance: 5 km
Elevation gain: 10 m
Degree of difficulty: Very easy
Hiking time: Allow 1.5 hours
Route: A quiet stroll around the shores of Emerald Lake is almost guaranteed to provide an opportunity to view wildlife. A moose frequents the lakeshore here, and birds seem to be as attracted to the lake as visitors are. Hike in a clockwise direction around the lake, using the lower pedestrian trail. You will soon cross an avalanche slope carpeted with wildflowers. Just past the avalanche slope is the location of the view on the old ten-dollar bill. At the junction, there is a northbound trail that leads to the Emerald Basin and Yoho Pass Trails at 1.4 km. Stay east (right along the lake). There are a number of horse gates along this section of the trail, and the trail divides farther uphill for horse traffic. At 3.9 km, the trails rejoin near the junction with the Burgess Pass Trail. Continue back along the lakeshore to return to the parking lot at 5 km.

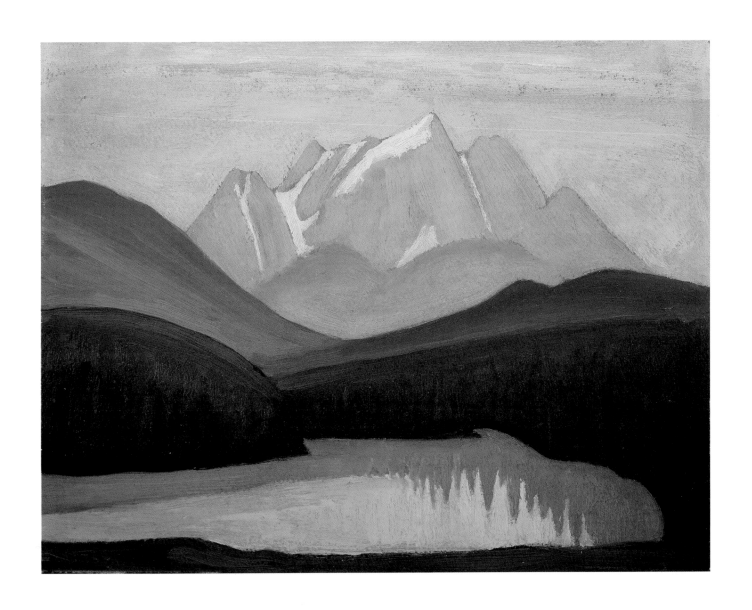

Lawren Harris
Emerald Lake, c. 1924
oil on panel
McMichael Canadian Art Collection

"WHAT IS MOST INTERESTING IN THESE PICTURES, PERHAPS, IS THE EVIDENCE OF THE STRAIN AND EFFORT OF WILL BY WHICH THEIR DECEPTIVE SEREN-ITY IS ACHIEVED. IN THE GAUNTNESS OF THE DEAD TREES, THE STARING INHUMANITY OF THE LONELY MOUNTAIN PEAKS, IN THE LOWERING MISTS ALONG THE SKY-LINE AND THE BROODING CONFUSIONS OF COLOUR IN THE FOREGROUND, ONE CAN SEE WHAT COLERIDGE MEANT WHEN HE SPOKE OF THE POET AS THE TAMER OF CHAOS."

—Northrop Frye in *Canadian Art*, 1948

The small oil *Above Emerald Lake* is interesting because it devotes only a very small portion of the panel to depicting the lake so famous for its beauty and often remarked upon for its size—it is the largest lake in Yoho National Park. Harris explored the region around the lake in this work and climbed the avalanche slopes on the northwest shore. This vista is based on a view from high above Emerald Lake, on the trail to Emerald Basin. The mountains of the Ottertail Range, with their distinctive glaciers, rise in the distance.

Clear in comparison to the *Emerald Lake* panel, the whites are whiter, the blues less grey. The foreground of the panel is in shadow, whereas the distant peaks are brilliant in the sun. The mountains are places of extreme contrast, of dazzling polarity of light and dark, offering the reward of a sparkling vista of distant peaks after trudging through heavy forest with no view. Harris has conveyed the sudden change from a forest-shaded trail to a brightly lit panorama, without being overly sentimental or trite. This is an inviting work, with the Ottertail Range calling you, and the small patch of turquoise water on the right only hinting at the size of Emerald Lake in the distance.

TRAIL INFO

Trail information: Emerald Basin and Emerald Lake
Type of hike: Half-day hike, or roadside view
Trailhead: The Emerald Lake parking lot
How to get there: From Field, follow the Trans-Canada Highway northwest for 1.6 km. Turn right onto the Emerald Lake Road. Follow the road until you reach the parking lot and Emerald Lake at 9.2 km. Allow 10 minutes for the drive.
Distance: 12.2 km
Elevation gain: 275 m
Degree of difficulty: Difficult
Hiking time: Allow 3 hours
Route: If you are planning a hike around the shores of Emerald Lake, you might as well make the effort to visit another of Harris's sketching locations, and hike the steep trail to Emerald Basin. Begin at the parking lot for Emerald Lake and hike in a clockwise direction around the lake, using the lower pedestrian trail. After you cross the avalanche slope and near the north end of the lake, watch for a trail leading left (north) from the lakeshore path. This trail intersects another trail coming up from the lake, which you can follow on the way out and then continue along the lakeshore circuit, if you wish. The forest fades here and the terrain becomes quite steep. You will reach Emerald Basin at 4.5 km. You can return the way you came, or continue back along the lakeshore as mentioned earlier, to return to the parking lot, for a total hiking distance of 12.2 km.

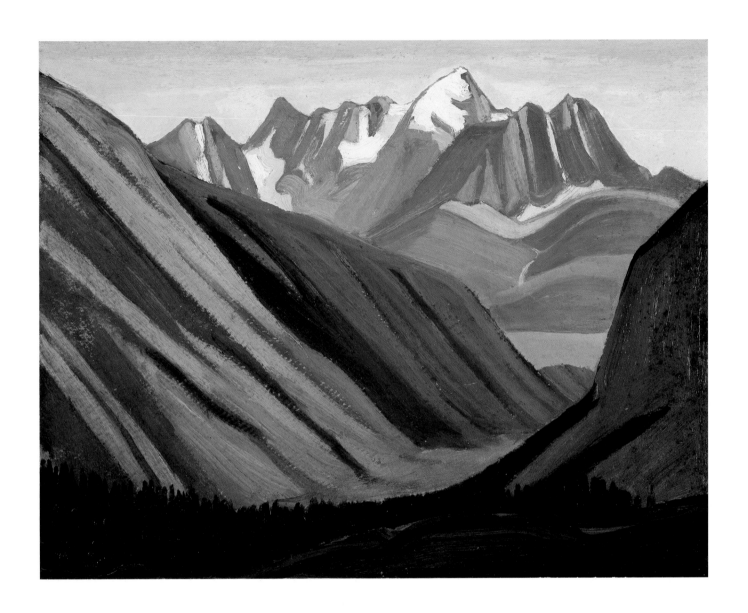

Lawren Harris
Above Emerald Lake, c. 1924
oil on panel
Private Collection

"LAKE LOUISE IS A WEB OF LAUGHTER,

THE OPAL DISTILLATION OF ALL

THE BUDS OF ALL THE SPRING."

—Rupert Brooke in *Letters from America*, 1916

Lawren Harris
Lake Agnes Above Lake Louise, Rocky Mountains, 1955
oil on board
London Regional Art and Historical Museums

Banff National Park

Banff National Park was established in 1885, making it Canada's oldest national park. It can also claim to be the most well-known national park internationally, attracting visitors from around the world. In addition, it seems to be the testing ground for Canada's park policies, and as such is an area of much contention.

Banff boasts over 1,500 kilometres of hiking trails, from easy walks to scrambles and everything in between. A region rife with history, Banff attracts diverse, sometimes amazing, and often inspiring people who live and work in the mountains.

The place names of Banff are truly a reflection of its history. For example, Mount Brewster is named for the family who has contributed so much to making Banff what it is today; Palliser Pass takes its name from the famous explorer who first charted the region; and Wedgewood Lake is named for a descendant of Josiah Wedgewood who climbed near there in 1910. Josiah Wedgewood created the china that brought fame to the Wedgewood name. The lake's name, in addition to honouring the climber, evokes the pale blue colour of Wedgewood china.

Banff's art history has an early beginning. Anonymous depictions of the mountains of the Bow Valley by topographers and geographers date from the mid to late 1800s. These draftsmen accompanied the earliest explorations by white visitors, and their works are the first testament to the grandeur of the mountains of Banff.

The Lake Louise region is as well known as Banff townsite, and boasts as many beautiful areas to explore. Lake Louise itself is the most-often painted vista in the Canadian Rockies, and on an average day, an interested hiker can usually peer over the shoulder of a painter somewhere along the lake's scenic shoreline.

Lawren Harris hiking near Mount Temple with
Ira Dilworth, 1947

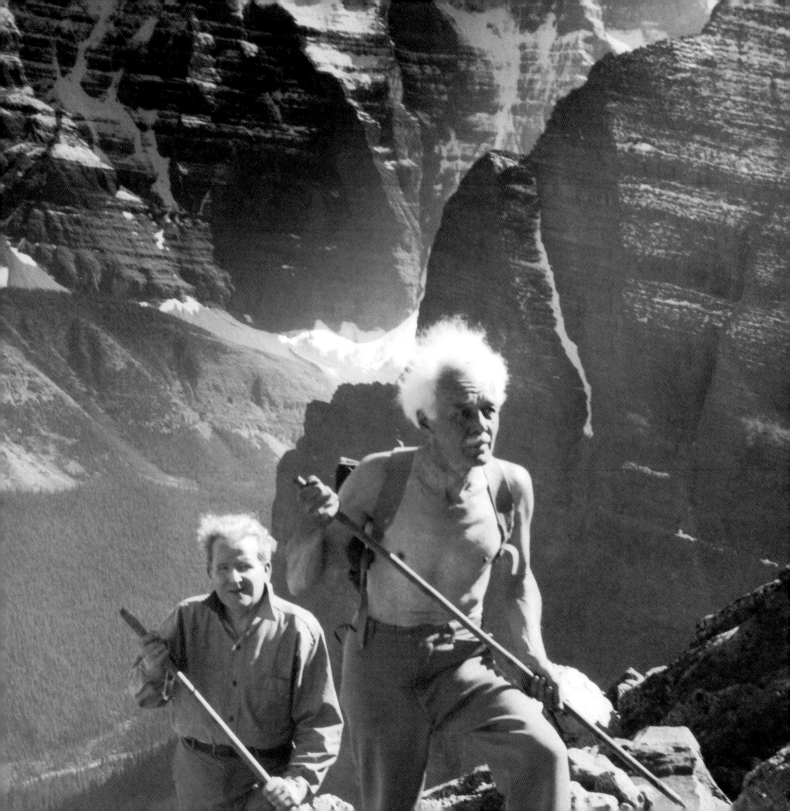

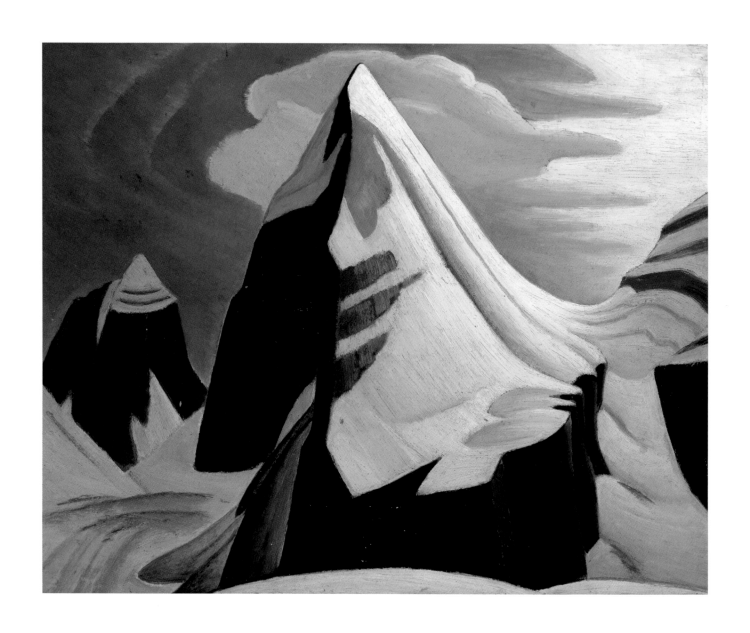

Lawren Harris
Mount Lefroy, c. 1925
oil on panel
McMichael Canadian Art Collection

"Harris had a messianic mission—he wanted to change men by pictorial revelations of cosmic truths."

—Roger Mesley in *artmagazine*, 1978

Mount Lefroy

Mount Lefroy was named for the British army general Sir John Henry Lefroy, but I would argue that it is a candidate for a name change. Sir John's name was given to this bullet of a peak by explorer James Hector in the honouring way of the time, and although Lefroy was noted for his studies in magnetism and is considered the father of Canadian meteorology, his attachment to the peak was not as magnetic as was that of Lawren Harris. Lawren's Peak, or Mount Lawren Harris strikes me as a much better name.

Harris's fascination with Mount Lefroy is clear in his repeated renditions of this upward thrusting, triangular peak. All his versions are set from the same vista, that of Pope's Prospect at the end of the Plain of the Six Glaciers Trail, which begins at Lake Louise. Despite the fact that you can never leave the crowds behind on this trail, it is still a spectacular hike. Combining it with a side trip to Lake Agnes, where Harris also worked, makes for a good day's outing.

Mount Lefroy, in all its triangular majesty, would have been easily accessible from Chateau Lake Louise, where Harris may have stayed during his visits in the 1920s.

Looking at the two studies of Mount Lefroy that are illustrated here gives us an opportunity to explore the progression of this subject in Harris's oeuvre. There are several pencil studies of Lefroy, in which the mountain progresses from the squat, conical form that is true to the peak's real dimensions, to the pointed, triangular shape that reaches its zenith in the painting *Mount LeFroy*, illustrated in *A Hiker's Guide to Art of the Canadian Rockies* (p. 28). This progression parallels Harris's own spiritual progression.

Between 1918 and 1930, Harris published many writings on theosophy, mysticism, karma, and spiritualism, in periodicals such as *The Canadian Bookman*, *The Canadian Forum*, and *The Canadian Theosophist*. He also reviewed writings on related topics and published a book of sixty-one free-verse poems, titled *Contrasts*. His own reading during this time included Wassily Kandinsky's important work *Concerning the Spiritual in Art*. Kandinsky, who was also a theosophist, developed a thesis that art was a path to spiritual exultation, which was shared by other writers of the time, whose works were also likely to have been on Harris's shelf. Clive Bell's book *Art* was among these titles. Bell believed that art could be the catalyst for an ecstatic experience, and that art and religion were simply two different expressions of spiritual ecstasy.

Theosophy, or divine wisdom, was a complete and all encompassing way of life for Harris, no mere Sunday religion. Harris followed the teachings of Helena Blavatsky, who founded theosophy in 1875, in New York City. Her teachings were laid out in *The Secret Doctrine*, published in 1888. Subtitled *The Synthesis of Science, Religion, and Philosophy*, Blavatsky's theosophy led to the Rudolf Steiner and C. W. Leadbetter interpretations that would later follow.[77] Blavatsky's teachings sought to create, within each individual, an awareness of the relationship between the natural world and the realm of the spirit, so that a receptive soul could thereby have a spiritual experience. A fellow member of the Toronto Theosophical Society describes Harris's take on theosophy as being "*of the saner order which belongs to 'the old times before us' but which is ever-living and ever-new, because it is of life itself and of the purpose of the Universe. It is therefore akin to art in its highest sense.*"[78]

Among the many teachings of Blavatsky was the rejection of religious dogma in favour of the principle that each individual is responsible for his or her own spiritual evolution. Harris took this teaching quite seriously: "*In order to make ourselves purposeful, creative beings, we should assume full responsibility for ourselves, and think in terms of that responsibility and of the unity of life.*"[79] Harris believed in the unity of all life, and the continuity of all life, including the idea of reincarnation. His definition of life followed the theosophical world view, in which "*it is inconceivable that anything can be without life, even those forms normally considered lifeless. Moreover, 'life' is*

111

"CLIMBERS HAVE THIS SAYING—'THE HIGHER YOU
GET, THE HIGHER YOU GET.'"

—Peter Hackett, physician, researcher, climber, as quoted in
The Power of Place, by Winnifred Gallagher, 1993

not limited to the physical, but is omnipresent through all the planes of consciousness including the emotional, mental, and spiritual.[80] This idea of the unity of all life is closely linked to the concept of and the respect for the brotherhood of all things. Harris felt that all mankind was *"linked and bound together within one great all inclusive common experience with one goal before it."*[81] The goal was spiritual growth, a goal towards which all mankind must aspire together. Harris saw his role as an artist as a way of helping mankind achieve this common goal. He felt that his works could guide others along the spiritual path, and that he, as an artist, was an envoy for the spiritual enlightenment that art could bring.

TRAIL INFO

Trail information:
Pope's Prospect via the Little Beehive, Lake Agnes, and the Highline Trail
Type of hike: Day hike
Trailhead:
The Lakeshore Trail, in front of Chateau Lake Louise
How to get there: From Lake Louise village, follow the road to Lake Louise under the railway overpass and 4.3 km uphill to the public parking lot on the left. Allow 15 minutes for the drive.
Distance: 4.2 km to the Little Beehive Lookout, 11.2 km to the teahouse
Elevation gain:
380 m to Lake Agnes, 605 m to Pope's Prospect
Degree of difficulty: Difficult. The last part of this trail is very steep and footing is poor.
Hiking time: 6 hours
Route: Start at Chateau Lake

Louise and follow the trail for 0.2 km. There is a trail sign for Lake Agnes at the junction. You will immediately begin to climb up through the forest. At 2.6 km, you will reach the junction with a short trail to Mirror Lake; keep right for Lake Agnes. As you walk across the open avalanche slope, watch for the tips of trees that have been sheared off in recent years. The junction with the first trail to the Little Beehive is at 3.1 km. The trail goes to the right and back into the trees, past the junction with a trail that heads back towards Lake Agnes slightly higher uphill. Take this trail on your way back if you wish to make a loop to Lake Agnes. You will reach the lookout at 4.2 km. Harris's work *Lake Agnes Above Lake Louise, Rocky*

Mountains, looks up the valley of the Plain of the Six Glaciers, with the edge of the Big Beehive showing in the centre of the work, and Lake Agnes below and to the right. Continue to Lake Agnes, a favourite painting spot of Walter Phillips. From here, you can continue on to the Plain of the Six Glaciers via two routes. The Highline Trail to the Plain of the Six Glaciers begins below Lake Agnes at Mirror Lake. Descend and watch for the trail to the right. You will climb steadily, alternating with trees and open views, and be rewarded with a view of Lake Louise that is unmatched, just before you connect with the Big Beehive Trail. Keep heading straight ahead. You will switchback downhill here and connect with the Plain of the Six

Glaciers Trail as it rises up towards the Plain of the Six Glaciers teahouse. You will now see Mount Lefroy beginning to look something like Harris's version of it on your left. Continue on to the teahouse. Pope's Prospect is a high-altitude, exposed trail. Do not attempt it without good footwear. Follow the Glacier Viewpoint Trail 150 m past the teahouse. The turnoff goes to the right and is easily missed. This very steep trail takes you 1.3 km up the flank of Pope's Peak, and puts you onto the north ridge of Mount Lefroy—the central vertical ridge in Harris's mountain. You will be well rewarded for your efforts with a view of this perspective of Lefroy that cannot be seen by those who only venture up the Lakeshore Trail. Return the way you came.

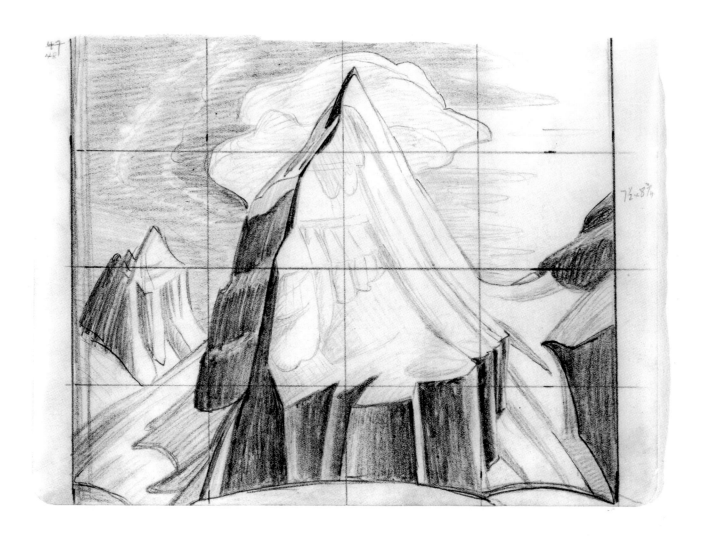

Lawren Harris
Preparatory Drawing for Mount LeFroy, c. 1930
graphite on paper
McMichael Canadian Art Collection

"FOR THE ARTS EPITOMIZE, INTENSIFY AND CLARIFY
THE EXPERIENCE OF BEAUTY FOR US AS NOTHING
ELSE CAN."

—Lawren Harris in *Theosophy and Art*, 1933

MOUNT TEMPLE

Harris painted several versions of Mount Temple when he
came to the Rockies to work. A landmark mountain, located
handily near a number of potential base camp locations,
Temple lived up to its monolithic iconography for Harris. As
a physical structure, the mountain embodied all things
essential to Harris's ideal composition. It towers far above
everything in the near vicinity; at 3,543 metres, it stands
some 500 metres higher than any nearby peak. It is clad
with the requisite white of a glacier. It is triangular, and at its
base, there is little to block an onlooker's gaze. It also has, by
virtue of its very massiveness, the ability to capture and hold
onto clouds and the weather. Although I have seen the
clouds trapped around the base of Temple on many occa-
sions, the monolithic mountain is depicted here as if caught
in a sudden sweep of ecclesiastic clouds, sent on a mission
to skirt the peak just for Harris, and then move on to their
next job of covering the privates of overweight putti and
chubby cherubs in a Renaissance painting on some Italian
church ceiling.

Set amid these sublime clouds, Harris has painted the
shape of the north face of Temple with reasonable accuracy.
The Black Towers, the two rock features on the left-hand
side of the mountain, roughly repeat the shape of the whole.
The sky on the right-hand side of the composition has been
evenly and smoothly painted, and is empty of any cloud for-
mations. Temple's glacier has been painted with truth to its
surface, and with just enough texture to give it believable
weight. Any fresh or semi-permanent snow that clung to this
face of Temple in 1928 has been completely omitted by
Harris, leaving us instead, with a solid face of blue-grey

mountain. The foreground
has been treated with a typi-
cal Harris device of ground-
ing the composition using
broad anchoring shapes, a
sort of frame within a frame.
These repeat the undulations
of the clouds, and echo the
shapes of the natural terrain
at the foot of this face of
Temple.

Mount Temple is visible
from many places near Lake
Louise. In Paradise Valley, the
views from the Giant Steps
Trail are spectacular. At Lake
Louise, the steep trail to the
Saddleback brings you much
closer to Temple's massive
face, and has the added
attraction of a fine lookout
to Fairview Mountain. The
Saddleback is the site of
another version of Temple by
Harris, illustrated in *A Hiker's
Guide to Art of the Canadian
Rockies* (p. 42), and permits
access to a trail from which
you can make an easy ascent
of Saddleback Mountain.
A vista across Mud Lake also
compares nicely with Harris's
view, and the lakeshore
ambiance is certainly prefer-
able to the numerous roadside
views of the spectacular peak,
along the Trans-Canada
Highway. Mud Lake lives up
to its name—be prepared for
slop if the weather has been
wet, and for muck even if
the weather has been dry.

Lawren Harris
Mount Temple, 1928
oil on board
Art Gallery of Ontario

"CANADA IS AN ENTITY WITH A SPIRITUAL FORM DRAWN FROM THE SIGNIFICANT CHARACTER OF HER ENVIRONMENT. ... TO BECOME AWARE OF HER NATURE IS TO TAKE SOME PART OF IT INTO ONE'S BEING AND SURELY BY ITS EXPRESSION ADD SOMETHING TOWARD THE REALIZATION OF HER FULFILLMENT. THIS IS WHAT ART DOES TO CREATE A NATIONAL CONSCIOUSNESS."

—Bess Housser in *The Canadian Bookman*, 1925

MORAINE LAKE

In his lifetime, Harris was privileged. He was born into wealth that would later become the Massey-Harris farm machinery fortune. He had the means that allowed him to live his life free of the obligation to make a living. So it seems that he was quite fortunate, that it would have been easy to paint as one wished, and to embrace an unorthodox life philosophy. But his life was certainly not without controversy. In 1934, he shocked Toronto society by leaving his wife of twenty-two years, Beatrice, and their three grown children, and then admitting to a relationship with painter Bess Housser, the wife of a long-time friend and fellow theosophist, Fred Housser. It was a time of great difficulty for Harris. His letters to Emily Carr tell of his frustration with his painting, of feeling that he was creatively spent and disinterested. Toronto society was incapable of dealing with the scandal and was very hard on the couple; there was even a worry over charges of bigamy, as both Housser's and Harris's

Reno divorces were not recognized as legal in Canada. To complicate matters, Fred Housser had begun a relationship with Yvonne MacKague, another painter, and they used Bess and Lawren's actions to excuse their own. To escape, Bess and Lawren moved to New Hampshire, where Harris began to paint anew. The change of venue was extremely positive for Harris, and he began to paint in an even more abstract style. By 1936 he was working in pure abstraction. Lawren and Bess would move to Santa Fe in 1938, and return to Canada, specifically Vancouver, in 1940. He was received there as a national figure, society having relaxed its attitudes some since 1934. Together, the couple would travel widely, frequently returning to the Rockies to hike, and for Bess, to sketch.

Harris found a comrade in Bess as a painter. Also a theosophist, she shared compatible views with Harris on the nature of the universe and life within it. She was equally sensitive to the spirituality that a receptive person could find in nature, and in her twilight depiction of Moraine Lake, set from the Rockpile Viewpoint, she has captured the picturesque

qualities of water, mountain, snow, and sky in a shimmering scene, with qualities of stained glass and the light effects of a cathedral.

TRAIL INFO

Trail information: Moraine Lake
Type of hike: Half-day hike
Trailhead: At the Moraine Lake parking lot
How to get there: From Lake Louise village, follow Lake Louise Drive towards Lake Louise. The Moraine Lake turn-off heads south at 2 km. The parking lot is at 14.5 km. Allow 25 minutes for the drive.
Distance: 1.1 km
Elevation gain: None
Degree of difficulty: Very easy
Hiking time: Allow ½-hour
Route: The Moraine Lake Shoreline Trail is an easy walk to the end of the lake. The trail runs alongside the tranquil waters of the lake, with the constant backdrop of the Ten Peaks on the far shore. Once at the lake, you can easily add a trip up to Sentinel Pass or into the Valley of the Ten Peaks, the site of Harris's spectacular oil *Mountain Sketch LXXXVII*.

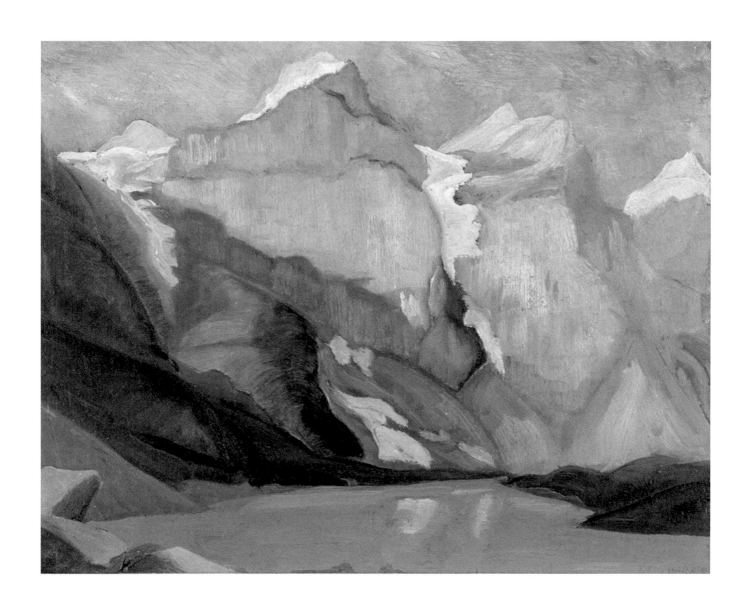

Bess Harris
Mountain Twilight, Moraine Lake, undated
oil on board
Private Collection

"A REPRESENTATIVE PAINTING OF A MOUNTAIN IS SIMPLY A COPY OF WHAT IS REFLECTED ON THE EYE'S RETINA. A TRUE PAINTING OF A MOUNTAIN IS A MORE OR LESS IMPERFECT RECORD OF WHAT TRANSPIRES IN THE SOUL OF THE PERSON BEHIND THE RETINA."

—F. B. Housser in *The Group of Seven Exhibition*, 1926

SENTINEL PASS

It appears from sketchbook drawings and from a number of paintings that Harris fully explored the hiking terrain near Lake Louise. Vistas within the regions of Sentinel Pass, Larch Valley, Paradise Valley, Valley of the Ten Peaks, and Consolation Lakes are all known. Many of these were worked into increasingly abstracted versions at a later date, and some appear to have played a role in the very abstract works of the 1950s and '60s. The tightly grouped mountains shown in a related series of works, the best known of which is *Lake and Mountains* (not illustrated), all depict the Wenkchemna Peaks, seen from an unusual perspective, as if forced by Harris into a tight football huddle.

Two of these famous Ten Peaks have been selected as the focus for the work *Mountain Sketch LXXXVII*, and are set apart from their companions in a striking oil sketch. The sketch depicts peaks number three and four of the ten, Mounts Bowlen and Tonsa. Harris has taken all indication that these peaks are part of a massif out of this painting, isolating their summits completely from the peaks on either side. The Wenkchemna Peaks are often depicted as running in a long, chunky line, as they do in reality. Harris has emphasized instead the verticality of the mountains, stretching the summits ever-upwards, and illuminating them in a shaft of white light. The sheer bands of light that shine on the mountain are painted in distinct stripes of blue. Despite the rigid form of these light bands, they create natural shadows of blue that contrast sharply with the areas of bright white light on the glaciated sections of the mountain.

The slight hint of a foreground ridge, on the bottom right edge of the work, corresponds roughly to Larch Valley floor, which, by definition, is heavily strewn with these engaging trees. Harris has omitted any reference to them in this work.

TRAIL INFO

Trail information: Minnestimma Lakes and Sentinel Pass
Type of hike: Day hike
Trailhead: Moraine Lake Lodge
How to get there: From Lake Louise village, follow Lake Louise Drive towards Lake Louise. The Moraine Lake turn-off heads south at 2 km. The parking lot is at 14.5 km. Allow 25 minutes for the drive.
Distance: 4.6 km
Elevation gain: 730 m
Degree of difficulty: Moderate
Hiking time: Allow 4 hours
Route: Park at Moraine Lake and follow the Shoreline Trail to the large sign for Sentinel Pass. You begin to climb almost immediately, but will cover about 1 km of trail before you reach the first switchbacks, which are long and steep. Outstanding views are found along the entire length of this trail, so rest often and enjoy them. Take the right fork to Larch Valley at 2.5 km. Thirteen years ago in this beautiful valley, I discovered how bold Canada gray jays are while sitting atop a picnic bench with a sandwich in my hand. A silent swoop and I was left with just the bread; the discriminating jay (or not— depending on your culinary opinion of my choice in luncheon meat) stole my bologna! After you leave the forest, the view begins to match the vista in Harris's composition in its starkness, but as you gain elevation, you are looking directly at, rather than up to, Mounts Bowlen and Tonsa. You will reach the last and highest of the Minnestimma Lakes at 4.6 km. The treeless region here echoes the "feel" of Harris's work, especially when the lighting plays off the ridges on Bowlen. A lucky hiker might encounter light effects similar to those in the work; the rest of us will have to content ourselves with imagining them. You can continue on to Sentinel Pass, the highest maintained trail in the Canadian Rockies, at 5.8 km.

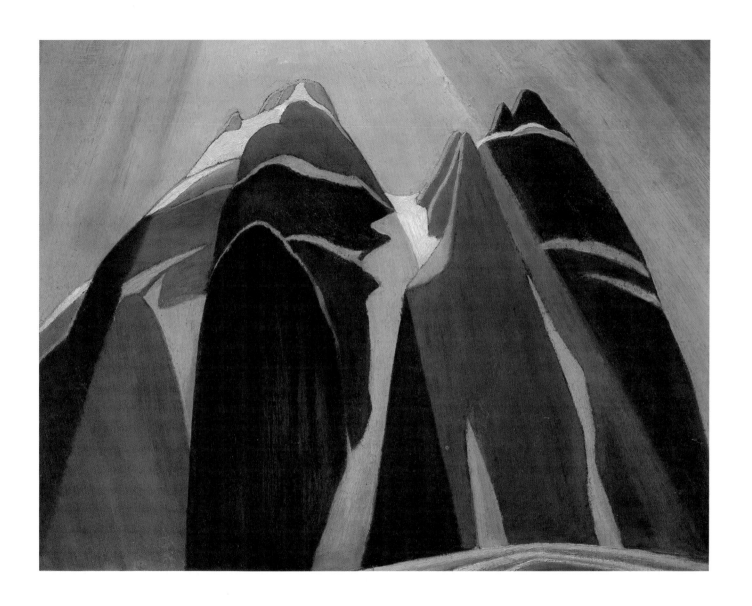

Lawren Harris
Mountain Sketch LXXXVII, 1937
oil on board
The Robert McLaughlin Gallery

I Think Harris Was Here—Or Was He?

When travelling in the Rocky Mountains of Canada, I often find myself mentally preoccupied with the activities of artists who have been there before me. I have begun to refer to the weather, light, and seasonal conditions as being characteristic of one or another artist because of the related qualities inherit in their works. Bright, sunny-cold, fresh-snow days are "Belmore Browne Days." Soft morning sunshine is "Walter Phillips Light," and grey skies are "J. E. H. MacDonald Days." I have also come to associate certain types of mountain terrain with certain artists. Meadows bring to mind Walter Phillips, as do waterfalls and melting snow. Catharine Whyte was interested in the details of nature. She comes to mind when I sit at the edges of ponds and see the soft fall-yellow of lanky, seedling larches.

I am immersed in art history when in the Rockies. Images flash into my head even on a mountain drive, and on several occasions, I have felt an overwhelming "Harris-y feeling" when I am in certain regions. One of these is the vicinity of Herbert Lake, just a few kilometres north on the Icefields Parkway from its southern start near Lake Louise. The image that always springs into mind, like a mental slide-show in vivid colour, is *Mountains and Lake*, and the peak that sparks the flash is the north face of Mount Niblock.

Much to my chagrin, I cannot, despite repeated trips to Herbert Lake, figure out where Harris composed his picture. Although the Pipestone Trail northeast of Lake Louise townsite is an obvious possibility, I have had no success there. Lost and Hidden Lakes, a few kilometres farther up the Trans-Canada Highway towards Field, are another possibility, but equally unfruitful. Wandering around in the woods in both regions, I have watched the distant peak of Mount Niblock receding or advancing as I hike, but never coming into the right perspective and juxtaposition with Mount St. Piran, which may be the pyramidal peak on the centre left in Harris's canvas.

Two other regions in the Rockies also trigger the same reaction about this painting when I am there: Mount Bourgeau, southwest of Banff townsite, and Mounts Inglismaldie, Girouard, and Peechee, the northern peaks of the Fairholme Range, just south of Lake Minnewanka. If it were not for this Harris-y feeling manifesting itself in three separate places in the Rockies, I would content myself with the Herbert Lake theory. And as this work is a larger format, studio canvas, I know it was not painted on the spot, and Harris may have taken a great deal of liberty with the forms on which he has based the image. Nonetheless it has become a small obsession, and my foot hits the brake involuntarily every time I drive past any of the three regions, so I will keep looking.

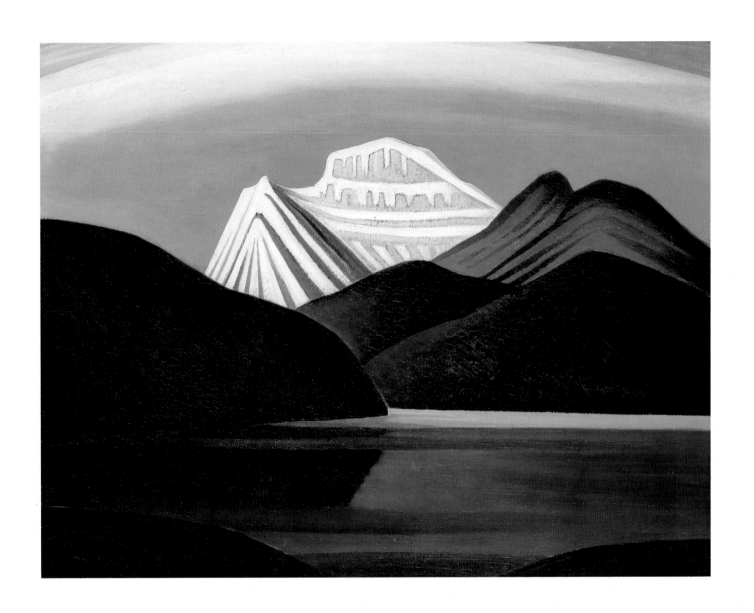

Lawren Harris
Mountains and Lake, 1929
oil on canvas
McMichael Canadian Art Collection

"I MYSELF INCLINE TO DRIFT, TO ACCEPT A LESSER SITUATION RATHER THAN STRIVE FOR A GREATER, AND YET, I KNOW THAT CHARACTER IN LIFE AND ART IS ONLY MADE BY AN EFFORT THAT IS QUITE BEYOND ONE'S ORDINARY EVERYDAY ACCEPTANCE OF THINGS AS THEY ARE."

—Lawren Harris to painter Catharine Whyte in personal letters, 1949

It is interesting that, although Harris and other eastern artists devoted only a short part of their painting careers to the depiction of mountain scenery, these works are subjects of such great interest and are so frequently discussed when looking at their work. One writer said:

"It is especially fascinating for Westerners, familiar with this landscape, to see how distinguished visitors painted the Rockies. … they represent a particular aspect of the history of Canadian art, when a group of ambitious men tried to find new ways of painting an untouched and rugged landscape. It is particularly interesting when that landscape is one we know well."[82]

I have come to know areas of the mountain landscape in a completely new way after looking at these places through the eyes of Lawren Harris. Each location has its unique qualities, and each painting, its own set of visual comparatives. As the mood, temperament, and character of a sitter are reflected in the painter's portrait, so the qualities of these places are reflected in the works of both Harris and Jackson.

The trip that Lawren Harris and A. Y. Jackson took together in Jasper National Park has long been a fascination of mine and planted the seed for this book. It was in Jasper National Park on the Maligne River where it all began, with a summer afternoon's discussion of a work by Lawren Harris. My interest in the adventures of the two in this park has developed into a small obsession, particularly with the work of Lawren Harris. I cannot look at the mountains without images of paintings flowing through my head in an effort to match a scene with a sketch. "Would he have painted that peak?" and "why didn't he ever paint that mountain?" are the conversations I have with myself. I have had many a long discussion with colleagues across the country since I began to approach landscape art with my boots on. Accepted by some as legitimate art history, shrugged off by others as mere diversion, I know, without any doubt, that for Lawren Harris, this approach is an essential part of the whole, and that a full understanding of his work cannot leave aside the realities of the experience of the place. Perhaps I am too far over to the "boots on" side, preferring to sit at the toe of one of the glaciers he depicted and contemplate it for myself, than to focus alone on the written story of his life, influence, teachings, practice, and theory. I am attached to many of these places for their simple beauty, and knew several of them before I knew of their depiction by Harris. His work and that of A. Y. Jackson have added another dimension to my enjoyment of them. The artwork has made the places all the more compelling, interesting, and worthy of time, contemplation, and stewardship. Harris and his theosophical philosophy have brought me to a clearer understanding of that intense, overwhelming, indefinable feeling of general good will and wellness that I get out in the woods. Perhaps I have had a glimpse of my own divine spirit.

"BEFORE I FIRST WENT TO THE MOUNTAINS, I HAD SEEN THESE FOLDERS WITH THEIR PRETTY WATERCOLOUR REPRODUCTIONS AND THEIR GLAMOROUS TATTLE AND I HAD PICTURED MOUNTAINS AS AN UNWORLDLY PARADISE AS HAD MANY OTHERS.

WHEN I FIRST SAW THE MOUNTAINS, TRAVELLED THROUGH THEM, I WAS MOST DISCOURAGED. NOWHERE DID THEY MEASURE UP TO THE ADVERTISING FOLDERS——OR TO THE CONCEPTION THESE HAD FORMED IN MY MIND'S EYE.

BUT AFTER I BECAME BETTER ACQUAINTED WITH THE MOUNTAINS, CAMPED AND TRAMPED AND LIVED AMONG THEM, I FOUND A POWER AND MAJESTY AND A WEALTH OF EXPERIENCE AT NATURE'S SUMMIT WHICH NO FOLDER EVER EXPRESSED. AND I CAME TO KNOW THAT THE WHOLE BUSINESS OF PETTIFOGGING NATURE, THE ELEMENTAL POWER OF MOUNTAIN REGIONS, WAS FALSE. YOU COULD NO MORE GET THE POWER OF A MOUNTAIN INTO ONE OF THESE PERFUMED WATERCOLOUR FOLDERS THAN YOU COULD PUT BEETHOVEN'S 9TH SYMPHONY INTO A MOON SOON SPOON SONG.

I CONCLUDED THAT ALL THIS SOFT SWEETNESS IN ADVERTISING, IN ASKING EVERYTHING OF A PROMISED LAND FROM WHISKY TO CAKE FLOUR, BREEDS A SENTIMENTALITY AND FALSE VALUES IN PEOPLE, WEAKENS THEIR WILL AND ROBS THEM OF THE VITALITY NECESSARY TO BE THEMSELVES, SEE WITH THEIR OWN EYES AND EXPERIENCE UNIQUELY.

WHEN CANADIAN ARTISTS STARTED TO PAINT THE LAND WITH SOME OF THE SPIRIT OF ITS OWN ELEMENTAL POWER, IT IS NO WONDER MANY PEOPLE WERE HORRIFIED. THEY HAD BEEN BROUGHT UP ON IMPORTED PICTURES THAT HAD BEEN CREATED IN LONG SETTLED, AND LONG DEVELOPED EUROPEAN COUNTRIES AND WHICH WERE AS FAR REMOVED FROM THE REAL CANADIAN BACKGROUND AS THIS ADVERTISING BUSINESS IS FROM THE REALITY. BOTH OF THESE HAD CONDITIONED THEM INTO A FRIGID NON-ACCEPTANCE OF THE GREAT REALITY BEYOND THE PAVEMENT'S END AND BOTH WERE DEHABILITATING TO A VITAL CANADIANISM.

THE ADVERTISING MYTHS ARE STILL DEHABILITATING. THEY PICTURE A PROMISED LAND OF SATISFACTION AND SOCIAL SMOOTHNESS FROM SOFT DRINKS TO BEAUTY AIDS WHICH HOODWINKS ALL TOO MANY OF US.

A VIRILE CANADIANISM GROWS OUT OF THE POWER AND RUGGEDNESS OF THESE VAST SPACES——FROM CONTACT WITH THE ENDLESS FORESTS AND LAKES AND MOUNTAINS OF THE LAND, AND THE PRIMEVAL SPIRIT WHICH FLOWS——IT SHOULD SPRING TOO FROM A NEW SOCIAL CONSCIOUSNESS——NOT THE ELEVATION OF CANADIAN IN ANY ONE PURSUIT——BUT IN ALL PURSUITS AND ABOVE ALL FROM A DEEP SENSE OF COMMUNITY AND THE CREATIVE CONSCIOUSNESS THAT WE CAN MAKE A NOBLER QUALITY OF NATIONAL LIFE."
—Lawren Harris in personal papers, early 1940s

LAWREN STEWART HARRIS (1885–1970)

1885 Lawren Stewart Harris was born 23 October, in Brantford, Ontario, to Anna and Thomas Harris. Thomas Harris was secretary of The A. Harris, Sons and Co. Ltd., a farm machinery manufacturer.

1887 Howard Harris was born.

1891 The A. Harris, Sons and Co. Ltd. joined the Hart Massey farm machinery company to form Massey-Harris. This farm machinery company would provide Harris with a life of wealth.

1894 Thomas Harris died.

1894–98 Attended Huron Street Public School.

1898 Ill at home, taught by a personal tutor.

1899 Attended St. Andrew's College in Toronto.

1903 Studied for four months in the arts faculty of University College, University of Toronto. A mathematics professor noticed Harris's drawings, encouraged Mrs. Harris to send Lawren to Europe to study art.

1904 Travelled to Berlin to study art. Teachers were Franz Skarbina, Fritz Von Wille, and Adolf Schlabitz. Visited the 10th through 13th exhibitions of the Berlin Secession. Encountered theosophic, esoteric, transcendentalist, and eastern philosophy.

1906 Viewed works by landscape painter Caspar David Friedrich in the exhibition *Ausstlellung Deutscher Kunst aus der Zeit, 1777–1875* (An Exhibition of German Art, 1777–1875). Climbed in Brixlegg, Austria; hiked in the Austrian Tyrol.

1907 Hiked in Germany, met the forward thinking painter/poet/philosopher Paul Theim. Worked in Egypt and Israel as an illustrator for *Harper's*. Returned to Canada.

1908 Sketched in the Laurentians. Became a charter member of the Arts and Letters Club of Toronto.

1909 Sketched in Memphremagog, and in Quebec with J. W. Beatty. Worked for *Harper's* in a Minnesota lumber camp.

1910 Married Beatrice Phillips.

1911 Showed in the Ontario Society of Artists (OSA) exhibition. Met Arthur Lismer, saw works by J. E. H. MacDonald. Saw the exhibition *Société des Peintres et Sculpteurs* (Society of Painters and Sculptors) in Buffalo, New York, and within it the work of landscape painter Le Sidaner.

1912 Showed in the OSA exhibition; the National Gallery of Canada (NGC) purchased a work. Sketched with J. E. H. MacDonald, visited Dr. James MacCallum's cottage on Georgian Bay.

1913 Financed and built the Studio Building in Toronto, together with MacCallum; the NGC bought works by Harris, Lismer, Jackson, and Thomson. The Armory Show (an International Exhibition of Modern and Contemporary Art) opened in New York, Chicago, and Boston, which included works by Cézanne and Kandinsky.

1915 Sketched with MacDonald. War broke out in Europe; Howard Harris enlisted.

1916 Sketched in Algonquin Park with Thomson and MacCallum. Enlisted in June. Served until 1918.

1917 Tom Thomson drowns on Canoe Lake, Algonquin Park. Harris believed he was murdered.

1918 Howard Harris was killed in action. Lawren Harris suffers a breakdown and is given a medical discharge. Returned to Canada and sketched with MacCallum in Algoma. Several of Harris's works toured internationally with an NGC exhibition. Harris, MacDonald, and Lismer sketch together on the first "boxcar" trip.

1919 Showed at the Art Gallery of Toronto (AGT), now the Art Gallery of Ontario (AGO). Sketched in Algoma on a boxcar trip.

1920 First Group of Seven show was held at the AGT (eight exhibits were held between 1920 and 1931). Two trips to sketch in Algoma are undertaken; the first was by boxcar.

1921 Sketched in Glace Bay. Second Group show at the AGT. Sketched along the north shore of Lake Superior with A. Y. Jackson; with Lismer and Jackson in Algoma.

1922 Third Group show at the AGT. Sketched along the north shore of Lake Superior, again with Jackson. Published *Contrasts*, a book of verse.

1923 Became a member of the Toronto Chapter of the Theosophical Society of Canada.

1924	Visited Jasper with A. Y. Jackson; Harris's first time in the Canadian Rockies. Painted at Maligne Lake including the Opal Hills and Coronet Creek, and in the Queen Elizabeth Ranges. Also worked in Jasper's Tonquin and Athabasca Valleys, the Colin Range, and near Jasper Park Lodge, at Lake Edith, north of Jasper near Pocahontas, along the Overlander Trail, at Pyramid Lake, and from The Palisade. Passed through the Yellowhead region of British Columbia near Mount Robson by train.
1925	Fourth and fifth Group shows held at the AGT.
1926	Painted in Yoho National Park at Lake O'Hara including Lake McArthur, Odaray Mountain, Opabin Plateau, Lake Oesa, Lefroy Lake, and Schäffer Mountain. Painted in Banff National Park near Lake Louise including Mount Lefroy, Mount Temple, Moraine Lake, and Valley of the Ten Peaks.
1927	Met Emily Carr; painted on the north shore of Lake Superior.
1928	Sketched in eastern Canada with Jackson; painted along the north shore of Lake Superior. Painted at Lake O'Hara including Lake McArthur. Sixth Group show was held at the AGT.
1929	Painted near Lake Louise in Banff National Park, at Mont des Poilus in Yoho National Park, and at Mount Robson in Mount Robson Provincial Park.
1930	Seventh Group show at the AGT, painted from the *S. S. Beothic* with A. Y. Jackson in the summer.
1933	Elected president of the Canadian Group of Painters (CGP), resigned from the OSA.
1934	Divorced Beatrice and married Bess Housser; moved to New Hampshire. Harris was artist in residence at University of New Hampshire. Met Wassily Kandinsky while there.
1936	Showed an abstraction with the CGP; the NGC mounted a Group of Seven retrospective exhibition.
1938	Moved with Bess to Santa Fe, New Mexico.
1939	Joined the Transcendental Group of Painters (TGP).
1940	Returned to Canada and settled in Vancouver. Continued to paint abstracts. Visited the Rockies regularly, including the Skoki region east of Lake Louise, Banff National Park, and Lake O'Hara, Yoho National Park. Painted *Mount Ann-Alice*, a peak northwest of Mount Robson. Gave numerous public addresses in the 1940s. Began to experiment with automatism. Wrote and published widely on the subject of abstract painting.
1941	Organized TGP show at the Vancouver Art Gallery (VAG).
1942	Met Lionel Lemoine Fitzgerald, an abstract painter.
1948	Harris retrospective was held at the AGT.
1950	Painted *Nature Rhythms* (NGC), an abstract clearly based on mountain forms.
1954	Wrote *A Disquisition on Abstract Painting*. Experimented with automatic drawing.
1955	VAG mounted a show of recent works.
1960s	Poor health resulted in sporadic painting of large, bold works. One biographer interpreted these works as "moving into greater light"[83] and as being indicative of Harris's belief in reincarnation.
1969	Bess Harris died suddenly; Harris was overwhelmed with grief.
1970	Lawren Harris died in Vancouver, on 29 January 1970, at the age of 85.

ALEXANDER YOUNG (A. Y.) JACKSON (1882–1974)

1882 Alexander Young Jackson was born in Montreal, Quebec, to Georgina and Henry Jackson, the third of six children. Henry Jackson would later abandon his family and leave for the U.S.A. to escape debts.

1902 Studied art in Montreal and attended Royal Canadian Academy (RCA) night classes.

1904 Exhibited with the RCA.

1905 Worked his way to Europe on a cattle boat with brother Harry. Visited London and Paris, visiting art galleries at the World's Fair at Liège.

1906 Studied at the prestigious Art Institute of Chicago; worked as a designer.

1907 Studied at the Académie Julian in Paris.

1908 Visited Italy, including Etaples.

1909 Visited Holland, lived in Épuisy, France.

1910 Sketched in Quebec, Berlin, Ontario (now Kitchener), and Georgian Bay.

1911 Exhibited with the Ontario Society of Artists (OSA); visited France, including Brittany, in the fall.

1913 Returned to Quebec, met J. E. H. MacDonald, Arthur Lismer, and Fred Varley. Sketched at Georgian Bay; took a studio with Lawren Harris in Toronto. Met Tom Thomson.

1914 Moved into the Studio Building recently built and financed by Harris and James MacCallum. Sketched in Algonquin Park in the spring, returned in the fall with Thomson, Lismer, and Varley. Elected to the Academy of Royal Canadian Artists (ARCA). Travelled to the Mount Robson region and through Jasper Park with J. W. Beatty. Hiked into the backcountry with various Canadian National Railway staff and painted vistas including Mount Robson, Mount Resplendent, Lynx Mountain, Five Mile Glacier, Yellowhead Mountain, Kushina Ridge, Whitehorn Mountain and Kinney Lake. Exhibited at the Arts Club in Toronto.

1915 Enlisted in the army. Shipped out in the fall as a private in the 60th Battalion Infantry.

1916 Wounded in June while in England and convalesced there.

1917 Appointed a Canadian War Memorials Artist; went to France to paint scenes of the war.

1919 Painted scenes depicting the war effort in Halifax and was discharged in April. Returned to Toronto. First boxcar trip took place; Jackson sketched on this trip with Harris, Lismer, and MacCallum.

1920 Painted at Georgian Bay and in Algoma with Harris, Lismer, and MacCallum in the spring; returned to Algoma with MacDonald, Johnston, and Harris in the fall. First Group of Seven show is held at the Art Gallery of Toronto (AGT), now the Art Gallery of Ontario (AGO). Eight exhibits were held there between 1920 and 1931.

1921 Painted in Algoma with Harris and Lismer; visited the north shore of Lake Superior with Harris. Exhibited at the NGC, second Group show at the AGT.

1922 Painted with Albert Robinson in Quebec, returned to the north shore of Lake Superior with Harris. Third Group show at the AGT.

1924 Painted in Baie St. Paul and Algoma in the spring. Visited Jasper National Park with Lawren Harris and the Harris family. Painted in the vicinity of Jasper Park Lodge, at Maligne Lake including the Opal Hills, Coronet Creek, and in the Colin and Queen Elizabeth Ranges. Also worked in Jasper's Tonquin and Athabasca Valleys, and from The Palisade. Taught at the Ontario College of Art (OCA) in the fall, exhibited at the NGC.

1925 Painted in Algoma with Lismer and Harris; returned to the north shore of Lake Superior. Resigned from the OCA.

1926 Painted in Quebec, visited the Skeena River area in British Columbia, through which he had passed with Lawren Harris the year before. Painted there with Marius Barbeau and Edwin Holgate.

1927 Painted in Quebec and on board the *S. S. Beothic* with Frederick Banting. Exhibited with the AGT.

1930 Painted in Quebec, and aboard the *S. S. Beothic* with Harris.

1932 Painted in Quebec, travelled with Banting, painted in the Gaspé with Harris. Resigned from the RCA.

1935–74 Exhibited regularly.

1936 Painted on the Fox River, Gaspé, travelled to Europe, painted in Georgian Bay, travelled to New York City. Attended reunion of army veterans in England; Naomi Jackson, A. Y.'s niece and a graduate student, travelled with him.

1937 Painted with Banting on the St. Lawrence River. Travelled to Lethbridge, Alberta, to visit brother Ernest Jackson, and painted there and in Pincher Creek, Cowley, and Lundbreck, Alberta.

1939 Painted in Quebec and at Georgian Bay; visited the World's Fair in New York City in August, painted near Grace Lake and La Cloche.

1940 Painted on the south shore of the St. Lawrence River, at Ste. Louise, L'Islet County, and at Georgian Bay, Gem Lake, and in the La Cloche Hills. *Canadian Landscape* (1942) was filmed by the National Film Board of Canada (NFB) featuring scenes of Jackson painting in the La Cloche hills.

1941 Further filming for *Canadian Landscape* took place in St. Tite-des-Caps and on the north shore of the St. Lawrence River. Assisted with the production of *West Wind*, an NFB film on Tom Thomson, released in 1943. Received LL.D. from Queen's University. Attended the Canadian Conference on the Arts in Kingston. Illustrated Henry Beston's book *The St. Lawrence* (New York and Toronto: Farrar and Rinehart, Inc., 1942).

1943 Wrote *Banting as an Artist* (Ryerson Press, 1943). Taught at the Banff School of Fine Arts in the summer. Sketched in Canmore and Rocky Mountain House, Alberta. Visited Waterton-Glacier International Peace Park (Waterton Lakes National Park). Travelled and painted scenes of the newly built Alaska Highway with Henry Glyde.

1944 Taught at the Banff School of Fine Arts in the summer, painted in Kamloops, British Columbia, and in Canmore. Visited Lethbridge, Waterton Lakes National Park, and Rosebud, Alberta.

1945 Taught at the Banff School of Fine Arts, painted in Kamloops, Ashcroft, Barkerville, and Williams Lake, British Columbia. Visited Lethbridge, Pincher Creek, Millarville, Alberta. Exhibited at Coste House in Calgary, Alberta, and in Toronto at Eaton's Fine Art Galleries. NGC purchased 25 oils.

1946–47 Taught at the Banff School of Fine Arts in the summer; visited the Bar X Ranch in southwestern Alberta, painted in the Cariboo region of British Columbia. Awarded the Order of Saint Michael and Saint George in 1946.

1948–49 Painted in Georgian Bay, along the Gatineau River, in St. Aubert, in the Cariboo region of British Columbia, at the Bar X Ranch, and in the N.W.T. Taught at Banff in the summer of 1949.

1950 Painted in the Gatineau, at Great Bear Lake, and on the barren lands, near the Teshierpi Mountains, N.W.T. Painted in southern Alberta in the fall, visiting Twin Butte.

1951 University of Alberta, Edmonton, presented Jackson with the National Award for Art. Visited southern Alberta in the fall, Calgary in October. Painted on Great Bear Lake and in the Coppermine region, N.W.T.

1954 Lawren Harris sold the Studio Building; Jackson moved into new studio at Manotick.

1955–68 Continued to paint on regular trips to favourite sketching grounds in Ontario, Quebec, British Columbia, Alberta, and the Northwest Territories.

1956 Visited Trinidad and Tobago in the West Indies. Accepted honourary membership in the Royal Canadian Academy of Arts, from which he had previously resigned.

1957 Accepted LL.D. from Carleton University; sketched in Hamilton.

1958 *A Painter's Country*, Jackson's autobiography, was published.

1959 Awarded Freedom of the City of Toronto.

1962 Presented with the Canada Council medal for 1961. Moved into a new studio in Ottawa; received LL.D. from University of Saskatchewan, Saskatoon.

1965 Visited Baffin Island and Pangnirtung with members of the Alpine Club of Canada (ACC) to paint.

1966 LL.D. from University of British Columbia, Vancouver.

1967 D. Litt. from McGill University, Montreal.

1968 Awarded the Companion of the Order of Canada, but suffered a stroke in April. Naomi Jackson accepted the award on his behalf. Jackson moved onto the grounds of the McMichael Conservation Collection (now the McMichael Canadian Art Collection, MCAC) at Kleinburg, Ontario.

1973 Health deteriorated further; moved into a nursing home.

1974 A. Y. Jackson died at the age of 92 and was buried on the MCAC grounds.

LAWREN HARRIS

Above Emerald Lake, c. 1924
Previously titled: *Jacques Lake, Jasper Park*
oil on panel
35.5 x 28.0 cm
Private Collection, Toronto
Courtesy John A. Libby Fine Art, Toronto

Athabasca Valley, Jasper Park, 1924
oil on panel
26.0 x 35.2 cm
Collection of The Edmonton Art Gallery, Edmonton
E. E. Poole Foundation

Athabasca Valley, Jasper Park, undated
oil on wood
27.0 x 35.0 cm
Collection of the Agnes Etherington Art Centre, Queen's University, Kingston
Gift of the Gertrude Matthewman Bequest, 1986

Athabaska at Jasper, 1924
oil on panel
27.0 x 35.2 cm
Private Collection, Red Deer
Courtesy Four Corners Gallery, Red Deer

Coronet Glacier, Near Maligne Lake, 1926
oil on panel
27.1 x 35.1 cm
Private Collection of Dr. and Mrs. W. H. Lakey, Edmonton

Emerald Lake, c. 1924
oil on panel
30.4 x 37.8 cm
1981.40.1
McMichael Canadian Art Collection, Kleinburg
Gift of Mrs. Chester Harris

From Opabin Pass, Rocky Mountains, c. 1924
oil on beaverboard
30.3 x 37.8 cm
4596
National Gallery of Canada, Ottawa
Purchased 1945

Goodsir Peaks, Rocky Mountains, undated
oil on board
30.5 x 37.9 cm
78.35
Art Gallery of Hamilton, Hamilton
Gift of Mr. Charles P. Fell, 1978

Isolated Peak, c. 1929
graphite on wove paper
19.2 x 24.5 cm
18713
National Gallery of Canada, Ottawa
Purchased 1976

Isolation Peak, c. 1929
oil on panel
29.8 x 37.5 cm
Private Collection, Calgary
Courtesy Masters Gallery Ltd., Calgary

Isolation Peak, 1928
pencil on paper
18.4 x 24.1 cm
Dalhousie Art Gallery, Halifax
Purchased 1976

Lake Agnes Above Lake Louise, Rocky Mountains, 1955
oil on board
29.8 x 37.5 cm
78.A.193
London Regional Art and Historical Museums, London
Gift of Mr. and Mrs. John H. Moore, London, through the Ontario Heritage Foundation, 1978

Lake McArthur, Rocky Mountains, c. 1920s
oil on plywood
30.0 x 38.1 cm
#L-7
Collection of the Winnipeg Art Gallery, Winnipeg

Lynx Mountain (Mountain Sketch XLI), undated
oil on panel
30.1 x 37.7 cm (sight)
Private Collection, Vancouver

Maligne Lake, Jasper Park, 1924
oil on canvas
122.8 x 152.8 cm
3541
National Gallery of Canada, Ottawa
Purchased 1928

Maligne Lake, Jasper Park, Alberta, 1924
pen and black ink on wove paper
32.8 x 40.0 cm
18290
National Gallery of Canada, Ottawa
Purchased 1975

Mount Lefroy, c. 1925
oil on panel
30.2 x 37.5 cm
1986.1
McMichael Canadian Art Collection, Kleinburg
Purchased 1986

Mount Resplendent, 1929
graphite on paper
21.6 x 28 cm
Private Collection, Halifax
Courtesy Masters Gallery Ltd., Calgary

Mount Robson, c. 1924–25
graphite on wove paper
18.9 x 25.4 cm
18774
National Gallery of Canada, Ottawa
Gift of Lawren P. and Anne Harris, Ottawa, 1977, in memory of Kathleen M. Fenwick

Mount Robson, c. 1924–29
graphite on wove paper
19.3 x 25.4 cm
18712
National Gallery of Canada, Ottawa
Purchased 1976

Mount Sampson, Maligne Lake, Jasper, c. 1924
pen and ink on card
19.7 x 37.1 cm
Private Collection, Vancouver

Mount Schäffer, Lake O'Hara, 1924 or 1926
oil on panel
30.1 x 37.7 cm (sight)
Private Collection, Vancouver

Mount Temple, 1928
oil on board
30.5 x 38.1 cm
2460
Art Gallery of Ontario, Toronto
Gift from Friends of Canadian Art Fund, 1938

Mountain Above Maligne Lake, North End, c. 1924
oil on canvas
26.8 x 35.2 cm
D 76 46 P1
The Musée d'art contemporain de Montréal Collection, Montreal

Mountain, Maligne Lake, c. 1951
oil on canvas
85.7 x 127.0 cm
95.45.8
Vancouver Art Gallery, Vancouver

Mountain Sketch, c. 1924–28
oil on plywood mounted on masonite
30.8 x 37.9 cm
L-8
Collection of the Winnipeg Art Gallery, Winnipeg
School of Art Collection

Mountain Sketch, c. 1928
oil on panel
38.1 x 45.7 cm
Private Collection, Calgary
Courtesy Masters Gallery Ltd., Calgary

Mountain Sketch XXXII, undated
oil on panel
29.2 x 37.5 cm
Private Collection, Calgary
Courtesy Masters Gallery Ltd., Calgary

Mountain Sketch XLVI, undated
oil on board
30.0 x 38.0 cm
Courtesy A. K. Prakash, Toronto
Courtesy Galérie Dominion, Montreal

Mountain Sketch LXVII, undated
oil on board
30.0 x 37.5 cm
Private Collection, Calgary
Courtesy Canadian Art Gallery, Canmore

Mountain Sketch LXXXVII, 1937
oil on board
29.9 x 37.5 cm
87HL34
The Robert McLaughlin Gallery, Oshawa
Gift of Isabel McLaughlin, 1987

Mountains and Lake, 1929
oil on canvas
92.0 x 114.8 cm
1970.1.1
McMichael Canadian Art Collection, Kleinburg
Gift of Mr. R. A. Laidlaw

North of Mount Mumm, Robson Park, undated
oil on panel
29.3 x 37.1 cm (sight)
Private Collection, Vancouver

Preparatory Drawing for Mount Lefroy, c. 1930
graphite on paper
19.3 x 25.5 cm
1975.64
McMichael Canadian Art Collection, Kleinburg
Gift of Mr. and Mrs. Lawren P. Harris

Rocky Mountain Sketch XXXVII, c. 1928–29
Alternate title verso: *View East from Whistler Mountain, Jasper*
oil on panel
30.5 x 38.1 cm
Private Collection, Calgary
Courtesy Masters Gallery Ltd., Calgary

Rocky Mountain Sketch LX, c. 1928
oil on panel
38.1 x 45.7 cm
Private Collection, Calgary
Courtesy Masters Gallery Ltd.,
Calgary

Rocky Mountains #733, c. 1923–30
pencil on paper
20.3 x 25.2 cm
89.A.13
London Regional Art and Historical
Museums, London
Gift of Mrs. Margaret Knox, Vancouver

Snow, Rocky Mountains, c. 1925
oil on panel
27.0 x 35.4 cm
1969.13.1
McMichael Canadian Art Collection,
Kleinburg
Gift of the Founders, Robert and
Signe McMichael

South End of Maligne Lake, c. 1925
oil on panel
27.0 x 35.2 cm
1968.16.1
McMichael Canadian Art Collection,
Kleinburg
Gift of Mrs. Lawren Harris

Throne Mountain, Rocky Mountains,
c. 1924–25
oil on canvas mounted on masonite
55.9 x 68.6 cm
Private Collection, Calgary
Courtesy Masters Gallery Ltd., Calgary

BESS HARRIS

Mountain Twilight, Moraine Lake,
undated
oil on board
25.7 x 33.3 cm
Private Collection, Edmonton

A. Y. JACKSON

Amethyst Lake, c. 1927
reproduction of a gouache on paper
15.8 x 18.1 cm
(reproduction measurements, original
measurements unknown)
Pam 917.238.J39c
Glenbow Library Collection, Calgary

Colin Range, Maligne, 1924
graphite on paper
13.0 x 21.5 cm
JaA 03.14
Collection of the Whyte Museum of
the Canadian Rockies, Banff

Coronet Peak, Jasper Park, 1924
oil on canvas
20.5 x 26.0 cm
80.62.1
Glenbow Collection, Calgary
Purchased 1980

Mount Edith Cavell, c. 1927
reproduction of a gouache on paper
15.8 x 18.1 cm
(reproduction measurements, original
measurements unknown)
Pam 971.238.J39c
Glenbow Library Collection, Calgary

Mount Resplendent, 1914
oil on panel
21.5 x 26.8 cm
Private Collection, Calgary
Courtesy Masters Gallery Ltd., Calgary

Mount Robson, 1914
oil on panel
21.6 x 26.7 cm
NJG inventory #1848
Collection of E. F. Anthony Merchant,
Edmonton
Courtesy Lando Fine Art, Edmonton

Mt. Resplendent, 1914
graphite on paper
18.0 x 24.0 cm
JaA 03.15
Collection of the Whyte Museum of
the Canadian Rockies, Banff

The Athabaska Valley, c. 1927
reproduction of a gouache on paper
15.8 x 18.1 cm
(reproduction measurements, original
measurements unknown)
Pam 917.238.J39c
Glenbow Library Collection, Calgary

The Ramparts, 1924
oil on panel
20.7 x 25.8 cm
Private Collection, Calgary
Courtesy The Collector's Gallery,
Calgary

J. E. H. MacDONALD

Jacques Lake, 1927
reproduction of an engraving on
paper
21.5 x 18.0 cm
(reproduction measurements, original
measurements unknown)
Pam 971.238.J39c
Glenbow Library Collection, Calgary

BOOKS, EXHIBITION CATALOGUES AND LEAFLETS, NEWSPAPERS AND PERIODICALS

Adamson, Jeremy.
—. *Lawren S. Harris: Urban Scenes and Wilderness Landscapes, 1906–1930*. Toronto: Art Gallery of Ontario, 1978.

Anonymous.
A Portfolio of Prints by Members of the Group of Seven. Toronto: Rous & Mann Press Ltd., 1925.

—. *Catalogue of Paintings of Scenes Along the Line of the Canadian Northern Railway*. The Canadian Northern Railway Building of the Canadian National Exhibition, 1915.

—. "Critic said they looked like a drunkard's 'innards,'" *Albertan* (Calgary), 1 February 1975.

—. "'Group of Seven' Artist Delighted With West," *Calgary Herald*, 30 September 1943.

—. "'Group of Seven' Returns to City," *Calgary Herald*, 6 December 1928, p. 12.

—. *Jasper National Park*. Ottawa: The Canadian National Railways, 1927.

—. "The Rockies as seen through a mystical eye," *The Globe and Mail* (Toronto), 20 September 1995, sec. A, p. 16.

Appelhof, Ruth Stevens, Barbara Haskell, and Jeffrey R. Hayes.
The Expressionist Landscape: North American Modernist Painting, 1920–1947. Birmingham: Birmingham Museum of Art, 1988.

Art Gallery of Toronto.
A. Y. Jackson Paintings 1902–1953. Toronto: The Art Gallery of Toronto, 1953.

Beers, Don.
Lake O'Hara Trails. Calgary: Rocky Mountain Books, 1996.

—. *The Wonder of Yoho*. Calgary: Highline Publishing, 1989. Rev. ed. Calgary: Highline Publishing, 1991.

—. *The World of Lake Louise*. Calgary: Highline Publishing, 1991.

—. *Jasper-Robson: A Taste of Heaven*. Calgary: Highline Publishing, 1996.

Bell, Andrew.
"Lawren Harris—A Retrospective Exhibition of his Painting, 1910–1948." *Canadian Art* (Christmas 1948): 51-53.

Bell, Clive.
Art. New York: (1913). Putnam's Sons, Capricorn Books, 1958.

Besant, Annie Wood, and C. W Leadbeater.
Thought-Forms. (London and Banaras: Theosophical Publishing Society, 1905). Adyar: Theosophical Publishing House, 1957.

Bice, Megan.
The Informing Spirit: Art of the American Southwest and West Coast Canada, 1925–1945. Kleinburg: McMichael Canadian Art Collection; Colorado Springs: Colorado Springs Fine Arts Center, 1994.

Blavatsky, H. P.
The Secret Doctrine, 2 vols. (1888). Pasadena: Theosophical University Press, 1970.

Brown, Elizabeth.
A Wilderness for All: Landscapes of Canada's Mountain Parks 1885–1960. Banff: Whyte Museum of the Canadian Rockies, 1985.

Christensen, Lisa.
A Hiker's Guide to Art of the Canadian Rockies. Calgary: Fifth House Ltd., 1999.

Cochran, Bente Roed.
"Harris Impressed by Rockies," *Edmonton Journal*, 16 April 1980, sec. D, p. 2.

Davis, Ann.
The Logic of Ecstasy: Canadian Mystical Painting, 1920–1940. Toronto: University of Toronto Press, 1992.

—. *A Study of the Group of Seven*. Ottawa: National Historic Sites Service, 1971.

Davy, Ted.
"Lawren Harris's Theosophic Philosophy." *The Canadian Theosophist*, Vol. 72, No. 3 (July/August 1991): 49-54.

Fairbairn, Phillippa, ed.
Spaces and Places: Eight Decades of Landscape Painting in Alberta. Edmonton: The Alberta Art Foundation, 1986.

Findlay, Nora.
Jasper: A Backward Glance at People, Places and Progress. Jasper: Parks and People, 1992.

Forster, Merna.
Jasper … A Walk in the Past. Jasper: Parks and People, 1987.

Frye, Northrop.
"The Pursuit of Form." *Canadian Art* (December 1948): 54–57.

Gadd, Ben.
Handbook of the Canadian Rockies. Second edition. Jasper: Corax Press, 1995.

Gallagher, Winnifred.
The Power of Place: How Our Surroundings Shape Our Thoughts, Emotions, and Actions. New York: HarperCollins Publishers, Inc., HarperPerennial, 1993.

Groves, Naomi Jackson.
A. Y.'s Canada. Vancouver: Clarke, Irwin & Company Limited, 1968.

Hannon, Leslie F.
"From Rebel Dauber to Renowned Painter: A Self-portrait of A. Y. Jackson." *Mayfair* (September 1954): 28–65.

Harris, Bess, and R. G. P. Colgrove, eds.
Lawren Harris. Toronto: The Macmillan Company of Canada Limited, 1969.

Harris, Lawren.
"Art as an Expression of the Values of its Day." (n.p., n.d.).

—. "Artist and Audience." *The Canadian Bookman* (December 1925): 197–198.

—. "Creative Art and Canada." Supplement to the *McGill News* (Montreal), December 1928, 6–11. Reprinted in *Yearbook of the Arts in Canada*, 1928–1929, edited by B. Brooker, 177–186. Toronto: Macmillan and Company Limited, 1929.

—. "The Group of Seven." Talk delivered during the Group of Seven exhibition, Vancouver Art Gallery, April 1954. (Mimeographed typescript: The University of British Columbia Special Collections and Manuscripts Section, Lawren Harris Papers).

—. "Modern Art and its Aesthetic Reactions." *The Canadian Forum* (May 1927): 239–241.

—. "Revelation of Art in Canada." *The Canadian Theosophist* (15 July 1926): 85–88.

—. "Review of the Toronto Art Gallery Opening." *The Canadian Bookman* (February 1926): 46.

—. "Theosophy and Art." *The Canadian Theosophist* (15 July 1933): 129–132.

—. "Theosophy and Art." *The Canadian Theosophist* (15 August 1933): 161–166.

Harris, Lawren S.
Contrasts, A Book of Verse. Toronto: McClelland and Stewart, 1922.

—. *A Disquisition on Abstract Painting*. Toronto: Rous & Mann Press Limited, 1964.

—. Letter to the Editor regarding "Dishnish Diary," Robert Ayre, *Canadian Art* (Xmas 1948), as published in *artscanada*, 40th Anniversary Issue (March 1982): 42.

—. *The Story of the Group of Seven*. Toronto: Rous & Mann Press Limited, 1964.

Hill, Charles C.
The Group of Seven: Art for a Nation. Toronto: McClelland & Stewart Inc., 1995.

Housser, Bess.
Letter to A. Y. Jackson, at Jasper, 8 September 1924. *"Dear Alex: When the postman poked his offering through the hole in the door …"* Collection of Dr. Naomi Jackson Groves, Ottawa (photocopy).

Housser, F. B.
A Canadian Art Movement: The Story of the Group of Seven. Toronto: The Macmillan Company of Canada, 1926.

—. "Thoughts on a Trip West." *The Canadian Theosophist* (October 1928): 225.

Jackson, A. Y.
"Artists in the Mountains." *The Canadian Forum* (January 1925): 112–114.

—. *A Painter's Country*. 1958. Reprint, foreword by The Right Honourable Vincent Massey, C. H. Vancouver: Clarke, Irwin & Company Limited, 1964.

Jackson, A. Y., and Sydney Key.
Lawren Harris: Paintings 1910–1948. Toronto: Art Gallery of Ontario, 1948.

Jackson, Christopher.
North by West: The Arctic and Rocky Mountain Paintings of Lawren Harris, 1924–1931. Calgary: Glenbow Museum, 1991.

Kandinsky, Wassily.
Concerning the Spiritual in Art. 1914. Reprint, translated and with an introduction by M. T. H. Sadler. New York: Dover Publications, Inc., 1977.

Knight, R. H.
"Report on the Death of Warden Goodair-Jasper." Department of the Interior, Canada, Dominion Parks Branch, Jasper Park, 7 October 1929.

Larisey, Peter.
Light for a Cold Land: Lawren Harris's Life and Work—An Interpretation. Toronto: Dundurn Press, 1993.

Leadbeater, Charles W.
Man Visible and Invisible. Rev. ed. Wheaton: Quest Books, Theosophical Publishing House, 2000.

Lismer, A. J.
"Canadian Art." *The Canadian Theosophist* (15 February 1925): 177–179.

——. *A Short History of Painting, with a Note on Canadian Art*. Toronto: Andrews Brothers, 1926.

Lismer, Arthur
"Art as a Common Necessity." *The Canadian Bookman* (October 1925): 159–160.

Mandel, Eli.
"The Inward, Northward Journey of Lawren Harris." *artscanada* (October/November 1978): 17–20.

Mays, John Bentley.
"Disputing Claims That Jackson's Later Work Was Dull," *The Globe and Mail* (Toronto), 29 May 1982.

——. "Harris Researches (sic) Fail to Illuminate," *The Globe and Mail* (Toronto), 12 November 1994.

Mesley, Roger J.
"Lawren Harris's Mysticism: A Critical View." *artmagazine* (November/ December 1978): 12–18.

Murray, Joan.
"Lawren Harris: How Bad Can a Great Painter Be?" *Montage* (February 1986): 41–46.

——. *Origins of Abstraction in Canada: Modernist Pioneers*. Oshawa: The Robert McLaughlin Gallery, 1994.

Murray, Joan, and Robert Fulford.
The Beginning of Vision: The Drawings of Lawren S. Harris. Vancouver: Douglas and McIntyre Ltd., 1982.

Nasgaard, Roald.
The Mystic North: Symbolist Painting in Northern Europe and North America, 1890–1940. Toronto: Art Gallery of Ontario, 1984.

Patton, Brian.
Parkways of the Canadian Rockies: A Road Guide. Fourth edition. Banff: Summerthought Ltd., 1995.

Patton, Brian, and Bart Robinson.
The Canadian Rockies Trail Guide: A Hiker's Manual to the National Parks. Sixth edition. Canmore: Devil's Head Press, 1994.

Pole, Graeme.
Classic Hikes in the Canadian Rockies. Canmore: Altitude Publishing Canada Ltd., 1994.

——. *Walks and Easy Hikes in the Canadian Rockies*. Canmore: Altitude Publishing Canada Ltd., 1992.

Porsild, A. E.
Rocky Mountain Wildflowers. Ottawa: National Museum of Natural Sciences, 1979.

Portman, Jamie.
"A. Y. Jackson Painting Turns up Two For One," *Calgary Herald*, 20 April 1974.

Preston, R. A., and G. F. G. Stanley, eds.
The Canadian Historical Association, Report of the Annual Meeting held at Victoria and Vancouver, June 16–19, 1948, with Historical Papers. Toronto: University of Toronto Press, 1948.

Putnam, William L., Glen W. Boles, and Roger W. Laurilla.
Place Names of the Canadian Alps. Revelstoke: Footprint Publishing, 1990.

Reid, Dennis.
A Bibliography of the Group of Seven. Ottawa: The National Gallery of Canada, 1971.

——. *Alberta Rhythm: The Later Work of A. Y. Jackson*. Toronto: Art Gallery of Ontario, 1982.

——. *Atma Buddhi Manas: The Later Work of Lawren S. Harris*. Toronto: Art Gallery of Ontario, 1985.

——. *The Group of Seven*. Ottawa: The National Gallery of Canada, 1970.

——. "Lawren Harris." *artscanada* (December 1968): 9–16.

Sandford, R. W.
Yoho: A History and Celebration of Yoho National Park. Canmore: Altitude Publishing Canada Ltd., 1993.

Schama, Simon.
Landscape and Memory. Toronto: Vintage Canada, 1996.

Smith, Cyndi.
Jasper Park Lodge: In the Heart of the Canadian Rockies. Canmore: Coyote Books, 1985.

Steiner, Rudolf.
Art as a Spiritual Activity. Translated by Catherine E. Creeger, foreword by Michael Howard. Hudson: Anthroposophic Press, 1998. Originally published as *Rudolf Steiner Gesamtausgabe 1884–1901* (Switzerland: Rudolf Steiner Verlag, 1901).

——. *Theosophy: An Introduction to the Spiritual Processes in Human Life in the Cosmos*. 1910. Ninth edition, with a foreword by Michael Holdrege. Hudson: Anthroposophic Press, 1994.

Tippett, Maria, and Douglas Cole.
From Desolation to Splendor: Changing Perceptions of the British Columbia Landscape. Vancouver: Clarke, Irwin & Company Ltd., 1977.

Tousley, Nancy.
"Painter Found Spiritual Reality in the Arctic," *Calgary Herald*, 21 June 1991, sec C, p. 7.

Tuchman, Maurice et. al.
The Spiritual in Art: Abstract Painting 1890–1985. New York: Abbeville Press Publishers, 1986.

Vickery, Jim Dale.
Wilderness Visionaries. Minocqua: North World Press, 1994.

Wilkin, Karen.
The Group of Seven in the Rockies. Edmonton: The Edmonton Art Gallery, 1974.

Yorath, Chris, and Ben Gadd.
Of Rocks, Mountains and Jasper: A Visitor's Guide to the Geology of Jasper National Park. Toronto: Dundurn Press, 1995.

ARCHIVAL SOURCES

Archives of the Government of the Province of Alberta:
Alberta Foundation for the Arts Files
Lawren S. Harris Papers
(MG 30 D 208)

The Archives of the Whyte Museum of the Canadian Rockies
Catharine Robb Whyte Papers
A. Y. Jackson Papers

The Art Gallery of Ontario artist files
A. Y. Jackson papers
Lawren S. Harris papers

Glenbow Museum Library, Calgary
Artist Files
Lawren S. Harris
A. Y. Jackson
Gallery Files
Canadian Art Galleries

Jasper-Yellowhead Museum Archives
Doris Kensit Fonds
(89.12, 994.45)

McMichael Canadian Art Collection
Artist files
A. Y. Jackson papers
Lawren S. Harris papers

National Archives of Canada, Ottawa
DePencier, Norah Thomson
Manuscripts
(MG 30 D 322, Volume 1)
Groves, Naomi Jackson Manuscripts
(MG 30 D 351)
Harris, Lawren Stewart Manuscripts
(MG 30 D 208, Volume 2)
Jackson, Alexander Young
Manuscripts
(MG 30 D 259)
Parks Canada Records
(RG 84)

The University of British Columbia
Special Collections and University Archives Division, Manuscripts Section
A. Y. Jackson Papers
Nan Cheney Papers, File 4, (10–11)
Lawren S. Harris Papers

CORRESPONDENCE AND CONVERSATIONS

Dr. Naomi Jackson Groves, with the assistance of Anna Brennan, to the author:
5 January 2000, 4 January 1999, 1 December 1998, 15 March 1996.

Mr. Stewart Sheppard, grandson of Lawren S. Harris, to the author:
September 1999–February 2000.

1. Naomi Jackson Groves, *A. Y.'s Canada* (Toronto: Clarke, Irwin and Company Ltd., 1968), 150.

2. Bess Harris and R. G. P. Colgrove, *Lawren Harris* (Toronto: Macmillan of Canada, 1969), 10.

3. A. Y. Jackson, *A Painter's Country: The Autobiography of A. Y. Jackson* (Toronto: Clarke, Irwin and Company Limited, 1958), 109.

4. Hector Charlesworth, "And Still They Come! Canada and Her Paint Slingers," *Saturday Night* (8 November 1924).

5. Peter Larisey, *Light for a Cold Land: Lawren Harris's Life and Work—An Interpretation* (Toronto: Dundurn Press, 1993), 100.

6. Bess Harris and R. G. P. Colgrove, *Lawren Harris* (Toronto: Macmillan of Canada, 1969), 62.

7. Lawren Harris, "Revelation of Art in Canada," *The Canadian Theosophist* (15 July 1926), 85–88.

8. Lawren Harris, "Revelation of Art in Canada," *The Canadian Theosophist* (15 July 1926), 85–88.

9. Winnifred Gallagher, *The Power of Place* (New York: HarperCollins Publishers, 1993), 96.

10. From a conversation with the artist's grandson Stewart Sheppard, 1999.

11. Harris is likely to have derived this analogy from Clive Bell's book *Art*, (New York 1913) with which he was familiar. Bell believed that music could transport man from mere existence in the daily world into a state of exaltation.

12. References to this trip having taken place in 1925 are incorrect. This is an error that Harris himself made and later corrected, which has nonetheless found its way into several publications.

13. Lawren Harris personal papers, notebook from the 1940s: National Archives of Canada (30D 208 vol. 2, file 12), 18.

14. An examination of this period of Jackson's career can be found in: Dennis Reid, *Alberta Rhythm, the Later Work of A. Y. Jackson* (Toronto: Art Gallery of Ontario, 1982).

15. Naomi Jackson Groves, *A. Y.'s Canada* (Toronto: Clarke, Irwin and Company Ltd., 1968), 150.

16. Walter Klinkhoff, *A. Y. Jackson Retrospective Exhibition Catalogue*, September, 1990 (Montreal: La Galérie Walter Klinkhoff, 1990), 4.

17. Janice Tyrwhitt, *A. Y. Jackson: All Canada For His Canvas* (Reader's Digest: April 1978), 43–48.

18. Don Beers, *Jasper–Robson: A Taste of Heaven* (Calgary: Highline Publishing, 1996), 211.

19. A. Y. Jackson, *A Painter's Country: The Autobiography of A. Y. Jackson* (Toronto: Clarke, Irwin and Company, Limited, 1958), 35–36.

20. A. Y. Jackson, *A Painter's Country: The Autobiography of A. Y. Jackson* (Toronto: Clarke, Irwin and Company, Limited, 1958), 37.

21. Naomi Jackson Groves, *A. Y.'s Canada* (Clarke, Irwin and Company Ltd., 1968), 148.

22. Leslie F. Hannon, "From Rebel Dauber to Renowned Painter: A Self-Portrait of A. Y. Jackson," *Mayfair* (September 1954).

23. A. Y. Jackson, *A Painter's Country: The Autobiography of A. Y. Jackson* (Toronto: Clarke, Irwin and Company, Limited, 1958), 37.

24. A. Y. Jackson to Dr. James McCallum, by letter, 1914.

25. A. Y. Jackson to Dr. James McCallum, by letter, 1914.

26. *White Horne* [sic] *Under Cloud*, 1914, oil on panel 21.6 x 26.7 cm. At the time of writing, this work was at auction.

27. Anonymous, "Critic said they looked like a drunkard's 'innards.'" *Albertan* (1 February 1975).

28. Naomi Jackson Groves in a letter to the author, 5 January 2000.

29. Leslie F. Hannon, "From Rebel Dauber to Renowned Painter: A Self-Portrait of A. Y. Jackson" *Mayfair* (September 1954).

30. *White Horne* [sic] *Under Cloud*, 1914, oil on panel 21.6 x 26.7 cm. At the time of writing, this work was at auction.

31. Leadbeater and Besant published many titles on theosophy and related subjects, both individually and as co-authors.

32. Cyndi Smith, *Jasper Park Lodge : In the Heart of the Canadian Rockies* (Canmore: Coyote Books, 1995), 11.

33. Cyndi Smith, *Jasper Park Lodge: In the Heart of the Canadian Rockies* (Canmore: Coyote Books, 1985), 15.

34. A. Y. Jackson to Norah Thomson DePencier, 21 May 1924, DePencier Fonds, National Gallery of Canada.

35. Jackson had been in Jasper townsite before the 1914 trip with J. W. Beatty. Beatty painted a depiction of Jasper (then Fitzhugh) which was listed in the 1915 Canadian National Exhibition CNR exhibition. No works by Jackson are known.

36. A. Y. Jackson to Norah Thomson DePencier, 22 July 1924, DePencier Fonds, National Gallery of Canada.

37. A. Y. Jackson to Norah Thomson DePencier, 22 July 1924, DePencier Fonds, National Gallery of Canada.

38. A. Y. Jackson to Norah Thomson DePencier, 22 July 1924, DePencier Fonds, National Gallery of Canada.

39. A. Y. Jackson to Norah Thomson DePencier, 22 July 1924, DePencier Fonds, National Gallery of Canada.

40. F. B. Housser, *A Canadian Art Movement* (Toronto: Macmillan of Canada, 1926), 193.

41. The canvas, which belongs to the National Gallery of Canada, is dated 1924, and was purchased from the artist that year, confirming the date, but seems to have more in common with the 1926 and 1929 works than any of the others from 1924. Harris's descendants speculate that many of the titles, signatures, and dates were given to the paintings at a later date by other family members. They may or may not be accurate. Stylistically, within the body of Harris's Rocky Mountain works, this canvas would more likely date from after 1925.

42. *The Canadian Forum* (October 1924), 83.

43. *Brazeau Snowfield, Jasper*, 1924, oil on canvas (at auction in 1999); *Brazeau Snowfield*, 1926 oil on canvas (unlocated); *Coronet Glacier, Near Maligne Lake*, 1926 (illustrated: Glenbow Museum); and *South End of Maligne Lake*, c. 1925 (illustrated: MCAC, 1968.16.1).

44. Notes for catalogue #129 (*Coronet Glacier, Near Maligne Lake*) in *Lawren Harris: Paintings 1910–1948* (Toronto: Art Gallery of Ontario, 1948), 36.

45. F. B. Housser, *A Canadian Art Movement* (Toronto: Macmillan of Canada, 1926), 194.

46. A. Y. Jackson, "Artists in the Mountains," *The Canadian Forum* (January 1925), 112-114.

47. F. B. Housser, *A Canadian Art Movement* (Toronto: Macmillan of Canada, 1926), 194.

48. A. Y. Jackson, *A Painter's Country: The Autobiography of A. Y. Jackson* (Toronto: Clarke, Irwin and Company, Limited, 1958), 106.

49. Lawren S. Harris, *The Story of the Group of Seven* (Toronto: Rous and Mann Press Limited, 1964), 22.

50. A. Y. Jackson, *A Painter's Country: The Autobiography of A. Y. Jackson* (Toronto: Clarke, Irwin and Company, Limited, 1958), 106.

51. F. B. Housser, *A Canadian Art Movement* (Toronto: Macmillan of Canada, 1926), 193.

52. A. Y. Jackson, "Artists in the Mountains," *The Canadian Forum* (January 1925), 114.

53. F. B. Housser, *A Canadian Art Movement* (Toronto: Macmillan of Canada, 1926), 194.

54. A. Y. Jackson, "Artists in the Mountains," *The Canadian Forum* (January 1925), 114.

55. A. Y. Jackson, *A Painter's Country: The Autobiography of A. Y. Jackson* (Toronto: Clarke, Irwin and Company, Limited, 1958), 106.

56. A. Y. Jackson, *A Painter's Country: The Autobiography of A. Y. Jackson* (Toronto: Clarke, Irwin and Company, Limited, 1958), 107.

57. A. Y. Jackson to Norah Thomson DePencier, 13 August 1924, DePencier Fonds, National Gallery of Canada.

58. A. Y. Jackson to Norah Thomson DePencier, 13 August 1924, DePencier Fonds, National Gallery of Canada.

59. A. Y. Jackson to Norah Thomson DePencier, 13 August 1924, DePencier Fonds, National Gallery of Canada.

60. A. Y. Jackson to Norah Thomson DePencier, 13 August 1924, DePencier Fonds, National Gallery of Canada.

61. A. Y. Jackson to Norah Thomson DePencier, 13 August 1924, DePencier Fonds, National Gallery of Canada.

62. Lawren S. Harris, *The Story of the Group of Seven* (Toronto: Rous and Mann Press Limited, 1964), 22–23.

63. A. Y. Jackson, *A Painter's Country: The Autobiography of A. Y. Jackson* (Toronto: Clarke, Irwin and Company, Limited, 1958), 107.

64. The Thomson Gallery Collection, Toronto.

65. At auction in 1999.

66. The Art Gallery of Ontario, A. Y. Jackson artist files, undated.

67. The first of these is now unlocated, the latter was at auction in 1999.

68. A. Y. Jackson, *A Painter's Country: The Autobiography of A. Y. Jackson* (Toronto: Clarke, Irwin and Company, Limited, 1958), 107.

69. See pp. 76–81

70. Don Beers, *Jasper–Robson: A Taste of Heaven* (Calgary: Highline Publishing, 1996), 156.

71. Naomi Jackson Groves, *A. Y.'s Canada* (Toronto: Clarke, Irwin and Company Ltd., 1968), 150.

72. Anonymous CNR Brochure, *Jasper National Park,* 1927.

73. Anonymous CNR Brochure, *Jasper National Park,* 1927.

74. Anonymous CNR Brochure, *Jasper National Park,* 1927.

75. The guest register reads: "Mr. and Mrs. Lawren Harris of Toronto and two children and their nurse."

76. The guest register for 16 July 1928 reads: "Lawren Harris, Toronto, with Howard Harris and Mrs. Lawren Harris." An additional entry on 18 July 1928 lists the arrival of Lawren P. Harris. They stayed in rooms 2 and 3. Howard and Lawren P. were Lawren and Beatrice's sons.

77. Rudolf Steiner (1861–1925) broke away from the Theosophical Society in 1913. He then taught a doctrine, correctly termed Anthroposophy, which had a greater emphasis on the occult than did the teachings of Blavatsky. It is important to note that in this case "occult" is defined as the hidden meanings of things that cannot be proved by science, not as we use it today to describe superstition, witchery, etc., all practices which he condemned. He based much of his teaching on Goethe.

78. Anonymous, as quoted in Ted Davy, "Lawren Harris's Theosophy," *The Canadian Theosophist*, Vol. 71, No. 3 (July–August 1991).

79. Ted Davy, "Lawren Harris's Theosophy," *The Canadian Theosophist*, Vol. 71, No. 3 (July–August 1991).

80. Ted Davy, "Lawren Harris's Theosophy," *The Canadian Theosophist*, Vol. 71, No. 3 (July–August 1991).

81. Ted Davy, "Lawren Harris's Theosophy," *The Canadian Theosophist*, Vol. 71, No. 3 (July–August 1991).

82. Karen Wilkin, *The Group of Seven in the Rockies* (Edmonton: The Edmonton Art Gallery, 1974), 3.

83. Peter Larisey, *Light for a Cold Land: Lawren Harris's Life and Work— An Interpretation* (Toronto: Dundurn Press, 1993), 175.

Lisa and Anna Christensen on the trail to Skoki,
July, 1997

Lisa Christensen is a freelance art historian, writer, and curator,

currently focused on the art history of the Canadian Rockies. She is a past

Associate Curator of Art at the Glenbow Museum in Calgary, and has her

bachelor's degree in Art History from the University of Calgary. Her first book,

the award-winning *A Hiker's Guide to Art of the Canadian Rockies*, introduced the

"trail guide to art" approach to mountain visitors and art lovers. Lisa advocates a

"boots-on" approach to communicating about the art that depicts the scenery of

the Canadian Rockies, and feels that a firsthand, personal understanding of place

is an important factor in developing a full appreciation of Canadian landscape art.